From Crime to Crime

These People Know Whodunnit...
Author Dennis Palumbo

"This sparkling assemblage features an assortment of fascinating and quirky characters, including a couple of amateur sleuths, a female psychologist who hasn't thought through the perils of her occupation, and even a young clerk named Albert Einstein who solves a series of brutal murders while simultaneously striking a blow against anti-Semitism. But it's the idiosyncratic members of the Smart Guys Marching Society that distinguish this collection. In updating the legendary Isaac Asimov's crime solving Black Widowers, Palumbo adds a touch of Neil Simon to the mix, gathering his odd quintet of armchair sleuths each Sunday for deli, theorizing, philosophizing, arguing and, thanks to one mutton-chopped brilliantly analytical member named Isaac, solving impossible crimes. Male bonding has seldom been more entertaining."

—Dick Lochte, author of *Croaked!* and *Sleeping Dog*

"Dennis Palumbo's gang of affable husbands solves some daunting mysteries with a combination of clever deduction and sly humor that is very appealing. Lots of fun."

—April Smith, author of the latest FBI Special Agent Ana Grey mystery, *Judas Horse*

"Palumbo's contemporary characters dig into these classic, brain-teasing whodunnits with humor and wit. It's a feast for crime-story lovers of all stripes."
 —Bobby Moresco, writer/producer *Crash*; *Million Dollar Baby*

"Dennis Palumbo's stories are fun to read: smart, well-written and delightfully original."
 —Peter Lefcourt, author of *The Manhattan Beach Project*

"If only I were smart enough, I'd like to join the Smart Guys Marching Society! (Or should that be "If I *was* smart enough...") See, that's why I'm stuck just reading the stories and trying my best to keep up with the ingenious twists and turns. The Smart Guys are good company---and great story-tellers."
 —Robert Masello, author of *Vigil* and *Bestiary*

"Smart and funny whodunnits... as if my own life isn't hard enough to figure out."
 —Garry Shandling, Comic, Actor, Writer

From Crime to Crime

MIND-BOGGLING
TALES OF MYSTERY
AND MURDER

DENNIS PALUMBO

Tallfellow®Press
Los Angeles

Published by
Tallfellow® Press, Inc.
9454 Wilshire Blvd, Suite 550
Beverly Hills, CA 90212
www.Tallfellow.com

ISBN: 978-1-931290-60-9

Printed in USA
10 9 8 7 6 5 4 3 2 1

For
Lynne and Daniel,
with love

Table of Contents

Acknowledgments

I'd like to thank the following people, without whose help and encouragement this collection of mysteries would never have seen the light of day:

First and foremost, Claudia Sloan, my editor at Tallfellow Press, whose initial enthusiasm for this project never wavered, and whose editorial guidance has been both welcome and extremely valuable;

Leonard Stern and Larry Sloan, founders and publishers of Tallfellow Press, for their insight and support;

Laura Stern, Mike Sund and Janna Wong Healy, who helped with the design, production and editing of this book;

Janet Hutchings, Andrew Gulli and Richard Stayton, editors of, respectively, *Ellery Queen's Mystery Magazine*, *The Strand* and *Written By*, in whose pages a number of these stories first appeared;

My friends and colleagues, too numerous to mention, for their support of my work over the years—but regarding this particular book, my special appreciation goes out to Hoyt Hilsman, Bob Masello, Rick Setlowe and Dick Lochte;

And, lastly, a huge thanks to my fellow members of the *real* Smart Guys Marching Society—Mark Schorr, Bill Shick and Fred Golan. I hope I did us justice, guys.

Introduction

Most of the stories in this collection feature a group of unlikely amateur sleuths who call themselves—only half-kidding—"The Smart Guys Marching Society."

Just so you know, their exploits fall under the category generally called "armchair mysteries." That is, they usually take place in one room, in which the clever main character listens to a story told by someone else in attendance, and, based solely on what's been related, solves a baffling crime.

This style of crime story has a long and venerable history, going back to Poe. Even William Faulkner made use of it, in his gothic tales about wise old Uncle Abner. Another real mistress of the form was Agatha Christie, whose *Tuesday Night Club* stories featured a recurring cast of characters who met on the designated night and tried to solve mysterious crimes. As one self-important person after another invariably failed to figure out whodunnit, it remained only for the beloved Miss Marple to shed light on the problem.

Another author, Isaac Asimov, usually known for his science fiction works, also tried his hand at armchair mysteries. His *Black*

Widowers stories featured a similar set of erudite, articulate characters—all men—who met regularly for elaborate dinners, during which they'd attempt to solve a crime or untangle a puzzle. When they failed to do so—as they inevitably did—their patient, long-suffering waiter Henry helpfully provided the answer.

While inspired by these classic stories, I also wanted to bring a modern-day sensibility to the form. "The Smart Guys Marching Society" is the irony-drenched name chosen by four reasonably successful baby boomers for their weekly Sunday afternoon bull sessions. Embattled males all, with assorted wives and kids and mortgages, they seek to hang onto whatever dignity is left to them in middle age by contentiously debating the issues of the day.

At least, that's what they *thought* they were going to do. Somehow, though, what they often end up doing instead is solving crimes...

Or rather, *trying* to solve them. To their surprise, the newest member of the group—a wry, somewhat mysterious old man named Isaac—is kind of a whiz at it.

Of course, there's another difference between the Smart Guys stories in this book, and the series of stories by Faulkner, Christie and Asimov I mentioned earlier.

Namely, the Smart Guys Marching Society is real.

Many years ago, my friends Mark, Bill, Fred and I met weekly in my house in the San Fernando Valley, north of Los Angeles. Though others joined us for short periods, or even as invited guests, we four made up the core group. As in the following stories—and for similar, self-deprecating reasons—we called ourselves "The Smart Guys Marching Society." We figured the name would imply that we didn't

really think we were all *that* smart—which, of course, was exactly what we did think.

Every Sunday, we'd scarf down snacks, drink beer and discuss what Fred invariably called "the big issues."

Trust me, it wasn't as lame as it sounds.

Okay, maybe it was.

In any case, there *is* historical precedent. As Louis Menand details in his book, *The Metaphysical Club*, a similar "conversation group" was formed in 1872 by Oliver Wendell Holmes, William James, Charles Peirce and John Dewey, among others. To be honest, I suspect the comparison with our Smart Guys meetings ends there, though I'm proud to say that we lasted a great deal longer than they did. Those cranky geniuses disbanded in nine months; the Smart Guys met (more or less) regularly for six years.

However, in the name of full disclosure, I must admit that I've changed the professions of a few of the Smart Guys in these stories for dramatic purposes. Also, the dialogue and interactions among the characters, though loosely based on the attitudes and opinions of the four of us, are entirely fictional as well. The real Fred, Mark and Bill are all, to a man, more intelligent, articulate and reasonable than my narrative needs required. Believe me, they'll be the first to say so.

Even more importantly, the only mystery we ever tried to solve involved a missing tub of artichoke dip.

Alas, the greatest difference between the real-life Smart Guys and the following stories is that there never was an Isaac. Part wish-fulfillment, part tribute to Asimov's tales, part memories of my own beloved grandfather, the Isaac that populates these stories is—for better or worse—a figment of my imagination.

Also, rounding out this collection are a number of stand-alone mysteries. At first glance, they might seem merely to provide a change of pace from the Smart Guys' adventures. Yet two of these stories also feature amateur sleuths, one a female psychologist, the other a penniless patent clerk named Albert Einstein...

I hope you enjoy these as well.

One final note. Like the above-mentioned mysteries by Christie and Asimov, the Smart Guys Marching Society stories follow a time-honored format: a puzzling mystery is presented, and each of the guys takes a stab at figuring it out. Until, finally, someone turns to the oldest, wisest member of the group and invariably says, "Okay, Isaac, what do you think?"

At this point, the alert reader should realize that he or she has read far enough to have all the clues necessary to solve the crime.

I suspect, if you're holding this book in your hands, you definitely qualify as an alert reader. If so, are you ready to match wits with Isaac? Are you ready to try to figure out whodunnit?

Then all you need do is turn the page...

THE SMART GUYS

The Smart Guys Marching Society

I'd made the popcorn, as always, but at least Fred brought the beers. "Can't be a meeting of the Smart Guys Marching Society without some brewskis," he said, letting the bottles rattle noisily as he dropped the bag on my new coffee table.

"Hey, watch it!" I lunged for the bowl of cheese whirls, now perched precariously at table's edge.

Bill, munching peanuts, reached past my hand for the photo propped against the table lamp.

"You got it framed!" he said—or, rather, mumbled. A lone peanut escaped his mouth, bounced off the throw rug and scurried under the sofa.

"It's a goddam feeding frenzy around here." I was crouched by the sofa, reaching under for the peanut. All I came up with was a fistful of dustballs.

Bill looked at Fred, smirking. "Jesus, is this boy whipped, or what?"

5

"I happen to *like* a clean house," I said, wiping my hand with a napkin.

"Lemme see the picture," Fred was saying, craning to see over Bill's shoulder. It was the Polaroid we'd taken with the auto-shutter last week of the four of us—me, Bill, Fred and Mark. Not a pretty sight. We looked like the chorus of a musical called "40-Something": assorted beards, glasses and receding hairlines, in sneakers, shorts and one particularly vivid Hawaiian shirt.

"Whew," Fred said, wincing at our smiling, casual images. "It's a good thing we're smart."

"That's open to debate," Mark growled, coming in the porch door, laden with grocery bags. His severe glasses, dark hair and military-stiff bearing—a legacy of his career as an Intelligence officer turned journalist—were softened as always for me by his willingness to drop a few actual bucks for some real eats.

"My favorite Smart Guy!" Bill exclaimed, bouncing up to take bags from Mark. "Cold cuts, slaw... now we're in business."

"Look, are we here to eat or talk?" Fred looked concerned. A lawyer by trade, but philosopher by avocation, he rarely let our monthly discussions stray from what he liked to call "the big issues"—life, death, truth, etc. The usual suspects. He stroked his neat beard thoughtfully. "Today we're doing Middle East policy, right?"

"I hope not," Bill said, settling back on the sofa. He had the trim, wiry frame of a marathon runner, which in fact he was. "I brought a great *Atlantic Monthly* article about health care."

He pulled copies of the magazine article from his back pocket, passed them around. A long-time actor and theater director, he had a tendency to try to control the flow and content of our discussions.

With little success, I might add.

"What happened to the Middle East?" Fred complained.

"Don't look at me." Mark shrugged. "I was nowhere near there all week."

"Ha. Ha." Bill nodded toward the pages in our hands. "We're doin' health care."

As a psychotherapist, with years of experience handling conflicts, I decided it was time to apply my professional skills to the impasse.

"We'll flip a coin," I said, doing so. Unfortunately, it bounced off the table and, with a perversity I'd swear was deliberate, rolled under the sofa.

Mark looked glum. "It's gonna be a long afternoon."

Let me explain. The Smart Guys Marching Society began as an impromptu bull session a couple years ago, when the four of us (and our wives and kids) were barbecuing in my backyard.

It was a typical Southern California day, the smog doing a slow dissolve over the Hollywood Hills. Lazy Sunday conversation turned into impassioned debate, the four of us guys huddled around the smoking grill. Women and children were scattered about, doing real life, while we grappled with such pragmatic concerns as Roman military strategy, foreign aid and the merits of certain long-dead playwrights.

"Can you *believe* these guys?" Bill ranted to his wife, throwing up his hands. "They think Ibsen is overrated!" She stared back at him, unblinking.

We decided to make it a formal event, every Sunday afternoon. Stag. We didn't plan it that way—our wives simply had the good

sense not to want to come.

"I have better things to do," Mark's wife reportedly told him.

"Like what?"

"Like... anything." Case closed.

Anyway, that's how the whole thing started. Every Sunday after-noon (excepting holidays, kids' birthdays and visits from in-laws) the four of us—therapist, actor, journalist and lawyer—met in my game room to scarf down munchies, trade insults and debate the issues of the day.

This particular afternoon, however, would take a decidedly dif-ferent turn, one that would change our lives, and the course of the Smart Guys, forever...

The conversation had somehow drifted away from the Middle East, health care reform and other such rhetorical stalwarts to various tales of unexplained phenomena.

"But that's just my point," Fred was saying, pretty exasperated by now. "We know from Heisenberg's Uncertainty Principle that the observed is changed by the observer."

"So—?" Bill said.

"So, that explains unexplained phenomena. We co-create reality, see? Research indicates that the more you believe in ghosts, for exam-ple, the greater the likelihood that you'll encounter one."

"Geez, I don't know," Mark said. "I believe in intelligent debate, and in all the years I've been coming here I haven't encountered it yet."

Fred gave him a look. "The salient factor is that reality, or what we call reality, is co-determined by both observer and observed. Sub-ject and object, if you prefer."

"Reality is reality, dammit." Mark folded his arms.

Bill gnawed a fingernail reflectively. "Does this have anything to do with Jung?"

I perked up. "That depends. Why?"

"I have this friend. An actor. I directed him last year at the Taper. George is a real fitness buff, hits the gym every day. And he's noticed a strange phenomenon, and is making a hobby of compiling other people's experiences, to see if there's a pattern at work."

"Since when do actors care about other people?" Mark said, opening another beer.

"Ignore him," I said. "What phenomenon?"

Bill went on: "George said he notices that when he goes to his locker in the gym's locker room, even if it appears totally deserted, the moment another guy shows up, it turns out this other guy's locker is right next to his."

"Coincidence," Mark said.

Bill shook his head. "George has made a study of this. No matter what part of the locker room—I mean, he'll just pick a locker at random—and four times out of five somebody's stuff is in the next one. With all these other lockers around."

"That is strange," I admitted.

"He's asked lots of other people, and they've had the same experience. It's like there's some kind of primal, unconscious need to bond or something."

I nodded. "That's why you mentioned Jung... maybe you're referring to his concept of synchronicity."

"Oh, yeah... like when you're thinking of someone, and the phone rings and it's that person on the line."

"Or," I said, "perhaps the locker room phenomenon is caused by some mechanism in the collective unconscious toward merging, or community..."

Fred stared at a corn chip, as though it held the secrets of the universe.

"I'm thinking now in terms of quantum physics," he said. "The tendency of subatomic particles, even at vast distances, to resonate at similar vibratory frequencies." He popped the corn chip in his mouth. "I mean, at that level, everything—you, me, this table—is just a collection of vibratory frequencies, out of which comes the world we experience."

"Yeah," I agreed. "That place where Buddhism and physics meet. Emptiness rising into form, manifesting reality."

Bill's eyes were glazing over. "Now I'm sorry I brought it up." He rose, and stretched. "We're gettin' low on onion dip."

"In the fridge," I said.

Before Bill could take another step, however, a tub of onion dip came sailing out of the kitchen. He caught it reflexively.

We all whirled, stunned.

"I couldn't help but overhear," the newcomer said brightly. "Thought I'd save you a trip."

It was my wife's Uncle Isaac, his bear-like figure filling out his workman's overalls. A retired contractor (a "Jack of all trades," he called himself), he was staying with us for a while. I'd almost forgotten about him.

"Uncle Isaac," I said, "let me introduce you around."

He shook hands vigorously with each of the guys, his pale eyes gleaming. Then he stood back a bit, stroking his thick muttonchop

sideburns with a crooked finger.

My wife explained to me once that calling him "Uncle" was a courtesy; there was such a convoluted tangle of branches on her family tree that nobody was really sure how (or even if) Isaac was actually related. It seemed as though he'd just always been... family.

"How long have you been in the kitchen?" I asked. "You should've come on in."

"I didn't want to interrupt. Pretty deep-dish stuff you boys talk. Like college professors."

Fred shrugged. "You should've been here last week. We spent an hour arguing about who's the all-time hottest *Sports Illustrated* swimsuit model."

"You're welcome to join us," Bill offered, then glanced ruefully at the coffee table. "I think there's half a sandwich left, and some Cheez Whiz."

"A tempting offer," said Isaac, "but I had a big lunch. I just came back from a constitutional around the neighborhood."

He settled into the corner armchair. A lamp table beside it was stacked with books he'd brought along. Mostly mystery and sci-fi paperbacks. Conan Doyle. Asimov. Heinlein. The classics. "If you don't mind, I'll just listen in. Please don't take offense if I doze off."

"No problem. Kind of a weekly occurrance around here." Bill carved a groove in the onion dip with a potato chip. "Now, where were we?"

"We were talking about reality," Fred said. "Or Jung. Or locker rooms."

It was then that I first noticed Mark, sitting somewhat pensively. He hadn't said a word in some time.

"Hey, you okay?" I asked.

"I was just thinking about something," he said, adjusting his glasses. "All this stuff about unexplained phenomena... it reminds me of something that happened earlier this week. It's kind of... strange, that's all."

Fred looked up. "Something at the paper?"

"Well, I've been doing a series for the *Times* about street cops, the nightly grind, you know? I've been riding the graveyard shift with these cop buddies, Vince and Harry, and a real mess came down a couple nights back, down on Walnut Street."

"I think I saw that on the news last night," Bill said. "Some drug dealer got killed—knifed—by a cop."

Mark nodded. "The cop's name is Sergeant D'Amato. Your basic Neanderthal. Couple reprimands for excessive force. Always carries a pearl-handled folding knife in his belt—strictly against Department policy, of course—but everybody knows...."

"Anyway, I've been riding with Vince and Harry's unit out of D'Amato's precinct, and all I hear the past two weeks is about D'Amato's obsession with Tommy Slick."

"Who?" Fred asked.

"The victim," Bill said helpfully. "TV news showed his mug shot. Looked like Al Pacino in *Scarface*. Your stereotypical murdering, gang-connected drug dealer."

Mark ignored him. "As I was saying, D'Amato's been trying to bust Tommy for years on a major rap, but Tommy's been too..." He smiled. "Well, let's just say Tommy's been too slick for him."

"Tommy Slick..." Fred muttered. "His real name's probably Wilbur Kablonski or something."

Mark sighed heavily. "Look, guys, if I want sidebars on this story,

I'll write 'em myself. Anyway, D'Amato's definitely got his reasons for hating Tommy. Couple years back, Tommy killed D'Amato's partner during a police raid...."

"Wait a minute! He killed a cop—and walked?"

"Nobody could ID Tommy as the shooter," Mark said. "But D'Amato swore it was Tommy, that he saw him waste his partner before taking off...."

"D'Amato's upset..." I mused aloud. "He feels guilty over his partner's death... blames himself. So he needs to fixate that blame somewhere else...."

"Spare us, willya?" Mark rolled his eyes.

"Yeah," said Bill impatiently. "Besides, this is all just backstory, right?"

"You could call it that," Mark said. "Anyway, all this week, the precinct's humming like a live wire... D'Amato's got Tommy's main squeeze Carla in the strike zone—"

"What?"

"He was grilling her, as they used to say," Fred explained. "Man, she must have a shitty public defender."

Mark smiled. "Carla's no deb queen herself. Juvie hall at 13, soliciting and dealing charges—real nice career track, if you know what I mean... Anyway, D'Amato's been pushing her hard. A big deal is rumored to be going down, with Tommy behind it. D'Amato's been wanting to take him down big-time, and figures this'll do it."

"But why would Carla help him?"

"Turns out, she's furious at Tommy 'cause she heard he was cheating on her." Mark leaned in. "Anyway, two nights ago, I'm in the patrol car with Vince and Harry, and a call comes in requesting back-

up. Seems the girl's taking D'Amato to where Tommy's holed up. So we hit the siren and red light, and go jammin' over to this rundown place on Walnut.

"When we get there, D'Amato's in his car with Carla, who's wailing and crying. We run up to them, Vince and Harry carrying the heavy artillery. Just then, a window smashes above us, glass showering down, and a couple of Tommy's guys start shooting at us."

"Jesus Christ," said Bill.

"Yeah, that name came up," Mark said. "I mean, all of sudden it's a goddam shoot-out. Vince is yellin' at me to stay down—Hell, *I've* got more combat experience than he does! Finally, after about ten minutes of this, D'Amato tells Carla to stay put and goes chargin' into the place. Vince and Harry got no choice, they go crashing in after him, with me bringing up the rear."

"What are you, nuts?" Fred stared at Mark, wide-eyed.

"It gets worse," Mark said. "Carla bolts out of the car, and the next thing I know, all of us, including her, are scurrying up this darkened stairwell inside the building—with Carla screaming her head off, trying to warn Tommy—"

"And you're in the middle of all this?" I said.

"Oh, yeah." His voice tightened. "Bullets are flying everywhere, and then we're upstairs, in Tommy's place. One of his gang is heading out the window. But Vince yells 'Freeze!' and the perp drops his gun. The other perp is in a heap by the bed, covered with blood...."

"Where the hell was Tommy?"

"That's what D'Amato wanted to know. We're all crouched in the doorway, guns drawn, Carla and me pushed behind the cops. Vince is covering the perp, still frozen halfway out the window...."

"'Where's Tommy, dirtball?' D'Amato yells at this guy. He doesn't say squat. Suddenly, D'Amato lifts his piece... 'I'm sprayin' the walls, Tommy!'... So Vince starts grabbing for his arm, to stop him—Just then, Carla breaks free and runs into the middle of the room. D'Amato roars like a banshee, goes right in after her.

"Suddenly, a door flies open—it was a special hiding place, no bigger than a closet... Anyway, this door flies open and Tommy's body falls out—right into Carla's arms! She reels back, screaming, as the body hits the floor. There's a knife sticking out of his chest, blood seeping through his shirt."

"A knife?" Bill asked, his voice a whisper.

Mark nodded, eyes narrowing. "Carla takes one look at it and yells up at D'Amato. 'You bastard! You killed him!' Before anyone could stop her, she pulls the knife from Tommy's body and lunges at D'Amato! It takes me and Vince to restrain her, Vince finally knocking the knife loose... Then we all just stand there, staring at it on the floor. Even stained with blood, there was no mistaking the pearl handle. It was D'Amato's knife."

"What?" Fred and I exchanged looks.

"Yeah. It was *his* knife that killed Tommy Slick. I glanced instinctively at his belt, where he keeps the knife—and it was gone.

"So Vince says to him, 'How'd ya do it, D'Amato?' But D'Amato just keeps staring down at Tommy, his face hard as stone."

Mark sat back, took off his glasses.

"So... what happened?" I asked.

Mark shrugged. "Homicide and Internal Affairs are all over it. Vince figures D'Amato did it, but nobody can dope out how."

"What does D'Amato say?"

15

"'Prove it,' is all he says. 'Maybe my knife wanted to kill the bastard more'n I did.'"

"He's crazy," said Bill.

"Not so crazy," Fred replied. "I mean, if he did it, *how* did he do it?" He turned to Mark. "You say this hidden closet was closed the whole time?"

"Like a drum. Apparently Tommy had had it constructed as a hiding place just in case of a raid or something... a little one-man bunker, just for him."

Bill looked thoughtful. "Maybe somebody else stabbed him... ya know, earlier, before you guys got there...."

"Vince thought of that. Like maybe one of the other perps on the scene... Tommy goes in to hide, leaving his two men to shoot it out with the cops. So one of the gang stabs him. The only problem is, where did he get D'Amato's knife to do it with?"

"Wait a minute," I said. "We're making this way too complicated. You said D'Amato grilled Carla for two whole days. What if she spilled the beans sooner than he said? What if he got the hideout's address from her, goes over earlier in the day, gets Tommy alone and stabs him, and stashes him in the secret closet?"

"How would he know about it?" Fred asked. "Unless Tommy conveniently told him, just before getting stabbed."

"Carla told him about it," I said. "So D'Amato kills Tommy, getting revenge for his dead partner—"

"And where were Tommy's two men while this was going on, out getting a pizza?"

"I don't know. Maybe. Anyway, D'Amato comes back, then he radios for backup and instigates the big raid. But it's only a charade

to cover his tracks. Meanwhile, Tommy's already dead."

"Interesting theory," Mark said, smiling. "Stupid, but interesting. For one thing, the coroner puts the time of death at roughly when we broke in there. And, hell, I *saw* the knife in his chest—that wound was fresh."

"Okay, let's be logical," Fred said. "It was nighttime, dark... probably the lights were shot out anyway...."

"Right," Mark said. "And it all happened kinda fast."

"So who's to say D'Amato didn't somehow get into the room ahead of you, your two cop buddies and Carla... It would just take seconds to slip the knife through a door slot, killing Tommy in that hidden closet."

Mark shook his head. "I'm telling you, that closet was airtight. Built flush with the wall, so that you couldn't even see a door without looking closely. I didn't see it until it fell open and Tommy tumbled out. Besides, we all got into that room about the same time. I don't believe D'Amato could've stuck a knife through the door jamb, even if he'd known where it was."

"Then what are we left with?" Bill asked.

Mark smiled. "D'Amato's knife magically left his belt, found its way into a sealed hidden closet and stabbed Tommy Slick to death. All this in a matter of seconds, in front of witnesses."

"I still think one of Tommy's men did it," said Bill. "Didn't you say one guy was down, but the other one was trying to go out the window when you broke in?"

"That's right. But according to him, Tommy jumped into his special hiding place as soon as the shooting started. The guy swears Tommy was in there the whole time—he never came out and nobody

went near the door—until Tommy fell out, dead...."

"With D'Amato's knife in his heart," I said. "Talk about your unexplained phenomena."

Bill frowned at Mark. "That's it?" he demanded. "I mean, what's gonna happen?"

"Who knows? D'Amato won't talk. It's kind of perverse on his part, if you ask me... he's so glad Tommy's dead, and that his knife was the instrument, it's like he doesn't care now what happens. Though one of my sources in the Department says that if charges are filed, D'Amato intends to plead not guilty."

"I'll bet," Bill said. "He's not *that* crazy."

Mark smiled ruefully. As though there wasn't much else to say.

Suddenly, a voice broke the silence.

"What does he look like?"

We all turned. It was Isaac, comfortably settled in the armchair, his cherubic face shining. Tell you the truth, I'd forgotten he was there... again.

"Look like?" Mark said, with some irritation. "Who? D'Amato?"

"No, no," Isaac replied. "I mean George, that actor friend of Bill's."

"Oh, yeah, the guy in the locker room," I said.

"What does that have to do with anything?" Fred asked. He glanced warily at Mark, and then at me.

"Uh... look, Uncle Isaac..." I must admit, I was somewhat embarrassed.

"I was just thinking," Isaac went on, leaning back in his chair. "I mean, about that curious phenomenon of the locker room. I was wondering what George looked like...."

Bill shrugged. "Very handsome, in a buffed, hunky kind of way.

If you like that type."

Isaac nodded. "You see, this fellow George noticed that whatever locker he chose—even if each day he chose a different area of the locker room at random—another guy would show up, his stuff in the very next locker. In a sea of available lockers, the odds almost always favored this coincidence."

"So?"

"So I just thought that coincidence—or even the collective unconscious, or a field of subatomic particles vibrating cooperatively—might be *nudged along* a little if George were a handsome man. Perhaps other men who found him attractive would make it a point to pretend their locker was next to his."

"But George said the other guy would show up, open the locker next to his, and start taking his stuff out—"

"Or start putting it *in*," Isaac said, "in such a way that it *looked* as if he were taking it out. I did that once in high school—many, many years ago, as you can imagine—when I was attracted to this girl named Shirley. I opened the locker next to hers, claiming it was mine, and put a book in and took a book out, while we stood there talking. Of course, it was the same book. It's really quite easy to do, especially if the locker door opens toward the girl, so her view is blocked as to the locker's real contents."

"Look, Isaac." Mark tried to remain calm. "That's real interesting, but what we've been talking about is—"

Isaac sat forward, eyes crinkling. "Yes, yes, I know. A mysterious crime. Unexplained. Your classic locked-room murder... only in this case, it's a closet."

"Are you trying to say something, Isaac?" I asked.

"Just a question I have. I was wondering why Carla attacked Sergeant D'Amato."

"She freaked out when she saw that Tommy had been stabbed," Mark answered. "She recognized D'Amato's knife and wanted to kill him."

"So I assume her fingerprints are on the knife?"

"Of course. From when she pulled it from Tommy's body to attack D'Amato."

"I'm afraid that's where we disagree," Isaac said, stroking his sideburn. "I think she grabbed the knife and attacked D'Amato in front of all of you to disguise the fact that her prints were *already* on the knife—from having stabbed Tommy."

"What?!"

"But how? When?"

"When Tommy conveniently fell out of the closet, into her arms," said Isaac.

"But D'Amato's knife killed Tommy."

"I know. She was holding it in her hand at the time."

Suddenly we were all talking at once. Isaac waved us down. "Look, maybe I'm wrong. After all, I wasn't even there. *Mark* was..."

"That's right," he said. "And she *couldn't* have planned it. I saw Tommy's body fall out of the closet..."

"Did I say she planned it? Look..." Isaac ticked his thoughts off on stubby fingers. "Here's a tough girl, angry at Tommy for cheating on her. D'Amato sweats her till she tells him where Tommy is. She's probably feeling very mixed emotions—hurt, rage, a desire for revenge... But she's a realist, too. What does she think Tommy's going to do when he finds out she led D'Amato to the hideout?"

"So now you're saying the murder *was* planned?"

"No," he replied calmly. "I'm saying that the opportunity presented itself. I'm suggesting that when Tommy fell out of his hiding place, into her arms, in that darkened room—it would only take a moment's thought for her to conceive of stabbing him... right there and then..."

"I get it," Bill said excitedly. "Then screaming as his body hits the floor, as though in shock..."

Isaac shrugged. "Maybe in real shock, in horror at what she'd done... Who knows? But she kept her wits enough to know her fingerprints would be on the murder weapon."

"So she pulled the knife from Tommy's chest and attacked D'Amato," I said, "thus creating the impression it was at *that* moment she first touched the knife..."

"Like George in the locker room, only in reverse," Isaac agreed. "Pulling out the knife disguised the fact that she'd been the one who put it in." Isaac folded his hands on his ample stomach.

"But how did she get the knife in the first place?" Mark asked.

"You said yourself, she ran from D'Amato's car and joined the rest of you, clambering up the stairwell. In all that confusion, a girl with Carla's street background and criminal record could certainly lift the knife from D'Amato's belt."

He closed his eyes reflectively. "After all, she needed some kind of weapon—some way to defend herself, in case things got nasty up there. Remember, she was playing a very dangerous game... both sides against the middle." He smiled. "Moreover, she is a thief. Thieves *do* take things."

Bill scratched his chin. "You might be onto something, Isaac. But

there's still one thing I don't understand. How come Tommy fell out of his hidden closet? He did fall, right, Mark?"

"Yeah." Mark nodded. "Kinda crumpled, pushing the door open as he fell. But if Isaac is right, he hadn't even been stabbed yet..."

"So what happened to him?" Fred asked.

Isaac looked at Mark. "You said Tommy'd had the secret closet built for just such an emergency—small, flush with the wall, airtight seal. Tommy's man said he'd seen him get in the closet at the first sign of trouble... and that the door never opened again till Tommy fell out. That's about ten minutes, right, Mark?"

"More like fifteen."

"Well, fifteen minutes in a small, airtight compartment..." Isaac spread his hands. "I think Tommy simply *passed out* from lack of air, fell forward—"

"Pushing the door open as he fell," I said excitedly. "Right into Carla's arms..."

There was a long pause. Finally, Mark turned from Isaac to the rest of us. "Well, that makes as much sense as anything else."

"Pardon me," Isaac said. "But it makes more sense than anything else."

Fred chuckled dryly. "I think he's got us there."

Mark was on his feet, heading for the kitchen. He took his cell phone from his pocket.

"I'm gonna run all this past Vince. If he presses Carla hard enough, she might come clean."

"Especially if D'Amato wises up and pleads not guilty," Bill said. "Him and his magic knife..."

I shook my head. "I still think it'll bother him that somebody else

got Tommy Slick after all..."

"Who cares?" Fred was smiling at Isaac. "The important thing was you! That was really something, Isaac."

The old man gave a quick nod. "My friends'll tell you, modesty's not my strong suit. But it's nice to know I can still rub two thoughts together."

"Are you kidding?" Bill raised his drink. "I say, a toast is in order... I think we've found a new member of the Smart Guys Marching Society."

"That's a great idea," I said.

"Works for me," Fred chimed in. He tossed a beer to Mark, standing just inside the kitchen. "Raise one with us, Mark. We're initiating Isaac into the Smart Guys."

Mark toasted him. "Sorry about that, Isaac."

Then, turning to the phone, he said, "Vince?... You got a minute? You're not gonna *believe* this, but..."

End

The Last Laugh

It wasn't a by-law of the Smart Guys Marching Society that someone had to bring up a murder every couple of meetings, it just seemed to be turning out that way. Ever since my wife's Uncle Isaac, our newest member, solved a baffling local case, I guess each of us secretly hoped another puzzling crime problem would emerge amid the usual Sunday afternoon's debate over the issues of the day.

I'm thinking of one recent meeting. It started out like most of the others, a kind of poor man's *McLaughlin Group*, with lots of arguing and pontificating about health care, education reform and Middle East politics, until, by a path too tortuous to recount, we arrived at the subject of stand-up comedy. Or, more precisely, the art of telling a joke.

"You guys are pathetic," Bill was saying, spreading Cheez Whiz on a cracker. "You can't analyze comedy. You just kill it when you try."

"That's right," Fred agreed. "It's like that great Woody Allen anecdote."

"Which one?" I asked, coming in from the kitchen with a fresh bowl of popcorn. I tried to find a place for it on the crowded coffee table.

"Somebody asked Woody the secret to writing a great joke. He replied, 'Well, first comes the setup, *then* comes the punch line.'"

Mark frowned. "I don't get it."

Fred sighed, patiently. "He was being sarcastic. *Of course*, the set-up comes first, and then the punch line. You can't do it in reverse. He was making an ironic comment on the fact that someone would ask such a stupid question in the first place."

"Yeah, right," Mark growled. "Irony. How postmodern. Gimme the old guys. Bob Hope. Buddy Hackett. Jackie Mason. No irony. Just real jokes—and real laughs."

As I recall, it was a typical August day in the San Fernando Valley, hot and smoggy, testing my game room's air conditioning to the limit. You'd think it was too miserable to argue about anything—and, unless you were a member of the Smart Guys Marching Society, you'd be right.

We were all there—Mark, the former Intelligence officer turned reporter; Fred, a lawyer by trade and philosopher by inclination; Bill, actor and theater director; and me, once again the beleaguered host, piling chips and cold cuts onto big platters in a vain attempt to keep up with the feeding frenzy that invariably accompanied our stag get-togethers. (As a licensed psychotherapist, I saw our weekly meetings as either an interesting sociological example of male bonding, or else some lame excuse for the four of us longtime friends—any one of whom could have been a poster child for "midlife crisis"—to get together and complain about the collapse of Western civilization.)

And then, of course, there was Isaac. Round, smiling, with white muttonchop sideburns, usually sitting in a corner, half-dozing,

surrounded by his beloved old paperbacks. Some distant relative of my wife's, he was a retired contractor (a "Jack of all trades," as he put it), and a good 20 years older than the rest of us.

As always, he glanced up, occasionally, whenever the group's decibel level rose, then rested his chin on his fist, somewhat dreamily. It wasn't until Mark's last comment that he finally stirred.

"Don't forget Jack Benny," he said. "And Milton Berle."

"Now you're talking about *great* comics," Bill said eagerly. "Guys who spent years on the vaudeville circuit, honing their craft, paying some real dues. Nowadays, some kid does ten minutes on Leno and he gets his own series."

"That's right," Fred said. "Look at how many comics got launched on Johnny Carson's old show. Flip Wilson. Garry Shandling. Roseanne Barr. Seinfeld...."

"I think Carrot Top started that way, too," I said.

"We can't blame *The Tonight Show* for everything," Mark murmured. "Besides, today's comics don't even *tell* jokes. Look at Chris Rock. Ellen DeGeneres. Hell, Richard Pryor was the funniest stand-up I ever saw, and he never told a joke in his life."

Isaac shrugged. "That may be. Still, I think it's much tougher today on young comedians."

Fred pointed his beer bottle at Isaac. "No way. I'm with Bill on this one. The old-timers had to work all over the country, small towns, everywhere, trying to make their reputations. Nowadays, one shot on an HBO special and you've got 30 million fans, overnight."

Isaac smiled. "That's right. Thirty million people who've just seen your act. So the next time you're on TV or at a club, you better have new material." He sipped hot tea from his favorite mug. "In the old

days, in vaudeville, comics like Benny and Hope could work up a 20-minute bit, and use it over and over again, town after town. My God, Burns and Allen toured with the same act for ten years..."

"That's why comics like Groucho Marx thrived on radio, and later on television," I offered. "He could improvise."

"Isaac, how come you know so much about old comedians?" Fred asked.

"When I was a kid, I used to work summers as a waiter in the Catskills," he replied. "There were these big resort hotels, and a lot of old comics performed there. I used to hang around, after hours, listening to them tell stories. By the way," Isaac added, matter-of-factly, "I *met* Groucho once."

"You did?" I whirled and faced him. "When?"

"His old quiz show, *You Bet Your Life*. I was in the studio audience. Afterwards, I went backstage and shook his hand. A great moment for me, I can tell you."

He leaned forward, tugged his chin reflectively. "You know, way back in the '50s, there was a big contest to name the greatest comic of all time. An ad agency did some kind of poll or something. For publicity."

"Who won?" Mark asked.

"That's the funny thing," Isaac replied. "I can't remember. But I remember that Groucho lost, and *why* he lost. They said he didn't have enough heart. That to be a truly great comedian, you had to have great heart."

"I guess that left out W.C. Fields," Mark said dryly.

Isaac sat back in his chair. "I couldn't say. All I know is, when Groucho shook hands with me, I was on cloud nine. I don't care how insulting he could be, I think it was all just an act. He grew up poor,

same as I did. Financial success came late in life, and he always feared it'd be taken away again." His voice softened. "That's something I can understand."

I stared at him. Isaac had never said anything so revealing, so personal before. I think it took us all by surprise.

All, it turned out, except Bill, who sat with his hands folded on his lap, uncharacteristically quiet.

"Hey, are you all right?" Fred said to him.

Bill hesitated, as though about to say something, but then changed his mind.

Mark's eyes darkened behind his thick glasses. "You're thinking of Lenny Sands, aren't you, Bill?"

Bill sat upright, startled. "How the hell did you know that?"

"Wait a minute," I said. "I remember Lenny Sands. I used to see him on the old *Ed Sullivan Show*, when I was a kid. He and Alan King were my Dad's two favorite comics."

Fred chewed on a carrot stick. "Geez, Lenny Sands... Wasn't he the one they called the Joke Machine? He's gotta be 80 years old by now. Whatever happened to him, anyway?"

"He's dead," Bill said flatly. "Somebody killed him."

Fred stopped in mid-chew. "You mean, as in murdered?"

"Looks that way." Mark took off his glasses, wiped them on his shirt sleeve. "Happened just last night—"

Bill gazed at him, still clearly astonished. "Then you *do* know about it...."

"So will everybody else," Mark went on, "when it hits the TV news tonight."

"How did he die?" Fred asked.

"He was poisoned."

"It happened at a table in Maude's Grill, down on Wilshire," Bill said glumly. "In the middle of his dinner."

"Unless he was poisoned earlier," Fred said, "before he got to the restaurant."

Mark shook his head. "No, the police said this stuff acts in a matter of minutes. It happened right there, in front of five people who were all having dinner with Lenny."

"So the killer had to be one of them," Fred said.

"One of *us*," Bill corrected him. "I was one of the five."

"What?" I was so surprised, I actually stood up, staring down at him. "Jesus, Bill, we've been talking about comics all afternoon—why didn't you mention any of this?"

"The cops told us to keep our mouths shut—" He spread his hands. "Plus there was this Federal agent..."

"The Feds?" repeated Fred, puzzled. "What the hell were *they* doing at a homicide?"

I ignored him, leaning down close to Bill. "Listen, Bill... If I remember right, *you* were the one who got us talking about jokes and stand-up comics in the first place. I think, unconsciously, you *needed* to talk about it...."

"Spare me, willya, Dr. Freud?" Bill looked miserable.

"It doesn't matter now," Mark said. "I talked to a friend of mine down at headquarters, just before I got here. They've made an arrest."

"Sylvia?" Bill said.

Mark shrugged. "I don't think they had any choice."

"But, Mark, I still don't understand how *you* know about all this—"

"Excuse me, please." It was Isaac, slumped in his corner chair,

looking at them plaintively. "Would one of you mind starting at the beginning?"

Bill nodded. "At one time," he began, "Lenny Sands was a big star. Most of us know him from TV variety shows in the '60s and '70s. In his glory days, he'd worked all the best hotels and nightclubs. Vegas, Atlantic City. A real comic's comic. But in the last 15, 20 years, he really fell on hard times. Couldn't get arrested."

"How do you know him, Bill?" Fred asked.

"Couple friends of mine took a stand-up class that Lenny taught. Other than a few club dates in Miami, that was the only gig Lenny could get lately."

"What did he live on?"

"Bitterness," Bill answered. "Plus a small pension. He'd gambled away practically all the money he'd made over the years."

"A familiar story," Fred commented.

"Anyway, I sat in on a couple of his classes, kinda for nostalgia's sake. Afterwards, we'd all go out for drinks. I liked the old guy. Every line out of his mouth was a joke. He cracked us all up. I mean, the guy was an artist."

He gave a rueful laugh. "An unemployed, over-the-hill artist. The only asset he had was his house on Mulholland."

"Why didn't he sell it for the cash?" I asked. "In this market, it's probably worth a fortune."

"He couldn't," Bill said. "Lenny's ex-wife Sylvia was suing him for title on the house, against the back-alimony he owed her. Just one of the things they fought about."

He shook his head. "They'd been divorced for 15 years, and still screamed at each other on the phone three times a week. It was kind

of a hate/hate relationship. In fact, a couple weeks ago, Sylvia threatened to kill him."

Fred scooped up a handful of peanuts. "Yeah, but was she at the table last night?"

"I'm getting to that, okay?" Bill opened another beer, took a sip. "Anyway, as Lenny and I got to know each other, he started confiding in me about his money troubles, and his problems with Sylvia. I mean, he made a joke out of all of it, but he got his message across. That was Lenny. Anything to get a laugh. Then, last night, I got the supreme honor Lenny can bestow. He invited me to his personal table at Maude's Grill, a corner booth where he's held court for years. I got there about eight. The place was packed."

"Who was at the table, besides you and Lenny?" Fred asked.

"A couple of his cronies from the old days, a comedy team called Dickens and French. I think they just work cruise ships now. And another guy, Sid Siddons, Lenny's agent from years ago. It was like being at the Friars Club—all bad hair pieces and pinkie rings."

Bill's eyes shone. "But, man, you should've seen Lenny, telling jokes, ordering the waiters around, doing *shtick* with the food. It was really *his* room, you know what I mean?"

I looked at Mark. "But what's *your* connection to all this?"

"You know that Federal agent Bill said was on the murder scene last night? A buddy of mine, named Gregson."

"Let me guess," I said. "You and he were in covert Intelligence together."

"A long time ago," Mark said, "in a galaxy far, far away." Fred groaned. "I hate when he gets all cloak-and-dagger."

"I happened to have dinner with him a couple weeks ago and

he told me what he was working on," Mark said. "It seems that Maude's Grill was a secret drop, used by agents of an unfriendly government."

Isaac spoke up for the first time in ten minutes. "Wait a minute. We're talking about the same Maude's? With the overpriced steaks? Involved in *spying?*"

"The management is clean, so far as we know," Mark replied. "But somehow, someway, enemy agents have used the place to spirit away classified material, probably on microdiscs. Something small enough to be exchanged, unnoticed, in the restaurant."

Fred frowned. "Hey, are you saying it was Lenny? He needed money, and he *was* at the restaurant a lot—"

"Every night, like clockwork," Bill said.

"Except that Lenny was in the clear," Mark said. "For one thing, he was more patriotic than Bob Hope. The Feds also checked him out thoroughly before approaching him."

"Approaching him for what?" I asked.

"Well," Mark said, "here's where it gets a little weird. Gregson and his people started paying Lenny Sands to *spy* for them. Actually, just to keep his eyes open for anything suspicious in the restaurant. Any noticeable patterns, repeat customers, things like that."

I couldn't get my mind around it. "Lenny Sands, the Joke Machine? A guy who used to do spit-takes on *Hollywood Squares?* Working undercover for the government?"

"Our tax dollars at work," Fred grumbled.

"Couldn't Gregson plant one of his own people in Maude's?" I asked.

"His people are all known to the enemy agents," Mark replied.

"Besides, it was worth a shot. Gregson's sources told him the drop always occurred during peak dinner hours. Lenny was such a fixture, Gregson hoped that whoever was working the exchange wouldn't pay any attention to him."

I looked at Bill. "Did you know about this?"

"Oh, yeah," he said. Now it was Mark's turn to look surprised—which Bill enjoyed immensely.

"Lenny told me himself," Bill went on, "one night after his class. I guess he'd had a little too much to drink. He said he'd just made a deal with the Feds. 'It's short money,' he told me. 'But a gig's a gig.'"

Fred sighed. "He *told* you he was working undercover? Kinda brings new meaning to the word 'clueless.'"

Mark, still clearly rattled, continued. "Anyway, Lenny went to work for Gregson, calling him every night with his report. Such as it was. He never came up with anything."

He adjusted his glasses carefully. "And that's the last I heard about it, till Gregson phoned me this morning and told me Lenny Sands had been murdered last night."

We all looked at Bill.

"I guess that's my cue," he said. "Where did I leave off? Oh, yeah. At Maude's. There was me, Dickens and French, Siddons the agent, and Lenny. Just having dinner, kidding around, ya know? Like I said, Lenny was in rare form. He had a woman at the next table in stitches—I mean, the lady couldn't eat, she was laughing so hard. Annoyed the hell out of her husband. He just kept glaring at us. We didn't care."

"I thought there were *five* guests at your table," Fred remarked suddenly. "You only mentioned four."

"Who's telling this, you or me?" Bill got up and moved about, as though setting the scene. "Remember, there's a lot of noise, waiters zooming around, people coming and going from tables. They must've been short-staffed, too, because some of the customers were complaining about the service. This one Indian guy—he had a turban and everything—kept pointing at his food and shaking his head. Then there was this other guy, at another table, showing his fork to the busboy, saying it was dirty. The poor kid races back from the kitchen with new silverware in a napkin—"

"Think we can cut to the chase?" Mark interrupted.

"I'm just trying to establish some atmosphere, okay? Anyway, suddenly, this skinny lady, all in bright red, comes storming across the room, heading right for our booth. She stands over us and starts raging at Lenny. Turns out, it's Sylvia, his ex. She's screaming like crazy, cursing Lenny up and down. I thought her face-lift was gonna give. He keeps trying to calm her, but she won't have any. Finally, Lenny gestures for me to shove over, give Sylvia a place to sit down next to him."

I nudged Fred helpfully. "The fifth person."

"Yeah, I got that." He looked at Bill. "And then...?"

"Then Lenny orders another round of drinks, and we're all trying to make nice with Sylvia, especially Siddons the agent, who reminds her of the great times they all used to have, blah, blah, blah...."

Bill paused. "It looked like it was working, too, because things got a lot more friendly. Lenny kept assuring her that they'd work something out about the house. He even proposed a toast. 'To divorce,' he says, 'the *real* tie that binds.' So we all drink, somebody cracks another joke, and suddenly Lenny is gagging and convulsing—"

"Oh my God," I found myself saying.

"Before anyone can do anything, his head hits the table. He reaches out, his fingers grasping the air. Then, with his dying breath, he says, 'Take my wife'..."

"What?!" Fred almost shouted.

"That's what he said," Bill replied, folding his arms. "'Take my wife.'"

"You mean, like the old Henny Youngman joke, 'Take my wife—please'?"

"What can I say? Lenny Sands' dying message was a joke. The guy told a million jokes in his life, why shouldn't his last words be one, too?"

"But it's not just *any* joke," Fred said. "I mean, he might've been saying he'd been murdered by his wife."

Mark nodded. "That's what the cops think. They arrested Sylvia this morning."

"Because of what Lenny said?" I couldn't believe it.

"Hey, it was a dying man naming his killer," Mark answered. "She had motive—15 years of hatred, plus the house. She certainly had opportunity, she was sitting right next to him. He orders that final round of drinks, she slips the stuff into his glass while reaching for a dinner roll or something..."

"But wait a minute," I said. "Why use the joke? I mean, if I'm dying and I've only got seconds to speak, I'm not gonna waste time being cute. I'm sure as hell not gonna leave any room for interpretation. I'm gonna point to the killer and say, 'She did it!'"

"But you're not Lenny Sands," Bill insisted. "I knew him well enough to know this is exactly the kind of exit he'd want. *Everything* was a joke to this guy. How perfect if he can name his killer and get a

laugh at the same time. Especially with a classic line like that...."

"But that's just it," Fred said, sitting forward in his seat. "How could Lenny know for sure who poisoned him?"

"He probably saw her drop the stuff in his glass."

"Really? Then why would he drink it?"

Bill threw up his hands. "C'mon, who else could've done it? Lenny knew she hated him, and wanted the house. Besides, she threatened to kill him, remember?"

"The cops see it that way," Mark agreed. "Nobody else had a motive, and, like I said, she was sitting right next to him."

"Nobody had a motive we *know* about," Fred corrected him. He turned to Bill. "Who was sitting on Lenny's other side?"

"Sid Siddons, the agent. Are you saying *he* did it?"

"He had the same opportunity," Fred said. "Maybe he had a motive."

"Look, every performer I know wants to kill his agent," Bill said, "but not the other way around."

"You know," I said evenly, "if Fred's right, and Lenny couldn't have known for sure who poisoned him, it's still possible he implicated Sylvia for another reason. I mean, he hated her, and he was dying. She'd get the house, she'd outlive him. In other words, she'd *win*. Finally. After their years of struggle. So, with his last ounce of strength, not knowing who the killer *actually* was, he named her anyway. She'd be convicted of his murder, and spend her remaining life in jail. In other words, *he'd* win."

I needed to wet my whistle after that tidy monologue. I motioned for Fred to hand me my glass.

"By the way," he said to Bill, "what happened after Lenny collapsed?"

"That's kind of a blur," Bill replied. "People were freaking out at all the tables, I guess they thought Lenny'd had a stroke or something. One of the old comics—French, I think—jumped up and flagged down the maitrê'd, who called the paramedics. They arrived in minutes, took one look at Lenny and called in the cops."

"When did Gregson show up?" Mark asked.

"Afterwards. I didn't know his name then, but this Federal agent came in, looked around for about ten seconds, then huddled with our booth. He seemed upset, but not about Lenny, if you know what I mean."

Suddenly, there was a clattering sound from the window. I turned to find Isaac, reading glasses perched on his nose, lifting up the blinds to the hazy afternoon sun. He peered intently at an old, well-worn paperback he held open in his other hand.

"What are you looking for, Isaac?" I asked.

"Corroboration," he said, snapping the book shut with satisfaction. "This is a collection of Asimov's *Black Widower* mysteries. I thought I remembered a story in here about a dying man's message. I was right."

He came back to his regular chair, sat down with a gusty exhalation of breath. "Unfortunately, in this case, Asimov was wrong. Lenny's dying message *had* to be as cryptic as it was. In his last remaining moments, he could think of no other way."

Nobody spoke for about half a minute.

"Well, Isaac," Fred said at last, "you've got *my* attention...."

"Are you on to something?" Bill asked eagerly.

"Maybe," the older man replied. "Bill, you said Gregson huddled with the five of you at the booth. This was after the police questioned

you, I assume?"

"Yes. They took each of us aside, and made sure we'd be available for more detailed questioning in the future."

"I understand. But when you were with Gregson, where was everybody else?"

"The cops had 'em all herded into the kitchen, before Gregson even showed up."

Isaac leaned back, seemingly relieved. "Good. That means there's still a chance to crack the enemy agent's operation."

"What are you talking about?" I said. "I thought you had some idea about Lenny's murder?"

"I do. You were all so busy speculating about the possible suspects at the table, particularly his ex-wife, you forgot what Lenny was *really* doing last night. The same thing he'd been doing for the past few weeks. Spying."

Fred and I exchanged looks.

Isaac announced, with just an air of smugness, "Lenny Sands was killed because he'd completed his mission. He'd figured out how the enemy agents were using the restaurant to pass secret information."

Mark took off his glasses, tossed them on the coffee table. "Now hold on," he said, clearly exasperated. "How the hell could you know that?"

"Because Lenny told us, in his dying message," Isaac replied coolly.

"You mean, the 'Take my wife' joke? If anything, all it does is implicate Sylvia in the murder."

"That's just my point." Isaac's voice sharpened. "The phrase 'Take my wife' *isn't* a joke. The joke is, 'Take my wife—*please.*' Remember what we were talking about before? 'Take my wife' is the *setup*; the punch line is the word 'please.'"

I stared. "I still don't get what you're saying."

"Look, granting Bill's suggestion that an old stand-up comic like Lenny might find it darkly amusing to die with a classic joke on his lips, particularly one that names his killer, why wouldn't he say the whole line? If he thinks Sylvia did it, or even if he just wants to implicate her out of spite, why doesn't he say 'Take my wife—please.' It gets the same message across, and with the black humor of the joke intact."

"Maybe he *tried* to say the whole line, but died before he could get the last word out," I suggested.

Isaac looked skeptical. "I considered that, though it seems unlikely. Especially when you remember what Lenny was secretly doing at the restaurant every night."

His pale eyes narrowed. "Let's suppose, for the sake of argument, that Lenny *did* tumble to the enemy agent's operation. Something he saw, something that didn't look right. Do you think he could keep it to himself? I mean, he told Bill he was working undercover, even made a joke about it. What if he did the same thing at Maude's? Despite himself, he makes some joking reference to what he's doing there, or to something he's stumbled upon."

He permitted himself a melodramatic pause. "I can't say for sure, but I think the enemy agent *knew* that Lenny knew something, and had to silence him."

"Then why didn't Lenny just say the agent's name as he was dying?" Fred asked.

"Because, as Mark informed us, Lenny considered himself a patriot. He knew that if he named his killer, the enemy agent, he might bolt and get away. Gregson's people would never learn who was at the other end of the pipeline. Moreover, they'd never learn how

the exchange was made at the restaurant, so it could be circumvented in the future."

Isaac placed his fingertips together thoughtfully. "No, Lenny had to leave a clue that was oblique enough that the agent would never know he'd been implicated, one that would *leave the agent in place,* so he could lead the Feds to the big boss."

"But at the same time, would tell anyone that could decipher it who the agent was," Mark said, nodding.

"*And* how the exchange was being made," Isaac said. He gave us a broad grin. "And there we got lucky. Remember I told you I'd worked as a waiter in the Catskills? Well, one of the things I learned in that job is that a knife, fork, spoon and napkin combo is called, in shorthand, a *setup.*"

Bill practically exploded. "The busboy!"

"You've gotta be kidding," said Mark.

"That's what Lenny tumbled to," Isaac explained. "The customer who complained about the dirty fork must've been a courier, probably one of a number of couriers who come to Maude's posing as customers. The busboy hurries back to the guy's table with clean silverware in a folded napkin—a new setup, in waiter lingo."

"That's how the exchange is made," Mark went on, excitedly. "The busboy transfers the microdisc, hidden in the folds of the napkin, to the customer, who manages to slip it into a pocket."

"Probably while he's opening the napkin on his lap," Bill mused. "A nice bit of business. That's how *I'd* do it."

Ever the actor, I thought.

"Poor Lenny," Fred said quietly. "You've got to be right, Isaac. Lenny sees what they're doing—he's probably witnessed some variation on it

a couple of times by then—and inadvertently communicates to the busboy that he knows what's going on."

"It would be simple, then, for the busboy to slip the poison into Lenny's glass when he ordered the new round of drinks," said Isaac. "Especially in all the hustle and bustle Bill described."

The room grew suddenly quiet.

"So," I said, "Lenny's dying words were a clue to the killer, *and* to how the exchange was made, at the same time."

"Fortunately, pointing to one points toward the other. If Lenny stumbled onto the operation, who else would murder him but the guy running it?" Isaac shrugged. "Remember, Lenny had been around hotels and restaurants all his life. He knew that silverware-and-a-napkin was called a setup. The same term that describes the first part of a joke."

"'Take my wife,'" I repeated. "The classic setup to a classic joke."

Mark got to his feet. "I'd better call Gregson, tell him your theory. If none of the restaurant staff knew he was there last night—and I think that was Gregson's intention—the busboy doesn't know Maude's is being watched. Or that he's suspected in the least for Lenny Sands' murder."

"All Gregson has to do is put someone on the busboy when he leaves after work tonight," Fred said. "Start surveillance on a regular basis."

Mark nodded. "Thanks to you, Isaac, we might put the whole operation out of business." He flipped open his cell phone. "Of course, I'll talk to my friend at police headquarters as well."

"That's right," I said. "The cops are still holding Sylvia."

Fred stood up, too, and stretched.

"This is getting to be a habit, Isaac," he said warmly. "How do you do it?"

"I'm a man of erudition and instinct," Isaac responded. "And I say that in all humility."

Fred chuckled. "Sorry I asked."

"Still," I said, "the one I feel badly for is Lenny."

"Don't," said Bill, with a sad smile. "Lenny couldn't have picked a better exit. He got what every comedian really wants—the last laugh."

End

Mayhem In Mayberry

Whoever said that conversation should stay away from the topics of religion and politics wouldn't last ten minutes in a meeting of the Smart Guys Marching Society. Which, it turned out, was fine with Mark.

"If you ask me," he said, ignoring the fact that no one had, "everybody's gotten a little too 'politically correct' lately. I mean, what's the point of debating issues if you've got to be so damned careful about what you say?"

"When have you ever been careful?" I said, struggling to open my beer's twist-off cap. "I must've missed those meetings."

Mark gave me a "Save-me-from-these-liberals" look through his dark-framed glasses.

"You sound just like my editor," he said. "She's always going through my copy, blue-penciling the good stuff—what she calls the 'socially sensitive material.' Like I'm not socially sensitive."

"Here, have a chip," Bill said, offering him the bowl from the coffee

table. "And chill out."

"I mean it," Mark went on, scooping some guacamole onto his plate, "it's getting to the point where you can't say anything about anybody. Take my article in today's *Times*—you have any idea of the kinda grief I'm gonna get from feminists? There'll probably be bomb threats!"

"Probably," Bill echoed. He popped open a can of peanuts, handed it over to Mark. "You oughtta try some of these, too."

"Wouldn't surprise me at all," I agreed. I turned to Bill. "Didja get enough of the chili? There's lots more, you know."

There was an awkward silence, as Mark looked from Bill to me, then back again. "Let me guess," he said tersely. "Neither of you guys *read* my piece in this morning's paper."

Bill and I exchanged guilty looks.

"It's great to have fans," Mark muttered.

"Now wait a minute," I said hastily. "With all the rain we've been having, the garage flooded. I spent the morning getting boxes off the floor."

"And I had two shows last night," Bill chimed in. "And you know my wife and I usually sleep in on Sundays."

"*I* saw it, Mark," said Isaac, coming in from the kitchen with the bowl of my wife's chili he'd been reheating in the microwave. "Very incisive. To the point."

"Good old Isaac," Mark said, smiling. "I knew I could count on the one *literate* member of the group."

"Speaking of the group," Isaac said, settling into his corner chair, balancing the bowl on his knees, "we don't seem to have a quorum." As always, he sat surrounded by untidy stacks of his beloved sci-fi and mystery classics. "Where's Fred?"

"He had to go out of town on business," I said. "Some little place up north. But he was supposed to be back last night. I know he planned to be here."

"Here" was the paneled game room of my house in the San Fernando Valley, the site of our weekly meetings of The Smart Guys Marching Society. We'd gotten off to a slow start today, due to the unusually heavy rains that had been pounding Southern California all week, making driving somewhat treacherous.

Bill, an actor and theater director, had arrived first, pulling a drenched jacket off his lanky frame and hanging it carefully on a brass wall-hook. Then came Mark, a former Intelligence agent turned journalist, wiping his shoes roughly on the backdoor mat, grumbling under his breath about the collective ineptitude of L.A. drivers whenever it rains.

And, of course, there was Isaac, our most recent member. A distant relative of my wife's, he was staying as our houseguest; in his late 60's, he had white muttonchop sideburns and a wry glint in his eyes. Retired now, he prided himself on being a "Jack of all trades."

I'm a psychotherapist, and the host of these weekly stag sessions, a sort of midlife experiment in male bonding. Though we came together last year to carve out an afternoon's respite from our careers and families to discuss the issues of the day, lately we've found ourselves often engaged in puzzling out some crime problem that's found its way into our midst.

Which is to say, Isaac puzzles them out. As unlikely as it seems, he's kind of a whiz at it.

Not that he'd had much chance to prove it lately. For the past few months, the Smart Guys had been pretty occupied discussing

politics, the stock market, early Christian mystics, the Zone diet, and the questionable practice of directors acting in their own films (high marks for Sydney Pollack and Spike Lee, not so good for Quentin Tarantino).

In other words, the usual eclectic mix of debate, pedantry, informed opinion and high rant.

"What we need around here," Bill had been given to remark on more than one occasion, "is another good crime to solve."

Which, it turned out, was exactly how we were about to spend the rest of this grim, rainy afternoon...

A sudden pounding at the back door made us all jump.

"It's me!" a familiar voice called out.

"It's open," I said, rising, just as Fred, laden with briefcase, over-coat and umbrella, bundled into the room.

"I made it!" he exclaimed, laying his things in a neat pile on a side table. He stroked his trim, reddish-brown beard brusquely. "Jesus, it's pouring out there."

"Glad to see you," Bill said, tossing him a beer. "You know how we worry."

"Where were you again...?" Mark asked absently.

"Little town north of Chico," Fred said, between grateful sips. He negotiated his way past the food platters and chairs to his usual spot on the corner of the couch. "It's called Praiswater...."

"Sounds quaint. Let me guess—white picket fences, farmland, church steeples, et cetera...."

"Close enough, except there's timberland instead of farmland. Actually, not much of that left, either. The logging industry's taken a

beating the past decade or so."

"What were you doing up there?" I asked.

"Your wife make the chili?" Fred was scooping heaping mounds of it into a bowl.

Mark smiled. "We better let the poor boy eat first."

"That's okay," Fred said with difficulty, mouth full of chili. "I can talk and eat at the same time."

"That's what we're afraid of," Mark said.

"Besides," Fred went on, after a huge gulp of beer, "I've got a surprise for today's meeting. I brought a guest—" He glanced at his watch. "That is, he should be coming along any minute. Probably got held up in the rain."

"A guest?" Bill said. "Is that allowed? I mean, is that in the rules?"

"What rules?" Mark said, frowning. "Up till now it's been pretty basic—we show up, eat and *kibbitz*, right?"

"I don't see why one of us couldn't bring along a guest." I looked at Fred. "Friend of yours?"

"Client," he replied. "Name's Brian McKay. I've been one of his family's lawyers for years. The senior partner at my firm was Brian's grandfather's classmate at Harvard."

Mark nodded. "Old money?"

Fred gave a wry smile. "Very old, and lots of it."

"What does Brian do?"

"Depends on the season. In winter, it's skiing in Vail or backpacking in Bhutan. Summers, he likes scuba diving in Bali or fishing in Belize. Of course, year 'round, there's the constant sex, drugs and rock 'n' roll."

"A real party animal," Bill said.

Fred shrugged. "Your basic trust fund kid."

"Yeah," Mark said dryly, "but is he really happy?"

"Delirious," Fred said. "Currently he's dating a lingerie model from Victoria's Secret."

Bill gnawed a knuckle. "This just gets better and better. Why don't I just shoot myself now?"

"If it'll make you feel any better, there is one hitch," Fred said, the smile leaving his face. "He's just been charged in connection with the death of a teenage girl."

"Good Lord." It was Isaac, looking up for the first time from a paperback collection of Asimov's Robot stories.

Before the rest of us could interject, a new voice boomed from the back of the house. "Hey, Freddie, my man! Are you somewhere in this monument to suburban kitsch?"

"Come on in, Brian," Fred called out.

Brian McKay, barely 20, was dark and wiry in his rain-soaked duster, long dirty blond hair clinging wetly to the collar. A diamond-stud earring, mirrored sunglasses and black leather boots completed the Euro-trash look.

He shook the oversized coat off, letting it drop in a sopping wet mess to the floor, and then collapsed with a gale-like sigh of disgust into my favorite old rocker. I thought I heard the weathered pine slats splintering. I winced.

"It's raining like piss out there," Brian said, glancing around my game room. He spied the bottles on the coffee table. "Don't tell me ya got nothin' stronger than beer? And like a feeb, I spilled the last of my stash in that piece-of-shit rental I drove over here. Man, I can't catch any kind of a break lately!"

Isaac leaned over and whispered in my ear. "An unpleasant youth," he said seriously.

Fred gamely went ahead with the introductions, drawing something less than a curt nod from our visitor. At which, Fred stood up and went over to where his client sat. With a single motion, he took off Brian's dark glasses and slipped them into his breast pocket.

"Hey!" Brian exclaimed.

"Were you wearing these, driving over here?" Fred asked. "In the pouring rain?"

"So what if I was? What are you, my mother?" Brian pointed a menacing finger up at him. "Don't forget, you work for me!"

"I work for your family, not for you personally."

"Big deal," Brian said, folding his arms. "Just remember: one call to my old man, and your boss kicks your Ivy League ass out on the street."

I was beginning to think that maybe we should re-examine the policy of allowing guests at our meetings.

"Look, Brian," Fred said evenly, "I don't care whether you like me or not. But I have an obligation, not to mention a retainer, to provide you with the best possible legal counsel, and I intend to do that."

"Yeah? Then what the hell am I doin' here with these losers?" Brian's desultory gesture took us all in. His eyes bored into mine. "Wait, don't tell me.... this is group therapy, and I'm gonna get in touch with my feelings."

"Okay, that's it!" Mark got to his feet, glaring at Brian. "Listen, you little creep. You're not the only one who can make phone calls. I know people who know people, you know what I mean? I can have your legs professionally broken by suppertime."

51

"C'mon, Mark," Fred said. "I brought Brian because I thought if we all heard his story, we might figure out a course of action." He looked meaningfully at his client.

"Don't let his amiable behavior fool you... this boy's in big-time trouble. He needs all the help he can get."

This seemed to quiet Brian a bit. His shoulders slumped in the rocker, and his voice thickened.

"Man, I don't know how the hell this thing happened..." He pressed the heels of his palms into his eyes, as though a child trying to shut out the sight of something upsetting. "I mean, I didn't do nothin'...."

Fred, softening somewhat himself, put a tentative hand on Brian's shoulder. "I'm afraid you did do something. And a girl's dead because of it. I'm just not sure it was your fault."

Mark sat back down, ran his hand through his black hair. "I guess it couldn't hurt to at least hear his story."

The rest of us nodded our assent. Even Isaac, with a rueful smile, was willing to close his book on his lap.

"Thanks, guys." Fred pulled a free chair over, sat next to his client. "Okay, Brian. Just tell it to them the way you told me..."

"It all started last week," he began, eyes blinking as he tried to focus. "Last Friday night. I was comin' down outta the Sierra Buttes, up at the border where ya cross into Oregon. A buddy from school's got a place on one of those little lakes, and I had just been up there, chillin'. Anyway, I'm toolin' down the highway—the weather sucked, foggy and drizzlin'—and there was this big lumber truck up ahead of me. I was gettin' tired of breathin' his exhaust, so I sped up to pass him. All of a sudden, I feel this sharp bump, and glass is spraying my

52

windshield—

"I, like, freaked, but I managed to pull over, and go take a look. Lousy truck musta kicked up a rock or somethin' with its rear tires. Knocked out my right front headlight."

He shook his head. "My brand new Porsche Turbo Carrera. Anyway, I figure I better try to get it replaced. That was all I needed—my old man finding out I trashed his latest gift. I drive on for a couple miles till I see an exit sign for Praiswater. I pull into town—and I'm tellin' ya, it's gotta be the most dead-ass, dried-out piece of real estate I've ever seen. Like Mayberry on life support, ya know what I mean?

"I find a gas station, but the rocket scientist who works there tells me the mechanic's gone for the night, and besides he'd probably have to send to Chico for the right part. No Porsche dealerships in Hicksville, I guess. So I'm stuck there for the night. Really blows. I get a deluxe suite in the nearest roach motel and crash till morning."

Brian favored us with a tight smile. "You guys with me so far?"

"I'm taking notes," Bill said, smiling right back.

"The next day's Saturday," Brian continued, unfazed, "and after talkin' with the mechanic, another genius, I learn it may take till evening to get the new headlight, so I place a couple calls to the real world. Just to make sure I'm not in the Twilight Zone or something."

"Who did you call?" I asked, for no good reason.

"My broker. My shrink. Dude I know who runs a club in Palm Springs. And Terri."

"Who?"

"The lingerie model," Fred replied helpfully.

"Oh, yeah," Bill said. "Her."

Brian's face grew animated. "And here's where I get totally bummed-out. Terri had to leave L.A. all of a sudden, to fill in for this other chick who got sick on some fashion shoot. I find out she's on a beach in Barbados, showin' her stuff for the spring catalogue, while I'm stuck in Mayberry with a busted headlight."

"That's a bummer, all right." Bill's mood seemed to have lifted somewhat.

"Tell me about it," Brian complained, oblivious. "I was goin' nuts sittin' around that motel room, so I figure I'll check out the locals. For laughs, ya know? Turns out, I landed in Praiswater just in time for the biggest event of the year—the Founder's Day Festival. And, man, if the constant drizzle was puttin' a damper on things, you sure couldn't see it. There were signs in all the shop windows, banners hanging over Main Street. Real small-town Americana. I thought I was gonna hurl....

"But the biggest thing of all was gonna be that night—the Founder's Day Dance. Old guy at a newsstand told me everybody was gonna be there. They had this tradition, guys askin' their girl-friends to marry 'em at the dance. 'The most romantic night in Praiswater,' accordin' to this geek."

"Sound like friendly people," I said.

"Bullshit," Brian retorted. "From what I saw, all those hicks did was trash each other. I had a burger in the local grease palace, just soakin' up a little atmosphere, and you shoulda heard 'em. Who's cheatin' on who, who's a lyin' crook, who's probably a homo. Like bein' in a Disney movie from hell."

Bill nodded. "Hitchcock's *Shadow of a Doubt*. The dark underbelly of small-town life."

"Can we try to stay on track here?" Fred said testily.

"Look, you told me before I came here not to leave anything out," Brian said, leaning back in the rocker. It squeaked mournfully. "Now where was I? Oh, yeah, I'm gettin' some lunch, and the waitress points out the window, across the street, to the one big business in town. 'Honest' Harve Hansen, whose appliance store takes up half of Main Street. Even through the fogged-up glass, you could make out his big frame standing on the sidewalk in front of his place. Had one of those grins like he was runnin' for office. Just then, a sedan rolls up to the curb, and a girl in a raincoat and hood jumps out, throws her arms around him.

"'Look at 'em, will ya?' says the waitress. 'Like they were teenagers. I swear, if that Sally Grant had her way, she and Harve'd be joined at the hip.' From what some of the other customers said, it sounded like old Harve'd got real lucky after his divorce. Sally was some young thing from San Diego, got together with him right after she'd moved to town. Was totally devoted to him, they said. Even pulled him out of a drunken fight he'd started in some bar."

"Was he some kind of troublemaker?" Bill asked.

"Are you kidding? Harve was the pride of Praiswater. Local boy makes good." Brian laughed darkly. "New money. You know what *that* kind is like."

"Yeah, well, 'that kind' is probably the only reason you're not behind bars right now," Fred said angrily.

"What are you talking about?" I asked.

"Look, guys, can we just cut to the chase?" Mark took off his glasses and rubbed his forehead.

"Okay, okay." Brian shifted uneasily in his seat. "I guess that brings

me to that night, Saturday night. I go back to the garage around five-thirty, and Mr. Goodwrench tells me the part never arrived for my car. I'm thoroughly cranked over this, but this guy just smiles and suggests I stay in town for the big dance. Every couple in Praiswater's gonna be there, he says—and everybody *else* goes just to see who's gonna propose to who. Like this is something I'd ever do in a zillion years, right?

"On top of this, I finally get through to Barbados, and guess who happens to be vacationing right on the same beach where Terri's shooting? Rick Ransom, lead singer of the Vipers, that's who!"

"So?" I asked.

"So? Ransom's a major hound. If I didn't get my butt to Barbados, he and Terri'd be shackin' up by Sunday. So I decided, to hell with waiting for the new headlight, I'd just risk drivin' down to Frisco and grabbin' the first plane to the islands.

"Naturally, the rain's picking up when I finally get my act together and get back on the road. With my one headlight, and the storm gettin' worse, highway's like driving down a dark tunnel. We're talkin' the boonies, just south of town, trees on both sides—I admit, I was nervous. I was even drivin' below the limit. Way below. Plus I'd taken a couple hits before I left—"

"You smoked some grass?" Mark stared at him.

"Just to take the edge off," Brian said, voice tight. "Anyway, I'm hunched over the wheel, tryin' to see. And I swear, not goin' over 35... when all of a sudden I see a blur appear right in front of me, a figure—I slam on the brakes, but I think I hear a bump—"

"Jesus," Bill whispered.

"I jump out of the car and go around to the front... and she's just

lyin' there, in the road." He sat forward, hands rubbing the tops of his knees. "It was a girl... all smudged, and kinda crumpled there. She was practically naked... just wearin' a bra and panties. Good bod, too, ya know?"

I looked at Fred, who just rolled his eyes.

"And I'm freaked to the max, I don't know what the hell to do. Then I hear a car pull to a stop half off the road behind mine... I look up, and it's Harve Hansen, peering down at me in the rain. 'Are you all right, son?' he says. 'I was just on my way to the dance and—Oh my God, that's Joy Phillips!' He gets down next to me, checks the girl over. 'She's unconscious,' he says. 'We gotta get her to the hospital.'

"I'm too numb to say anything. Harve goes to his car, comes back with a big blanket, and we wrap her up in it. He picks her up like she don't weigh nothin', starts back toward his car. 'Follow me,' he says.

"I get back behind the wheel, and watch him in my rearview mirror gently lay her in the back seat of his car. Then he gets in the driver's seat and pulls around, and starts back down the highway, with me following. We drive back toward town in the rain, until he pulls into the driveway of the county hospital.

"I park right next to him, outside the Emergency entrance, and run in behind him as he carries her to the admitting desk. I just kinda stand there, stunned, as a couple nurses put her on a gurney and take her through some swinging doors.

"Harve tells me he's gonna go call her parents. I don't know what to do, so I just sit down on a couch there, by the vending machine. After awhile, this older couple shows up, looked like somebody punched 'em in the gut. Harve comes with them, tells me they're Mr. and Mrs. Phillips. The old lady just stares at me, her mouth moving, but no

words are comin' out.

"Then I heard Mr. Phillips arguing with somebody—the doctor, I guess—they want to see their daughter. The doctor says no, they gotta operate right away. But Phillips breaks away, runs down the corridor, and I find myself running right behind him, just in time to see the surgical team pushing a gurney into the operating room. They got the girl on the table, oxygen mask on, tubes in her arms...

"It's like some kinda dream... 'cause then they whisk her away, and the doctor is shouting, and Harve is pulling Phillips back from the doors..."

Brian lapsed into silence so suddenly, it took us all by surprise. Then, after taking a few breaths, he looked up at us, the color drained from his face.

"So then we all just sat there on the couch, waitin'. Nobody sayin' nothin'. Suddenly, this guy comes in, says he's Sheriff Winston, and he's got this kid with him—I mean, he looks like freakin' Opie—and he's totally wigged out, pacing back and forth. His name's Bobby Ancetti, looks like he's about sixteen. Turns out he works in the Phillips' grocery store. The sheriff says the kid admits that he'd taken Joy Phillips to an old abandoned shed in the woods he knew about, just off the highway. He was gonna do her before goin' to the dance, ya know?... I guess they were halfway into it when she got scared and changed her mind, and just ran outta there in a panic, in her bra and panties, cryin' and stuff. She musta run out onto the highway, just as I was comin'...."

Brian's voice choked. His hands turned to fists on his knees. "But, I didn't see her till it was too late. I swear, all of a sudden, she was just... there...."

He struggled to compose himself, and I noticed again how youthful his face looked. Unformed. And—I allowed myself a professional hunch—unparented.

"Anyway," he went on at last, "about two hours later, the doc came out to where we were all waiting, and told us that Joy was dead. Her parents just started sobbing, but Opie went nuts and jumped me, screamin' 'You killed her!' Harve and the sheriff had to pull him off. Then... well, I knew I better call my old man."

He smiled without humor. "Took me three hours to track him down. He and his new girlfriend were in Paris."

"The next morning, Brian's father called me," Fred said. "By the time I could clear my schedule to get up there, it was Monday night. A lot had happened by then. The Phillips were pressing charges against Brian, with Sheriff Winston only too happy to consider everything from substance abuse to vehicular manslaughter. Brian's attitude didn't help."

He glanced balefully at his client.

"Look, I'm sorry the girl's dead, but I didn't mean to hit her. Christ, she ran right into me!" Brian looked away.

His mood swings, from easy bravado to a kind of little-boy incredulity, were becoming familiar to me now. He seemed to shift, perhaps unconsciously, into whichever role would absolve him of responsibility in that particular moment.

"I also found out," Fred continued briskly, "that the grieving parents have hired a high-profile attorney who's urging a civil trial, regardless of what actions the police take, to claim damages in the millions."

"What can you expect?" Mark said. "Brian's family has those deep

pockets lawyers just love."

"Thanks a lot," Fred said. "Anyway, I got Brian released, but the police have impounded his car. Of course, the rain wiped any possible physical evidence clean...."

"Tell 'em about the funeral you dragged me to," Brian said glumly. "That whole crummy town would like to lynch me."

"It's true, I persuaded Brian to come to the funeral home, to pay his respects." Fred shrugged. "It may have been a mistake. The family must've posted Harve Hansen at the door, because when we showed up he told me the Phillips had requested that Brian not be permitted to attend. I insisted I be allowed to enter and express my condolences on behalf of the McKay family. Hansen said okay, and I went in for a few minutes. It seemed like half the town was there. I met Sally Grant, Bobby Ancetti, the surgeon who'd operated on Joy... and, of course, Mr. and Mrs. Phillips. They refused to speak with me. I guess I couldn't blame them. So I went out and got Brian, and we flew back to L.A."

We all looked at each other for a long minute. There didn't appear to be anything to say. Brian seemed to realize this, and suddenly hauled himself out of the rocker.

"Maybe I missed it," he said to Fred, "but it doesn't look like any of your buddies here has a brainstorm. I'm screwed, and I know it."

"But those damages the Phillips are talking about are outrageous," Fred protested. "I'm sorry about their loss, of course, but it *was* an accident...."

"Who cares?" Brian pulled on his still-damp overcoat. "Don't you get it? Them hicks saw me comin', man. They wanna bleed the family vault, I say let 'em."

He turned to the rest of us. "Thanks for nothin'. I'm outta here. With my luck, Terri and that metal-head spent the week wreckin' the bedsprings, so I got a plane to catch. Maybe if I wave what's gonna be left of the family fortune in front of her, I can do a little damage control."

With that, Brian McKay snatched his dark glasses back from Fred's shirt pocket and stomped out of my game room, and then out of the house. Another long moment of silence followed.

"Well, that was a complete and utter thrill," Bill said at last. He headed into the kitchen. "Anybody else want a beer? I'm buying."

"Okay," Fred said, "so he's got a slight attitude problem."

"Don't forget him and Terri," Mark said, laughing. "Now *there's* a heart-tugging romance. I really hope those two wide-eyed kids can work it out."

"You boys can laugh," Isaac said suddenly, from his corner chair. As always, I'd almost forgotten he was there. "But there *is* real romance at work here. In fact, she loves him very much."

"Who, Terri?..."

Isaac shook his head impatiently. "No, no... I'm talking about Sally Grant. She must love Harve Hansen very much indeed. Why else would she take such a risk to protect him?"

Mark, Fred and I turned, almost as one, to face him.

"Of course," he mused, "it's possible that it all happened exactly the way it seems, but I don't think so..."

"What are you saying, Isaac?" It was Bill, coming back in from the kitchen.

"Actually, it was Brian McKay himself who unwittingly suggested it to me," Isaac went on. "Something he said just before he left. 'Them hicks saw me comin'.' He'd meant, of course, that they'd targeted him

as a rich chicken to be plucked in court. But I suddenly realized that he'd inadvertently stumbled on the truth."

"What truth?" Mark said.

"That Harve Hansen and Sally Grant had *literally* seen him coming," Isaac said. "How could they not, despite the rain and the darkness? His single working headlight was a dead giveaway, since in such a small town everyone knows everyone else's business. Everyone knew about Brian's broken headlight, in what was certainly the only Porsche for a hundred miles, so it was easy for Hansen and Sally to recognize it.

"Of course, they had to act quickly, very quickly. She'd have to strip off her clothes, down to her bra and panties, smudge herself with dirt. Crumpled on the road, in the rain and the glare of Brian's single headlight, feigning unconsciousness... It was a daring move, perhaps foolhardy, but—"

Isaac smiled. "I don't know why, but I like to think it was *her* idea, rather than his. I never cared for that boisterous, newly prosperous, rowdy type. I can just see 'Honest Harve' standing in his store, pumping the hand of some poor sap before stiffing him on a new washer-dryer combo the lad probably can't afford anyway."

"Excuse me," I said, head spinning, "is anybody else lost?"

"Let me explain," Isaac said. "It all becomes quite clear if you remember the sequence of events. Brian is driving slowly on a rainy highway, when suddenly a figure appears in front of him. He slams on the brakes. Lying on the road is the crumpled body of a girl, apparently injured by the impact with his car. As luck would have it, Harve Hansen shows up, and announces that the unconscious girl is Joy Phillips. Having never met or heard of the girl, why wouldn't

Brian believe him?"

"I'll be damned," said Fred.

"If, as I maintain, that girl pretending to be injured is actually Sally Grant, what happens next is crucial. Harve wraps her in a blanket and carries her to his car. Brian stays behind, watching in his own car's rearview mirror. He sees Harve lay the girl gently in his back seat—where the real Joy Phillips, who is actually injured, has been hidden. Sally climbs out of the blanket, wrapping it around the real victim, and slips unseen out of the back seat.

"Now, with the real Joy Phillips in the blanket, Harve drives to the hospital, with Brian following. Sally, left behind on the road, dresses again and makes her way on foot back to town. Her part in the plan is done."

Mark broke in. "But at the hospital, Brian saw the girl being wheeled into the operating room. Wouldn't he notice that it wasn't the same girl as on the road?"

Isaac shook his head. "When Joy Phillips was wheeled past him on the gurney, her face was covered with an oxygen mask. And remember, there was no reason for him to doubt it was the same girl."

"But wait," Bill said. "Brian knew what Sally Grant looked like. He saw her hugging Harve Hansen on the street that day."

"Through a window, across the street," Isaac reminded him. "And Sally was wearing a raincoat, with a hood. There's no way he could've gotten a good enough look at her to recognize her later that night on the ground."

"Lucky break for old Harve," Mark said quietly.

"Yes. The plan depended on Brian, as a stranger in town, having never seen either Sally Grant or Joy Phillips before that night."

"I just thought of something," Fred said. "Now I understand about the funeral..."

"Exactly," Isaac said, eyes twinkling.

"Yeah, well I don't," said Bill.

"Harve planted himself at the door of the funeral home just in case Brian and I might show up," Fred explained. "He couldn't allow Brian to enter, and so he made up that story about the family not wanting him to attend."

"Maybe they really didn't want Brian there," I suggested.

"It doesn't matter," Fred continued. "The important thing, as far as Harve was concerned, was to keep Brian out. Because if he went in, as I did, he'd encounter the same people I saw... including Sally Grant! He might recognize her as the girl he saw crumpled on the road—a girl who was supposed to be dead!"

"But, Isaac," I said, "what *I* can't figure out is how *you* figured it all out in the first place?"

He chuckled. "Something about Brian's accident just felt wrong to me, but I didn't know what it was... until I remembered what night the accident happened. Saturday night. 'The most romantic night in Praiswater.' The Founder's Day Dance."

"I see," I said. I didn't see.

"Everyone in town said Harve and Sally were inseparable. Like a couple of teenagers. When Harve stopped behind Brian on the road that night, he said he was on his way to the Founder's Day Dance. If so, why was he alone? Where was Sally?

"My guess is, Harve and Sally were driving together, on their way to the dance, when poor Joy Phillips suddenly ran out in front of them. Harve couldn't stop in time—maybe he'd had a few drinks. Remember,

Sally had had to retrieve him from a drunken brawl once.

"In any event, they see that the girl is badly hurt. Perhaps Sally realizes that with his previous reputation for drinking, he could be in serious trouble. For all we know, Harve could have a couple of DUI's that nobody but the police know about.

"They've just gotten Joy into the back seat when, in the distance, they see a car slowly approaching. With only one headlight. Thinking fast, Sally strips to her underwear, and has Harve pull the car off to the side of the road, in the shadow of the woods. Just as Brian's car arrives, Sally takes the dangerous risk of running in front of him, pretending to be hit—"

"It's an old con artist trick," Mark said, nodding. "I'd be curious to see if the police have a record on her down in San Diego."

"I wouldn't doubt it," Isaac said. "It's not something *I'd* have the nerve to do. But, then, I suspect Sally Grant has quite a remarkable love for Harve Hansen. One which I doubt very much he deserves."

"Geez, Isaac, you sound jealous." Bill was fishing in a basket for one of the few remaining chips.

The older man smiled. "You may be right."

"But what about my case?" Fred asked abruptly.

"I suggest you have Sheriff Winston get a photo of Sally Grant down here for Brian to examine. If he can ID her as the girl he thought he hit with his car, she and 'Honest Harve' will have a lot of explaining to do."

Fred looked thoughtful. "I just hope I can catch him before he flies to Barbados."

With that, he got up and started punching buttons on his BlackBerry.

"Hold it!" Bill exclaimed, tortilla chip poised halfway between the basket and his mouth. "This means Brian's gonna be exonerated. The little creep skates free—!"

"Free to travel the world," Mark added with a bemused smile, "with a lingerie model from Victoria's Secret."

"It... Dammit, it isn't fair!" Bill tossed the chip, uneaten, back into the basket.

"I must agree," said Isaac, reaching for a book, "it isn't. As I said, an unpleasant youth."

I had a thought. "Is that why you didn't tell us your theory about what really happened until Brian left?"

"Now that you mention it, yes..." Isaac smiled, opening his book. "Something to do with 'pearls before swine,' I'm afraid..."

The book must have been a favorite, for in moments he was lost in it.

End

Time Served

It wasn't my first time in jail. Back in college, I was an overnight guest of the Pittsburgh Police as a result of protesting the U.S. invasion of Cambodia. Well, to be honest, this totally hot girl who sat next to me in Comp Lit did the actual protesting—I just went along to offer moral support, and in the vain hopes of getting some action.

The only action I got, of course, was a thrilling ride in the back of a police cruiser, an awkward call to my parents and a night rooming with two stoners and a pickpocket named Dwayne. Nice guy, by the way.

Anyway, up until now, that had been the extent of my experience in the criminal justice system. But as recent events have made clear, a lot of new experiences were coming my way, thanks to the Smart Guys Marching Society.

This particular meeting stands out in my memory for a number of reasons, but primarily because it was the first time we assembled

somewhere other than my game room.

It all started one bright morning in early spring, as I was putting out the guacamole and chips, calculating probable beer consumption and wondering what the topics of the day would be. We'd spent most of the previous Sunday locked in heated debate about how to balance a citizen's right to privacy with national security concerns. (Which was as much fun as it sounds.) Naturally I was hoping today's subjects would lean a bit toward the lighter side.

Shows what I know.

Just before noon, the phone rang. It was Mark.

"Is everybody else there yet?" His familiar, take-no-prisoners tone bespoke the years in covert intelligence that preceded his current job as a reporter for the *Times*.

"Nobody's here yet. Why?"

"I need a favor. For a friend. Actually, a friend of a friend. A public defender named Carolyn Mullins."

"Is she the friend, or the friend of the friend?"

A quick, exasperated sigh. "Look, when the rest of the gang gets there, just drive 'em down to Parker Center and meet me on the fourth floor."

"Parker Center? That's LAPD headquarters."

"I know what it is. I'm calling from there now. I pulled some strings and got us a conference room."

"I don't understand. We always meet at my place. It's tradition. Besides, I'm all set up here. My wife made her mother's special guacamole and everything."

"I feel your pain. Meanwhile, I just need you to get the Smart Guys down here ASAP." Then his voice changed. "It's important, okay?"

I hesitated. "Okay, I guess. That means Isaac, too?"

Mark laughed. "Are you kidding? *Especially* Isaac."

Which is how the five of us—Bill, Fred, Mark, Isaac and yours truly—ended up sitting around a venerable conference table in a quiet, carpeted room on the fourth floor of police headquarters. Since it was a Sunday, and we were in an administrative area, we practically had the floor to ourselves.

Not that getting everybody to make the trip was a piece of cake. After showing up as usual at my place, none of the Smart Guys were too thrilled about braving the weekend freeway traffic to go downtown. Except for Isaac, of course, who still had his generation's love for long Sunday drives—even if the destination was an eight-story building filled with cops.

Anyway, after a lot of unnecessary grumbling and complaining, we all piled into my Toyota Highlander and, for the first time, took the Smart Guys Marching Society on the road.

Mark met us in the lobby and took us up to the conference room, where we found, sitting at the table, a pretty, 30-something blonde in a stylish power suit—think Ally McBeal, without the eating disorder. Her opened briefcase was overflowing with files, legal papers and curled Post-It notes.

Mark had introduced her as Carolyn Mullins, a public defender engaged to a cop who was one of his longtime contacts. Apparently, Mark had known Lt. Steve Hartwell since he'd made detective years before.

"Steve's a real straight shooter," Mark said. "No playing the angles, that bullshit."

Carolyn smiled. "Except when it came to getting engaged. I practically had to twist his arm to get him to propose."

Mark feigned confusion. "And your point is...?"

Feeble laughs all around.

"So," Carolyn said, after a polite pause. "Mark tells me you guys get together every Sunday, talk about current events, that kind of stuff. And you call yourselves the Brilliant Men or something?"

"The Smart Guys Marching Society," Mark said.

"It's kind of a self-deprecating, ironic sort of name," I added defensively. "You know, like an inside joke. I mean, it's not like we really think we're that smart or anything." *Jesus*, I said to myself, shut *up*.

Fred rescued me. "We were going to call ourselves Desperate Husbands, but it seemed too derivative. Accurate, but derivative."

She chuckled. "C'mon, it can't be that bad."

"The optimism of youth," murmured Fred, who'd taken to saying things like that a lot lately. He'd just turned 47.

Meanwhile, Bill was looking a bit restless, glancing around the room. He'd told me he had a dress rehearsal at four for the new play he was directing at the Mark Taper Forum. And he hated being late.

Mark watched him fidgeting, then turned to Carolyn. "How long till she gets here?"

She checked her watch. "Steve just signed the papers to get her released. Once they get the escort duty straightened out, they'll be right up. Figure ten, fifteen minutes."

Fred was helping himself to coffee from a large cardboard Starbucks carry-out keg. We'd stopped on the way here. Paper cups, napkins and plastic silverware were splayed on the table next to a box of chocolate donuts and two cartons of low-fat milk.

"I assume we're talking about a crime suspect," Fred mused, eye-balling the coffee-to-milk ratio in his cup. "Given our surroundings."

"First-time offender," Mark said. "But she's being held without bail."

Fred gave Carolyn a questioning look, old legal pro to young public defender. But she recovered nicely.

"It's a first-degree murder charge," she explained. "Premeditated. Plus... well... the other thing."

"What other thing?" I asked.

Mark answered. "The accused won't talk."

"That's right," Carolyn added. "She won't say a word about the night of the crime. Or the victim. Not even to me, her attorney. Which is another funny thing. She can afford to hire her own lawyer, but she refused to even discuss legal counsel. The court had no choice but to assign her a public defender. I was next up in the rotation. Lucky me."

"That *is* strange," said Fred, frowning.

Bill just seemed annoyed. "Look, since I don't know who or what we're talking about, mind if I ask a question?"

"Sure."

"Who or what are we talking about?"

"A reasonable question."

It was Isaac, sitting back in his chair at the far end of the table. His hands rested on his round belly, eyes half-closed, gentle face book-ended by his signature muttonchop sideburns. As was his custom, Isaac had been practically silent since we'd arrived, so that when he did speak, it came—as it almost always did—as a surprise.

"Very reasonable," Mark agreed. "Carolyn here is defending a woman named Martha Bramlett on a charge of first-degree murder.

73

She's accused of killing a real estate mogul named Elliot Keyes."

"Hey, I saw that story on the news," I said. "Happened a couple nights ago, right?"

Bill sat up. "Yeah, Elliot Keyes. The one with his face plastered on all those bus benches." He scratched his chin. "What's that slogan of his again? 'He's the Keyes to your next home.' Pretty lame, if you ask me."

I ignored him. "And this Martha Bramlett is supposed to have killed him? How?"

"According to the papers," Fred said, "he was dispatched by the proverbial blunt instrument."

"Not so proverbial," Mark said. "The cops are keeping it from the media for now, but they *have* the murder weapon. Looks like she bashed Mr. Keyes' head in with a heavy brass candlestick." He gave a wry smile. "Just like in the game *Clue*."

Carolyn winced. "Yeah, everyone in my office has been doing that joke. 'Martha in the living room with a candlestick.' Everybody thinks it's hilarious but me. I'm the one who has to defend her, and she's giving me nothing. Not a word in her defense. She barely seems to care."

"No alibi?" Fred asked, taking his seat. He carefully laid out two donuts on a napkin next to his coffee.

"Nope. Pretty much just name, rank and serial number."

Bill looked at Mark. "*Now* I know why you asked us to meet you here. You want us to give Martha the old Smart Guys treatment."

"Something like that," Mark said. He adjusted his dark-framed glasses. "Carolyn told me she was getting desperate, so I thought maybe if we put our heads together we could help her out."

"How?"

"Well," Mark turned to me. "I thought maybe as a therapist you could use some of that empathy crap to get Martha to open up." A smile. "No offense."

I smiled back. "None taken."

Carolyn raised her eyes across the table to Fred. "And when Mark told me *you* were a friend of his, I must admit I got excited. A lawyer with your notoriety, your wealth of experience. I thought it could only help."

Fred considered this carefully. "Mark, I like this woman. Carry on."

Mark just rolled his eyes. But I had a question, too.

"Carolyn, aren't attorney-client conferences supposed to be con-fidential—*and* private? I mean, is Martha okay with having us join you here?"

"I asked her, of course. She said I could bring along the Mormon Tabernacle Choir, if I wanted. She didn't care. Sometimes I wonder if she even registers anything I say."

"I assume you're doing a psych eval?" I said.

She nodded. "Tomorrow. We'll have *our* shrink talk to her, then the D.A. will have *his*. Ought to be a fun day."

Mark stirred. "Look, maybe the best use of our time till Martha gets here is to go over what we know for sure. Start at the beginning. You mind, Carolyn?"

"Makes sense to me."

We waited as she went through some papers in her briefcase, then began laying them out neatly before her on the table.

I was aware suddenly of the subtle scent of her perfume. How different from the usual aroma of beer, burnt popcorn and half-eaten

burritos that usually permeated a meeting of the Smart Guys. *Viva le différence,* as guys a lot more sophisticated than me used to say.

"This past Thursday night," Carolyn began at last, reading from a police report, "9-1-1 got a call from outside Elliot Keyes' home in the Pacific Palisades. It was from a kid delivering groceries to Keyes. He says he rang the bell a number of times, then moved off to one side of the front porch and looked in the lighted window. He could just see past the hall entrance into the living room. He saw an outstretched arm on the hardwood floor, and what looked like blood oozing out from under it. He immediately took out his cell and called it in."

"So much for his tip," Bill murmured.

"Jesus." Mark scowled at him.

Carolyn looked up from the report. "No, it's kind of funny. When the cops got there, the delivery kid was pretty upset. According to the officer who questioned him, the place the kid works for charges the delivery people if they don't come back with payment due. The kid was freaking out, since he had a full bag of groceries, including a bottle of Dom Pérignon."

"Tough break."

"Tougher on Elliot Keyes. The cops broke in and found him on the floor of the living room, head caved in, blood pooling everywhere. The wound was fresh, must've happened shortly before the delivery kid got there."

She put down her file. "This is where things get interesting. Ten minutes later, as the M.E.'s van is pulling up to the driveway, the driver spots a car with its lights on about a hundred yards down the street, parked at the curb. He tells the cops on the scene, who go down and find a woman sitting behind the wheel, staring straight

ahead, like she's in shock. She barely acknowledges them as they open the driver's side door."

She took a long breath. "This, they will learn, is Martha Bramlett. For now, all they know is that a woman in her late 20s is sitting in her car in a blood-splattered dress, with a large blood-splattered brass candlestick on her lap. Oh, and she's wearing gardening gloves."

"Let me guess," said Fred. "Equally blood-splattered."

"If not more so. They take her into custody without incident, though they note she seems pretty out of it. Like she's stoned or something. Though a blood test confirms there wasn't a trace of alcohol or drugs in her system."

"She consented to giving the blood sample?"

Carolyn nodded. "I know. She gave consent without an attorney present, and in a questionable state of mind. Goes to competence. Goddamn cops know better, but..."

"You and Lieutenant Hartwell must have some interesting conversations," Bill said.

"Tell me about it. Anyway, I think I can use the lack-of-consent issue to get some leverage with the D.A."

"About the candlestick," Mark said. "I assume the blood was Elliot Keyes'?"

"Yes. Positive match with the victim. Same is true for the blood on Martha's dress, as well as the gardening gloves."

"Martha's sure making it easy for 'em," Bill said.

"What about the crime scene?" I asked. "Anything there? Like a matching candlestick? Those kinds of things usually come in pairs, don't they?"

"Usually," Carolyn replied. She pulled a large manila envelope

from her briefcase and spilled its contents on the table. She fished through the small pile of Polaroids until she found a picture of the murder weapon.

"Here it is," she said, and we passed it around the table. It was an ornate, weathered brass candlestick, about 20 inches tall. Obviously old, like an antique, its dull patina was streaked with rivulets of dried blood.

"Was it from the Keyes house?" Fred asked.

"The cops don't think so." Carolyn glanced at another report. "They questioned the maid, who comes every day but leaves at six. According to her, there was no such candlestick in the house. At least she'd never seen one, and she's been the maid there for ten years. She made a big point of claiming to have cleaned every inch of the place a hundred times, and that she never saw anything like the murder weapon."

"But the crime scene itself," I repeated. "What did they find?"

"There were definitely signs of a struggle. Crime scene techs found a dozen sets of prints, all of which could be accounted for. Keyes himself, of course. Plus, according to the maid, he had an ex-wife who came by frequently to scream at him over money. As did Keyes' accountant, lawyer and business partner. There were matches, or at least partials, for all these folks."

Carolyn opened another file. "Unfortunately, there were a number of prints ID'd as Martha's as well. On tables, glassware."

"Sounds like the maid was a bit less thorough than advertised," Mark said.

"Yeah, that's a problem. See, the maid was on vacation. She had a week off with pay to go see her relatives in El Salvador. Lots of time

while she was gone for fresh prints to accumulate."

"Keyes had a lot of visitors," Fred said.

"He was a busy man," Mark explained. "Heads one of the city's leading real estate firms. Offices all over, an army of agents, generating millions in commissions."

Carolyn shook her head. "Not according to his most recent audit. His accountant told the cops that with the market going soft the past couple years, Keyes was actually in some financial trouble. Though he lived like a rock star. Yacht, couple houses, the usual status toys. But in terms of liquid money, the well was running dry."

"What else did the police find?" Mark asked.

"In the house, not much. But they went through Martha's car, of course, and found a suitcase with clothes packed inside. Also, on the passenger side front seat, a book that Martha had checked out of the library that same day. It was in a white plastic bag, whose loop handles were also smudged with blood."

"A book?" I said. "What kind of book?"

She showed around another photo, this time of a thick hard-cover book with the unmistakeable imprint of the L.A. public library on its cover. It was a travel guide to Switzerland.

"Again, Martha's making the case for the cops," Carolyn said. "They had the tech geeks run a check on her personal laptop in her apartment. They found that she'd checked her American Express account online to find out how many member miles she had, and about flights to Switzerland."

Mark sighed, taking off his glasses. "That just about nails it, don't you think, Carolyn?"

"I don't know what to think. Anyway, here's the rest of the evi-

dence photos, if anyone's interested."

We took turns looking at the pictures. One showed a somewhat wrinkled, bloodstained pair of vinyl blue gardening gloves. Another was a photo of the blood-splattered dress Martha had been wearing the night of the crime. I don't know anything about women's fashions, but it sure looked expensive. I said so.

"It was," Carolyn said. "And it didn't take Columbo to figure that out. Poor Martha must have been in some state, all right. The price tag was still on the dress, attached to the sleeve."

"Do the cops know when the dress was bought?"

She nodded. "When and where. Earlier that same day, at a place in Beverly Hills. Very trendy. At least, *I* couldn't afford to shop there."

Then, staring at the evidence photo which had just been passed to him, Isaac spoke. His voice had its usual wry, curious tone.

"About this book they found in her car. Any specific details?"

Carolyn consulted the report. "Not much. Taken out that day from the public library on San Vicente. Published in 1998. Third edition."

Isaac looked puzzled for a moment, then passed the photo back up the table to Carolyn.

Then, folding his arms, Fred spoke: "So, Carolyn, adding it all up, what do the cops think?"

"They think the same thing the D.A.'s office thinks, which is that Martha Bramlett killed Elliot Keyes." She shook her head. "Their theory has a zillion holes, as far as I'm concerned, but the physical evidence is damning."

"On first glance, yeah," Bill said.

"Anyway, here's the way they see it," Carolyn went on. "Martha plans to kill Elliot, then skip the country. She goes to his house, and

either lets herself in—they found a key to the house among her own set of keys—or else the victim himself lets her in. The point is, there was no sign of forced entry.

"Martha has the candlestick with her, and wears the garden gloves to make sure she doesn't leave any prints on it. The fact that she brings the murder weapon with her, and is wearing gloves, is clear evidence of premeditation.

"Plus the choice of murder weapon suggests what the D.A.'s calling 'callous disregard,' a desire to cause great pain and suffering. When you add in the online research about plane tickets and member miles, the Switzerland travel guide found in her car *and* the packed suitcase..."

"They figure she planned to do the deed and skip the country," Fred finished for her. "Premeditated, all right."

"Sure looks it. The D.A. is going to argue that she went into the house, with or without Elliot Keyes' consent. Then she attacks him, clubbing him from behind with the candlestick. The kind of blow that splatters a lot of blood, on her and her clothes. Then she runs to her car, tries to drive away, but stops after half a block. The shock of what she's done hits her. She's frozen behind the wheel, in some kind of daze, still holding the murder weapon. That's when the cops find her."

"And she really won't talk?" Bill said. "Won't defend herself? Tell her side of the story?"

"I'm telling you, I've tried to confer with her three times. Couple hours each. I think she asked for a glass of water, a bathroom break and what the weather was like outside. Other than that, she just stared at me. I swear, I wanted to bash *her* head in with a candlestick."

We all sat for a moment in silence.

Finally, stroking his trim beard, Fred said what I suspect we all were thinking.

"C'mon, Carolyn. This is nuts. Who brings a candlestick to a guy's house to kill him?"

She shrugged. "I've seen stranger things. I remember this one freak who strangled his wife while wearing hand puppets. And I had another client who stormed into her boyfriend's office at work, took a shish kabob skewer from her Louis Vuitton bag and stabbed him in the heart."

Fred looked over at me. "*Now* do you see why I mostly do corporate work?"

Carolyn raised her chin. "Hey, she had a legit beef. That guy was a two-timing prick."

Mark rubbed his forehead. "Look, can we stay on task here? My question is, are the cops sure she brought the candlestick with her? I don't care what the maid says, it just seems more credible that the candlestick was on a table or something, and Martha just grabbed it up."

"Two problems with that," Carolyn replied. "First, the maid swears she's never seen that candlestick, or anything like it, in the house. Second, your theory supports the idea that the murder was a crime of passion. That Martha and Keyes got into some kind of argument, and in the heat of the moment she killed him. The thing is, how then do you explain the gloves, the travel guide, the online research about flights to Switzerland? It's circumstantial evidence, I agree, but it sure as hell points to premeditation."

"Maybe," Mark said. "But it still doesn't add up. If, for example, Elliot himself opened the door to let her in, wouldn't he think it's a little strange

that she's standing in his doorway with a heavy brass candlestick?"

"Maybe she had it behind her back," I said.

Mark sighed heavily. "Yeah, that would look normal. Keyes wouldn't suspect anything funny about *that*."

"Okay, then," I went on, unfazed, "how about this: whether Keyes sees the candlestick or not, why doesn't Martha just clobber him the moment he opens the door?"

"Remember, forensics concluded he was hit from behind," Carolyn said.

"That's what I mean. She could've done it the moment he turned his back, to lead her into the house. Why give up the element of surprise? Why does she wait until they're in the living room?"

Carolyn started scribbling notes on a legal pad. "Hey, I like that. I think I can use it. Thanks."

I admit, I shot Mark a smug look. He shrugged.

Then I spotted Bill glancing at his watch. I knew he was getting anxious about the rehearsal. I guessed he was debating whether to stay or go.

Finally, he got to his feet. "Look, let's say she *did* whack the guy. Why? What was her relationship to Elliot Keyes? Did she even *have* one? I mean, there has to be some kind of motive."

"Another reasonable question," Isaac remarked dryly.

"See? Isaac agrees with me."

Bill stretched, as though stiff from sitting, and went over to pour himself a cup of coffee. A large one. I knew then that he was in this for the duration.

Meanwhile, Carolyn was fishing for another file from the papers in her briefcase.

"I'm afraid Martha *had* a motive," she said, spreading out pages on the table. "We have statements from co-workers, friends and relatives. We also have statements from people close to Elliot Keyes. Based on everything we know so far, I've pieced together the story, at least as I understand it."

She paused, gathering her thoughts. "Martha Bramlett worked in one of the branch offices of Keyes' real estate company. According to everyone who knew her, Martha was a real star there, on the rise. Beautiful and smart, which is always a two-edged sword for a career woman. I mean, everyone loved her, but they also envied her. You know?"

Are we talking about you or Martha? I thought. Even nowadays, women like Carolyn had a rough road to hoe in such a competitive, testosterone-fueled environment as criminal law.

"Anyway, Martha was also a bit of a contradiction. She was supersharp, even ran the company website. But friends say she was also kind of old-fashioned. Liked men to open doors for her. Spent her weekends gardening in the yard behind her duplex on Wilshire."

"Hence the gardening gloves," Fred said.

"Hence," Carolyn agreed. "In terms of her personal life, she'd been going with a guy named Richard Langley. He runs some kind of music production house. Does stuff for record labels, the movies."

"How was the relationship?" I asked.

"Depends on who you ask. They'd been together for two years, very intense. He apparently was the more serious about it. Wanted her to move in with him. The problem was, rumor had it that Martha was secretly seeing Elliot Keyes. Meeting him after work. Having 'nooners' at local hotels."

"Just your typical old-fashioned girl," Mark said.

Carolyn shot him a dark look. "Don't be so damn judgmental, Mark. Haven't *you* ever done something stupid for love?"

Mark leaned back in his chair, a bit stung by the vehemence in her voice.

Fred nudged him. "As your attorney, I'd advise you to take the fifth."

Mark adjusted his glasses. "Will do."

"Anyway," Carolyn continued, somewhat testily, "Elliot Keyes was recently divorced from his wife Anita, who apparently hated his guts. She was always going after him for more money. But his business had been hemorrhaging cash and losing assets for at least a couple years. Like I said, Keyes' own financial people confirm that things were looking bad. Last month, Keyes had to sell his yacht to give more money to his ex. In fact, there were rumors that he was thinking of getting back together with Anita. Purely for financial reasons. And that Martha found out, and was devastated."

Fred groaned. "There's the motive."

"Right. Keyes wants to go back to his wife, Martha is furious. Goes to his place on Thursday night and puts a super-sized divot in the back of her lover's head."

"Another two-timing prick for your collection," Mark blurted out. As though he couldn't help himself.

Which got him another look from Carolyn.

"I don't know why Steve likes you so much," she said. Seriously. The tension between the two of them definitely ratcheted up a notch. "Or maybe I do."

Bill cleared his throat. "See, this is what happens when we have an alcohol-free meeting of the Smart Guys. No lubricants for those

touchier moments."

Another long, awkward pause. Then, thankfully, Carolyn's cell rang. She answered.

"Okay. I guess we're ready. Thanks."

She clicked off. "That was Steve. They're bringing Martha Bramlett up now."

In less than a minute, there was a knock on the conference room door. Mark rose to answer it, letting in an unsmiling Latina police matron, a tall, thick-shouldered man in a blue blazer that I assumed was Lt. Steve Hartwell and the suspect herself.

Martha Bramlett was indeed beautiful, almost as tall as Hartwell, with dark, lustrous hair pulled back from her proud face, and piercing grey eyes. Even the loose prison clothes couldn't disguise the curves of her slender figure as Steve and the police matron perp-walked Martha to some empty seats around the table. She seemed indifferent to the handcuffs binding her wrists.

I took another minute to take in Martha Bramlett's pale, drawn face. There was something haunted in her look, something both fragile and determined at the same time.

Mark introduced Steve all around, and then the lieutenant came over, gave Carolyn's shoulder a quick, affectionate squeeze and sat down next to his suspect.

"What are you doing?" Carolyn asked him.

Steve frowned. "Sitting down."

"Oh no you're not. This is a priviledged communication between me and my client." She indicated the police matron, who'd taken up a position in the far corner. "You and the matron have to leave."

Steve's face darkened. Then, with a sweep of his catcher's mitt-

sized hand, he indicated the rest of us.

"What about *these* guys?"

"They're my consultants," she replied evenly. "They're participating with my client's consent."

"Look, Carolyn," Steve said deliberately, "I called in a lotta favors to get the suspect released from Metro. She's being held without bail, remember?"

Her eyes were steady, looking into his. "Martha Bramlett has a right to confer with her attorney. Due to the number of participants in this meeting, a different venue was required."

She tried on a smile at her fiancé. "Christ, Steve, if sitting in a windowless room in Parker Center isn't still being in custody, I don't know what the hell is."

There was no question, her intended looked unhappy. He glanced over at Mark.

"This *your* idea? If so, man, you owe me." Then back at Carolyn. "You *both* do."

With that, he rose, nodded to the police matron, and headed her out the door. But he turned at the threshold.

"You have 20 minutes. And I'll be right outside this door."

"Good," said Mark coolly. "In case Martha overpowers all of us and makes a run for it."

Steve managed a grim smile then. "Gimme a break, will ya? Next beer call, you're definitely buyin'. And for the record—this sucks."

He closed the door behind him.

Bill sniffed loudly. "I thought that went rather well, don't you?"

"Don't mind him," Carolyn said. "All bark and no bite. Well, hardly any."

She turned, about to speak to her client, when suddenly Isaac got up and went over to where Martha sat.

To my astonishment, he took her cuffed hands in his own and looked directly into her startled eyes.

"I'm so sorry for your loss," he said quietly.

She just keep staring at him, something shifting behind her eyes. Then she spoke her first words since entering the room.

"What's your name?" she asked him.

"Isaac," he answered. "And I just want to say, I sincerely hope the person you're protecting is worth it."

There was a collective murmur as we all shifted in our seats, or exchanged puzzled glances. Martha kept her gaze on Isaac, as if there were no one else in the room.

"I still won't say anything," she announced softly.

"I know," Isaac said.

With that, he went back to his seat at the table.

"What was *that* all about?" asked Carolyn.

"As you said yourself, Ms. Mullins," Isaac replied, "there are a zillion holes in the police theory of the crime. I don't know exactly how much a 'zillion' is, but it's close enough."

"C'mon, Isaac," said Mark. "If you've got something on your mind, let's have it. What do you think?"

Isaac settled back in his chair. As always, I got the sense that he took tremendous pleasure in enlightening his audience. The magician about to pull yet another rabbit out of another hat.

"Well, as rude as it is to speak of someone in the third person when they're sitting right next to you, I think that Martha Bramlett and I share one thing in common: we're both somewhat old-fashioned."

He glanced in her direction, but she was back to staring straight ahead. Silent—and seemingly uninterested.

"But, as do I, Martha lives in the modern world. She's a successful career woman. She has enough computer savvy to run the company's website. She researches her travel possibilities online, as well. And yet she takes a travel guide out of the public library? A book at least ten years out of date? Why do that when she could find much more current information online? And, finally, what was it doing in a plastic bag in her car?"

I took another look at Martha, watching for any telltale sign on her face. Nothing.

"That certainly caught my attention," Isaac went on. "As did her use of the old brass candlestick as the murder weapon. But it wasn't till I learned about the dress that I knew for sure."

"What about the dress?" Carolyn asked.

"You said the price tag was still on it. Of course, that could indicate either extreme haste on Martha's part, or sloppiness on the part of the clothing store clerk. But it also suggests something else. As do the gardening gloves."

"She wore those so she wouldn't leave any prints," Mark reminded him.

"On a murder weapon she intended to remove from the crime scene?" Isaac looked doubtful. "Remember, she was found sitting with it in her car. Presumably, she planned to dispose of it. If the crime *was* premeditated, as the police claim, that had to have been her intent. Right?"

"Then what *do* you make of the gloves?" Fred asked. "Why are they important?"

Isaac smiled. "This is where being old-fashioned gave me a slight advantage. Maybe for people your age, this quaint notion is passé... but in *my* time, women assembled the kinds of items we're discussing for a specific reason."

He leaned forward. "What I mean is this: The candlestick was something *old*, the dress was something *new*, the library book was something *borrowed* and the gloves were something *blue*.

"Martha Bramlett wasn't going to Keyes' house to murder him. She was going there to *marry* him."

The room practically exploded, as suddenly everyone was talking at once. To each other, to Isaac, to Carolyn. Everyone but me.

I was just focused on Martha herself. Something had indeed shifted in her expression. Her eyes had suddenly softened. Grown moist, and achingly sad.

"Married?" Mark finally managed to get Isaac's attention. The rest of the room quieted. "To Keyes?"

"Of course," said Isaac. "He and Martha were in love. His ex-wife was grinding him down, his finances were dwindling. I think it likely that he and Martha planned to elope that night, and leave the country. Start a new life in Switzerland."

"How can you be sure?" I asked.

"I can't be, of course," Isaac said. "Though I think the bottle of Dom Pérignon that Keyes was having delivered is certainly suggestive. Perhaps he planned on having a celebratory goodbye-to-our-old-life toast with Martha before they flew off into the sunset."

Mark took off his glasses and aimed them at Isaac.

"But if all of this is true, what the hell happened? Why isn't the happy couple sitting having a drink, as we speak, somewhere in the Alps?"

Isaac finally turned to where Martha sat, as still as before, but now obviously fighting a tremble in her lips.

"Only Martha can tell us that," he said kindly. "Am I at least correct on what happened just before the murder? That you and Keyes planned to get married and run away? That you showed up that night, as prearranged, and you had with you a plastic bag containing the borrowed book, the blue gloves and the candlestick? And that you kept the price tag on the dress to show Elliot that it was, indeed, something new. Something you'd bought just that day?"

Now he and Martha were looking at each other as they had before, as though they were alone in the room.

Suddenly, Carolyn put a restraining hand on her client's arm.

"Martha, no. Don't say a word." Carolyn turned to Mark. "I'm afraid I'm going to have to ask you and your friends to leave."

Bill nearly sprang from his seat. "Wait a minute. After bitching this whole time that Martha wasn't talking, *now* you want her to shut up?"

"Yes," Carolyn said sharply. "At least until she and I are alone. I don't want her to incriminate herself in any way. She and I have to talk this through."

"*No!*" Martha's voice rang out in the room like a gunshot. Clear, striking.

"No, Carolyn," she continued, in a calmer tone, "I don't want them to leave. It doesn't matter now anyway."

"No, it doesn't," Isaac said. "Since the person you're protecting is long gone by now, right? Out of the country. Out of the reach of the law."

"Is this true, Martha?" Carolyn asked.

Her client smiled sadly. "I hope so, yes. So your friends might as

well stay. Truth is, with Elliot dead, I don't much care what happens to me now."

We all looked dumbly at each other.

"Looks like we're staying," Mark said to Carolyn. "If that's okay with you, too."

She spread her hands. "Whatever."

Isaac looked at Martha. "May I continue?"

"Feel free." Her voice was flat. "You've been doing great so far."

"Well," Isaac said, "I think you showed up at Elliot's house, as expected, and he opened the door. You were delighted to show him what you'd assembled for good luck, for an auspicious start to your new life. He welcomed you in, said perhaps that he'd ordered some champagne for a wedding toast. But what neither of you knew was—"

"—I'd been followed," Martha said.

She let out a long breath, as though she'd been holding it in since the night of the murder. Her shoulders relaxed, and I thought she almost smiled.

Then, just as quickly, her eyes grew sad again.

"I was so happy, it almost seems pathetic now. Running around all day, taking out the library book, buying the dress, digging out my favorite blue vinyl gardening gloves. I guess I couldn't resist taking out a book about Switzerland, since that's where we were going. Just too perfect, you know?"

"And the candlestick?" asked Fred.

"It had belonged to my grandmother. It was part of a pair, but the other one was lost years ago. I loved my grandmother dearly. It was my most cherished memento, so I thought it appropriate to..."

She choked up then, her cuffed hands in front of her mouth. She drew a couple quick breaths and continued.

"Anyway, I put the book, gloves and candlestick in the bag, put on the new dress and went to Elliot's. I hadn't told him what I was bringing. I wanted it to be a surprise."

Her tone strengthened again. "But *I* was the one who got a surprise. I was followed to Elliot's place—"

"By Richard Langley," Isaac said.

Mark stared. "How did you know that?"

Isaac shrugged. "It seemed to me that the only other person with a probable motive was Keyes' ex-wife Anita. But even if she *was* angry or jealous of his relationship with Martha, why kill the goose laying golden eggs?"

Fred agreed. "True, she *was* managing to squeeze more and more money out of the sorry bastard. In fact, if Anita were going to kill anyone, I think it'd be Martha."

"As do I." Isaac turned to Martha. "It *was* Richard, wasn't it?"

"Yes. I wasn't in the house 30 seconds before he came in the door. Elliot hadn't locked it behind us."

"So Langley knew about the rumors," I said carefully. "About you and Elliot."

She nodded. "He also knew they were more than rumors. Richard was very... This is so hard to say, because I know he loved me—*loves* me—with all his heart. And I'd *tried* to break up with him... tried to do it kindly, without hurting him..." She sniffed, as tears filled her eyes. "But I'd lied to him all the same. Never told him about Elliot and me. Never really admitted to Richard that I didn't love him anymore."

Martha looked anxiously from one of us to the other.

"You have to believe me, I'm not someone who... I'm not casual about love, or sex... I'm not—"

She hesitated, then glanced down at the table. Her voice grew an edge. "I'm not someone who screws around on her boyfriend, then runs off with the boss. Except that, when it comes down to it, I guess I am."

Nobody spoke.

Martha rubbed her wrists inside the handcuffs, as though just now aware of being bound. "Anyway, I'd just opened the bag and shown Elliot my grandmother's candlestick. I'd put it on the coffee table. We were laughing about how old and huge it was, but also that it was perfect. That we'd move heaven and earth to find its mate after we were married. That we'd..."

"All of a sudden, Richard came in and saw Elliot and me. He just started yelling, like a crazy man. He said that he loved me, that I was ruining his life, that he'd never find someone like me again. Elliot got between Richard and me, pushing Richard away. Elliot told me I didn't have to listen to this, that he was going to call the police. That it was *our* life now. That's when—"

"That's when Richard grabbed up the candlestick," Isaac said. "And hit Elliot from behind."

Her voice rose, choked with tears. "But you have to understand, he didn't know what he was doing! He was out of his mind with rage and grief. Over *me*. *I'd* brought him to it, I'd cheated on him. It was all *my* fault..."

"Now wait a minute," I said.

She didn't even hear me. "We just stood there, looking down at

poor Elliot. Richard was frozen, like a statue. He couldn't believe what he'd just done. I knew my Elliot was dead. And that was my fault, too. The whole thing had happened because of *me*..."

She wept openly now. Carolyn began softly stroking her client's arm.

"That's when you decided to protect Richard," Isaac said quietly. "That's when you told him to leave."

She nodded. "I told him he had to get out. Right away. At first it was like he was paralyzed, the candlestick still gripped in his hand. So I reached into the plastic bag and put on the gardening gloves. Then I made Richard give *me* the bloody candlestick.

"I told Richard I'd take care of everything. I'd get rid of the candlestick, the police would never even know he'd been there. Maybe they'd think a burglar killed Elliot. It took a few minutes, but I finally persuaded him to leave. He went out the front door as fast as he could."

She took a quick, calming breath. "Then I scooped up the plastic bag and left the house myself. I'd just gotten into my car and driven off when I saw the delivery van pulling up the street from the other direction."

She'd regained her composure completely by then. Her voice was quiet but clear.

"I pulled to a stop halfway down the block. Sitting behind the wheel, I rubbed the candlestick with both gloved hands now. I guess I hoped it would rub off Richard's fingerprints, in case it was ever found. Though I had no idea what to do with it. People in the movies always throw the murder weapon in the river or something.

"Then... suddenly... I don't know, I guess it was a delayed reaction. But all my pain and grief about Elliot just washed over me. A kind of searing pain like I've never felt before. I couldn't even start the car

up again. All of it... Elliot's death, what Richard and I had just done... it was all so overwhelming. So I just... sat there, with the candlestick on my lap."

"Until the police opened the door," Mark said.

She looked off. "All I knew was that I had to protect Richard. So I didn't say anything... to anybody...."

Carolyn chose her next words carefully. "Martha... don't you think that we should go to the police with this? I mean, I understand why you did what you did... but this isn't fair to you, and you know it. It isn't right."

Martha almost smiled. "I don't need anyone to tell me what's right or wrong. The way I was brought up, I know that only too well. That's why I told Richard to leave the country. Besides, if the police ever *do* find him, I'll deny everything I just said."

I had to speak up.

"Martha, please listen to me. I appreciate your upbringing, the values that were instilled in you. But don't allow your guilt and sense of responsibility, no matter how sincere, to ruin your life."

"For once, Mr. Sensitive is right," Fred added. "You can't go to prison for life for a crime you didn't commit."

Martha's jaw tightened. "Watch me."

Carolyn's eyes were fierce with frustration. Then she took hold of Martha's cuffed hands and squeezed. Hard.

"Goddammit, Martha, don't you see—?"

There was a loud knock at the door, and then, without waiting for a response, Lt. Steve Hartwell was in the room.

"Steve," Carolyn said. "*Please.* Another minute—"

"I don't think you'll need it." He looked directly at Martha. "Rich-

ard Langley just walked into his local precinct and confessed to killing Elliot Keyes."

She half-rose from her seat, stricken. "No..."

"Jesus," Mark said softly.

Martha just stared. "But I told him to get away. He *promised* me—"

Carolyn patted her arm. "Honey, it's better that he didn't keep that promise. Better for you. Maybe even better for him."

"That's not true." Martha let herself sink into her seat again. "You know that's not true. But why? Why did he do it?"

"Because he loves you," Isaac said kindly. "He couldn't let you be convicted for a crime he committed."

"But don't you see? It was *my* fault. All of it... My fault..." As she began crying again.

"Carolyn." Steve's voice was terse. "I think your client ought to come down and make a full statement. Langley's confession changes everything. Now she's just looking at accessory after the fact."

"I know. A first offense. In a state of grief and emotional confusion." She looked up at him. "I can make a meal out of that."

"I've seen you do it with less," Steve said, with a reluctant smile. "Let's get going, okay?"

The same police matron stepped in the room from behind Steve. Carolyn gave us all a somber look, then helped lead Martha from her chair and slowly out of the room.

I couldn't help but notice that Martha had retreated to a kind of dissociated state again. I told myself to make a point of contacting Carolyn soon, to be sure Martha was getting the professional help she would need.

As Martha was led away by the matron and Steve Hartwell, Carolyn stopped at the doorway and turned.

"I want to thank you all," she said. "Especially you, Isaac."

"No need," Isaac said. "I had a feeling that Mr. Langley would eventually confess. At least I *hoped* he would."

"Then you have more faith in human nature than I do," she said thoughtfully. "Price of the job, I guess."

With that, Carolyn Mullins followed her client out.

This left the rest of us alone in the room.

Fred broke the thick silence. "Remarkable..."

"My sentiments exactly." Mark was absently wiping his glasses on his shirt.

"We should probably turn out the lights on our way out," I said at last. I couldn't think of anything else to say.

As we began packing up the coffee leftovers and trash, Mark turned to Isaac. "Amazing work, as usual. Hell, I'm not even surprised anymore."

"Nor should you be."

Bill put his hand on Isaac's shoulder. "That's what I like about this guy. No false modesty."

"Actually," Isaac said, "I believe Mark deserves some credit for suggesting this to Carolyn Mullins in the first place. I think a change of venue did us a world of good."

Fred chuckled. "You may have a point there, Isaac. How about we do the next one on the beach in Maui?"

"Works for me," Bill said.

On our way out the door, he had another thought.

"By the way, if Lt. Steve and Carolyn *do* get married, I got 20

bucks that says it won't last six months."

There were no takers.

Ghost Whistle

"Do any of you guys believe in ghosts?" Fred asked, nursing his second Jack Daniels on the rocks. He stood at the small wet bar in a corner of my game room.

"Define your terms," Mark said. "You mean, actual ghosts? Apparitions of the dead that haunt the living? Like Casper. Or Keith Richards?"

Fred just shook his head. Cretins.

"There's also Ibsen's play, *Ghosts*," Bill said cheerily. "I did three weeks in Chicago in that sucker. Got huge laughs, too. Unintentional, but huge."

Irritated, Fred turned to me. "A little help?"

"Are we talking about the afterlife, something like that?"

Fred came over and took a seat on the couch. He looked somberly at the drink in his hand. "I'm talking about the dead, living on as ghosts. Spirits."

I was struck by both his earnest tone and the fact that our upright, cool-headed representative of the legal profession had, within minutes of arriving for our weekly Smart Guys meeting, gone straight for the hard liquor.

Meanwhile, Mark had made himself comfortable on my new La-Z-Boy, showing us the bottoms of his scuffed Florsheims. "I read that somebody asked Samuel Beckett what he thought the afterlife would be like. He said, 'We'll just sit around talking about the good old days, when we wished we were dead.'"

Bill laughed and spread eggplant appetizer on a sesame cracker. He'd done a deli run before showing up for this afternoon's meeting, and had chosen a slightly more exotic mix of snacks than our usual fare. I myself was on my second crab wonton with apricot glaze. Not bad.

Isaac came in from the kitchen then, noting the sizeable buffet spread out on the coffee table.

"My compliments, Bill," he said, settling into his familiar corner armchair. He balanced a mug of Darjeeling tea on his knee. "We needed some culinary variety."

"My pleasure," Bill said. "That'll be $18.50 from each of you guys."

"Do you take checks?" Mark asked.

"With two forms of ID and valid driver's license," Bill answered. "Can't be too careful nowadays."

For some reason, Fred wasn't amused by this dazzling display of wit. He just sat back on my couch, stroked his trim beard in a slow, deliberate manner and looked off.

It was a typical late-spring Sunday afternoon in the San Fer-

nando Valley, which means it was atypical cool and overcast. The TV weather people call it "June gloom," a time when the marine layer gets trapped by competing air pressure fronts (or something), and we get a few weeks of damp fog worthy of Victorian London—before shifting into the glaring sun and 100-plus degree temperatures of summer in L.A.

Anyway, given the high-end chow arrayed before us, we did more eating than talking for the next half-hour, though a few topical items did slip briefly into and out of the conversation. Mostly politics, or the latest celebrity divorce circus. Garden-variety stuff.

Somehow, finally, we ended up debating the cultural ramifications of Internet dating—admittedly a dicey topic for a bunch of middle-aged married guys—though it was clear that Fred's mind was still elsewhere.

Not that the rest of us were firing on our usual eight cylinders. Maybe it was the weather.

In fact, Isaac had actually started to doze, his empty mug resting on the side table next to a well-thumbed collection of Agatha Christie's Miss Marple stories. For a few moments, we just found ourselves listening to his gentle, oddly comforting snore.

At which point, Fred abruptly got to his feet.

"Look, guys, I'm gonna have to cut it short today. I'm meeting my mother and uncle in a few minutes."

"C'mon, man," I said. "Obviously you have something on your mind. Want to talk about it?"

Fred considered this. "No. Well, yeah... but I sort of don't know how. It's personal."

"Hey, don't worry about it," said Bill. "They got pills for that now.

Not that *I've* ever needed 'em, but—"

Fred, wisely, ignored him.

"It's just that it involves my family," Fred said after a pause. "We're all kind of shook up about it."

"Anything we can help you with?"

"Maybe. Hell, I suppose that's not a bad idea." Fred gave a rueful grin. "As long as you all promise not to think my whole family's nuts."

"Don't worry," Bill said. "We take that as a given. They raised *your* tight ass, didn't they?"

"Cool it, Bill." Mark took off his glasses and looked at Fred. "You said you were meeting your mother and your uncle. Why not bring 'em here?"

"Bring my family to a Smart Guys meeting?"

"Why not?" I said. "It wouldn't be the first time we had guests."

"We're talking about my *mother* here," Fred said.

Bill shrugged. "So we'll watch our language."

After a moment, Fred nodded. "Okay, I'll call and ask them to come here instead."

Mark stirred. "What's this all about, anyway? I mean, can you give us a hint?"

"I'll do better than that," Fred answered. "How about a visual aid?"

With that, he took something out of his jacket pocket and tossed it to Mark.

"It's a train whistle," Fred explained. "It belonged to my grandfather, my mother's father. He was a station master for the Union Pacific. He died last week."

"I'm sorry, Fred," Mark said. "My condolences."

"Mine, too," I said. "But why didn't you mention it?"

"You know me. I don't like to talk much about personal things. I guess I have a lawyer's reticence."

Bill gave a cough. "Look, man, I was just messing with you before... I didn't—"

"Hey, I know. Don't worry about it."

Then Fred's face softened. "He was a great guy, my Grandpa Joe. When I was a kid, he'd sit me on his knee and tell me amazing stories about his days on the railroad. Soon after he retired, he gave me his train whistle. He'd used that old thing for over 25 years. And he knew I'd always loved it."

"And you've kept it ever since?" I said.

He nodded. "Every day, in one pocket or another. I guess I've always felt it brought me luck."

"Funny," Mark said, "you never struck me as the sentimental type."

Fred smiled. "You never knew my grandfather."

With that, he went outside for some privacy to call his family. Meanwhile, we handed the old, brass whistle around. When it reached Bill, he put it to his lips and blew.

"Jesus—!" Mark winced.

But it was too late. The whistle made a sharp, high, one-note sound, instantly familiar from dozens of old movies featuring elegant train platforms and huge steam locomotives. As the sound faded, the silence in its wake was tinged with a sense of...well, I can only call it melancholy.

"See, I blew it the *right* way," Bill was saying, rolling the whistle between his fingers. "None of that *tweet-tweet* crap. One nice long note, like in *Murder on the Orient Express*. Man, now there was a train!"

"Give me that." Mark snatched it from Bill's hand.

"Sure does remind you of the past," I said. "When travel was more adventurous. Exciting."

Isaac made a kind of chortling noise, eyes still closed. "Believe me, train travel had as many negatives as positives. Smoke, soot, cramped conditions. Not to mention the way the porters and baggage handlers were treated."

He shifted in his seat, as though to rouse himself awake again. "It's funny. You young people are always so quick to romanticize the world before you were born."

Bill smiled. "See, that's why I love having Isaac around. To him, we're still young."

As Isaac blinked awake, Mark handed him the whistle.

Isaac was studying it appreciatively when Fred came back into the room.

"They're on their way," he said. "They agree that running the story by some impartial listeners might help."

He sat down and reached for his whiskey glass. He drained it in a gulp.

"Take it easy, man," Mark said.

"You do realize you're self-medicating," I told Fred, feeling a bit lame as I did so.

"Damn right I am," he replied. "What would *you* do if your dead grandfather's ghost suddenly showed up?"

A half hour later, Fred was making introductions.

"Guys, this is my mother, Missus—"

"Just call me Ruthie," his mother said. "No need to be formal

at a time like this."

I liked Fred's mother instantly. She looked to be in her mid-70s, small and thick-waisted, with a cloud of white hair that seemed laquered in place. Her clothes were appropriately dark and somber, and her face was etched with the tracks of recent—and frequent—tears. But her smile was warm and friendly.

Her companion was a taller, more distinguished looking man, perhaps a few years her junior. He had a broad, intelligent face, and the firm handshake of someone confident about his effect on people. He seemed okay, too.

"This is my uncle," Fred said. "My mom's brother, R. David Hastings. We all just call him Uncle Dave."

His uncle laughed. "When your first name's Rutherford, being called anything else is a blessing. Our parents had a strange sense of humor when it came to naming their kids. It's the only thing I ever held against them."

Uncle Dave gave me a knowing look. "Ought to be a nice change for you, eh? My nephew here says you're a therapist. I was a city planner, so I know what it's like to listen to people complain all day long—though usually it was about their streets, not their parents. Thank God."

Before I could reply, Fred's mother spoke up. "Our father was a great man, in his simple way. Gentle and wise. With such a clear view of right and wrong. Unshakable." She smiled. "So naturally, when I brought home a rascal like Freddie's father—"

"Mom, please," Fred said. "And Dad wasn't a rascal."

Ruthie's eyes suddenly held a playful glint. "In all the ways that made *me* happy, he sure as hell was..."

Fred groaned. "Okay, Mom. T-M-I. Too Much Information. Jesus, I knew I was gonna regret this."

Bill laughed. "Hey, let your mother talk...Freddie."

Fred gave him what can only be described as a death stare, but Bill just ignored him and offered Ruthie a seat.

I did the same for Uncle Dave. I also offered him something substantial to drink, but he shook his head.

"Never touch the stuff," he said.

As Uncle Dave found a place on the couch, he nodded at Isaac. "I must say, it's nice to see another man my age in the room. I don't have to feel like such an old fart."

"Happy to oblige." Isaac lifted his empty cup. "I just had a cup of tea. I could make you some, if you like."

"No, thanks. I'm strictly a coffee man. My only vice, sorry to say."

Then, just as quickly, the hearty mood he'd seemed bent on maintaining faded. His shoulders slumped a little.

"First of all," he said quietly, "thanks for making us feel so welcome. Truthfully, though, I'm not exactly sure how you fellas can help. But Freddie says you've sorted out problems for people before. And at this point..."

He looked down at his hands, as though he expected to find them shaking. "At this point, I'll take whatever advice I can get."

Ruthie sniffed loudly. "I *gave* you my advice, Dave. We should hire a good medium. Someone who could help us..." Here she hesitated. "Well, I mean, if it *was* Daddy..."

Fred shook his head. "Mom, that's impossible and you know it."

"Do I? You know I've felt his presence since the day after he passed on. Remember, I'm the one who's been in the old house, sorting

things. I'm the one who..."

She sniffed again, and reached into her purse for a handkerchief. "I'm just saying... I felt him there. Felt him watching me."

Uncle Dave frowned. "But you said yourself, you'd sat down to rest and dozed off. Maybe you just... dreamed it. You've—we've—all been so upset since Dad died, it's no wonder you imagined seeing him..."

"Then how do you explain what *you* saw last night? And what we all *heard*. How do you explain that?"

Her brother sighed heavily. "I—I can't."

Fred offered his mother a glass of white wine and sat near her on a chair. "Mom, I think it would help if we went over the whole thing again... from the beginning."

"Good idea," Mark agreed.

Fred turned to the rest of us. "My grandparents lived in the same old house for 50 years. Even when Grandma Rose died ten years ago, Grandpa Joe refused to move."

"And God knows we tried," Ruthie said. "We asked him to move in with Freddie's father and me, but Dad wouldn't hear of it. When we suggested a retirement home—and believe me, we found a really nice place—he just blew up. It was one of the few times I'd ever seen him angry."

Uncle Dave grinned. "And you should see that old dump. Frankly, calling it a 'fixer-upper' is an insult to fixer-uppers. Needs new wiring, plumbing, the works. But he was determined to stay. He wanted to leave it to one of his children, as a legacy of sorts. The problem was—"

He and Ruthie exchanged a guilty look.

"The problem was," Ruthie finished for him, "neither Dave nor I

wanted it. Still don't."

She sighed heavily. "Poor Dad. He always said he wanted to die in that house... not in some big hospital, with strange doctors and nurses. He didn't get his wish."

Uncle Dave quietly took her hand.

After a thick moment of silence, Fred continued. "Anyway, a few days after Grandpa Joe died, we heard from Walter Hicks, our family lawyer. He needed to meet with Mom, Uncle Dave and me in his office right away. When we got there, Walter had some files on his desk. He told us that Grandpa Joe called him to his hospital bed only days before his death. He told Walter that he'd made a new will, written by hand, and that he'd put it in the wall safe in the old house."

"A new will?" Mark said.

Fred nodded. "Walter argued with him, of course. Insisted that this new will should have been drawn up with his help, as was the old one. But apparently Grandpa just laughed and accused Walter of implying that he wasn't of sound mind. But Walter knew damn well he was. Plus, Grandpa Joe said he'd had the new will witnessed by his gardener before putting it in the wall safe, so it was a legal last will and testament.

"Anyway, Grandpa Joe was the only one who had the combination to the safe, which he wrote out then and there in the hospital and gave to Walter for his files. Then Grandpa instructed Walter to gather the three of us together in the old house exactly one week after his death. Which would make it Saturday—yesterday. Then Walter was to open the safe and read the contents of this new will."

"As you can imagine," Uncle Dave said, "this came as a shock to all of us. So much so that poor Ruthie fainted, right there in Walter's

office."

Ruthie clucked her tongue. "There's no need to tell them *that*, Dave. Honestly, sometimes..."

"Well, Mom, it's true," Fred said. He turned back to the rest of us. "Mom got dizzy, so I helped her to the sofa in the adjoining room, while Walter ran to get some water."

"Such a fuss," Ruthie said, scowling.

"We were worried about you, dear," Uncle Dave said.

"We were more worried the next day," Fred went on, "when Mom went to the old house alone to start sorting through Dad's stuff."

"I know what I saw," she said stiffly. "And I *wasn't* dreaming."

She looked past her brother and son to find Isaac's kind face. "Let me see, we went to Walter's office on Wednesday, so the next day was Thursday. I wanted to get started on some of Dad's things in the old house. Personal items that would mean something to his family. Trust me, I know how relatives can be after a loved one dies. Who gets the embroidered tablecloth?—who gets Dad's old teakettle?—who gets my mother's French silverware? Just stupid *things*, I know... but they're keepsakes. Mementos of my mother and father's life together."

"We understand," I said.

"Anyway, after an hour of sorting and wrapping, I got kind of tired. So I went into the living room, where it was dark, and sat down on Dad's faded old armchair to rest."

Her jaw set then, as though in anticipation of our reaction.

"And, yes, I guess I *was* nodding off a bit...It was kind of gloomy in there, like I said, with the curtains drawn and everything. But I swear I saw, out of the corner of my eye... It was Dad, alive! But sort of... faded. He was just... drifting... past the doorway, in the hall..."

"Jesus," Bill said.

"Then I—I forced myself all the way awake and tried to get to my feet. But I get dizzy nowadays when I stand up too quickly, and..."

She sat back on the couch. "Well, as you can probably guess, by the time I got to the hallway, Dad was gone. There was no sign of anyone."

Ruthie took a gulp of wine. "So if Freddie and Dave and the rest of you want to say I'm a crazy old lady, or that I dreamed the whole thing up, then fine. Think what you want. But I didn't just *see* Dad... I *felt* him. I'm telling you, his presence is still in that house."

She turned to her brother. "And after what happened last night, I don't know how you can say otherwise."

"What happened last night?" Mark asked.

Uncle Dave looked abashed. "Well, here's the funny part. I mean, I know it isn't possible... it *can't* be... but I'm afraid *I* saw the old man myself last night. I saw my father in the hallway. His... ghost, I suppose."

It was then that I first noticed the misting rain outside the game room windows. Pushed by a late afternoon wind, rivulets of moisture dappled the glass and gently shook the magnolia trees in my backyard. Plus, I swear the temperature dropped ten degrees in the room.

"Just what we need," Bill said. "Atmosphere."

Uncle Dave smiled weakly. "At times like this, I wish I were a drinking man."

"Can we get back to last night?" Mark said sharply.

Fred took a breath. "Well, as arranged with Walter, we all planned to meet at Grandpa Joe's place at eight. I picked up Mom, and Walter and Uncle Dave each drove there separately. Uncle Dave arrived first.

Mom and I saw him knocking on the front door of the house as we drove up...."

"I'd just gotten there," Uncle Dave said, "but I realized I'd misplaced my key. Anyway, I thought maybe somebody else had already arrived—Walter, perhaps—so I tried knocking. Finally, Fred and Ruthie pulled up."

"Both Mom and I had our keys," Fred continued, "but we decided to wait on the front porch for Walter. He showed up a few minutes later, so we all went in together. It was pretty creepy in there, I have to admit. Nobody'd lived there since Grandpa had been taken to the hospital six weeks ago. Not that he'd exactly been Martha Stewart before that. Dust, cobwebs in every corner. Old furniture. Gas stove. Tell them, Mom."

Ruthie nodded. "It was just Dad's way. Never fussed over domestic things. Especially since Mom died..." She teared up and dabbed her eyes again. "It used to break my heart, the thought of him rambling around that dilapidated house all by himself these past few years."

"Anyway," Fred said, "we flipped on some lights and went down the hallway to the living room. The hallway goes right down the middle of the first floor, opening onto the kitchen, linen closet and guest bath, so we had to walk past all these open doors to reach the living room. At the back wall, behind a standing lamp that I think is a Tiffany knockoff, was the wall safe."

"Did the family know about this safe?" I asked.

"Oh, yes," said Ruthie. "Dad had it put in years ago. For his important papers, Mom's few good pieces of jewelry. That kind of thing."

"I'm surprised Walter Hicks didn't suggest a safe deposit box," Mark said.

"He did," Fred answered. "So did I. But Grandpa Joe didn't trust banks much. He'd lived through the Depression, after all. Hell, it took years to convince him to keep a checking and savings account."

"Anything strange about the place that struck you at the time?" I asked him.

"No, I don't think so. Some of the lamps had burned-out bulbs, but the overheads worked fine."

"I probably should have changed those bulbs when I was there Thursday," Ruthie admitted. "But I was so busy just sorting things out. Or at least, I *thought* I'd been busy. When we went down the hallway last night, I glanced in the kitchen and noticed that some of the cooking things I thought I'd wrapped were still out."

Fred gave her a warm smile. "Mom, that just means you were more exhausted and stressed-out than you realized. It was so soon after Grandpa Joe's death."

"We told her all that wrapping and organizing could wait till later," Uncle Dave said, gently touching her shoulder. "But my sister has a mind of her own."

Ruthie folded her thin arms. "Well, I can't help that. All us Hastings women are strong-willed, you know."

Bill cleared his throat, impatient.

Fred took the hint and went on: "As I was saying, we all assembled in the living room. Walter took out the combination from some files he brought along and opened the wall safe. Inside was all the stuff Mom mentioned, plus a single business envelope with the words 'My new will' written in ink on the front. We all recognized Grandpa Joe's

handwriting immediately. Anyway, Walter was just about to open the envelope when—"

"When suddenly all the lights went out!" Ruth's voice was like a gasp. "The whole house—plunged into darkness."

"You're kidding," I said.

"Mom's being a bit melodramatic," Fred said. "The power went out, and it was pretty dark, all right. But some ambient light from outside still came through the windows."

"Dark is dark," Ruthie said. "What would *you* call it, Mr. Yale Law School?"

"Exceedingly dim," Fred replied. "I just figured there had been some power outage in the neighborhood. Or maybe—"

He hesitated, looking from his mother to his uncle, then back at the rest of us.

"But then," he went on quietly, "not 30 seconds after the lights went out, we heard it."

"Heard what?" Bill said.

"Grandpa Joe's whistle. His train whistle. From somewhere down the hall."

"What?" Mark sat upright in the La-Z-Boy.

"No way," said Bill, wide-eyed.

"We all heard it," Uncle Dave said. "Dad's whistle. That's when Ruthie started crying out, 'It's Daddy! He's here! He's with us in this house!'"

"I knew Daddy's spirit was still in that house," she said forcefully. "I'd seen him two days before, and now he'd appeared again, blowing his whistle..."

Mark turned to Fred, but before he could say anything the latter held up his hands.

"I know what you're going to say, Mark. But I had the whistle with me the whole time. When we heard the sound, I instantly reached into my pocket... and there it was, same as always. Nobody had taken it. Which means nobody was at the other end of the hall, blowing it."

"Then who?—" Bill said. "How?"

"That's what I intended to find out," Uncle Dave said firmly. "I'm afraid I became quite irritated with Ruthie. 'It can't be Dad,' I said to her. 'I'll prove it!' So before anyone could stop me, I went back down that blasted hallway, feeling my way, and—"

"I yelled at him to stop," Ruthie said. "I told him not to do it—"

"So did I," said Fred. "But he went anyway. In a second Uncle Dave had disappeared down the hallway... It was so dark I couldn't see him at all. And still that mournful whistle...." He let out a long breath. "Truth is, I was pretty rattled. But then I started in the same direction myself. When all of a sudden, the whistle faded. Just faded away... like some ghostly sound in the distance."

He paused, then looked at Uncle Dave, who sat staring down at his hands again. His face looked less animated than before. You could see the wrinkles, the strain at the edge of his eyes.

"I know that what I'm about to say is ludicrous," he began. "I don't even believe it myself. But I *saw* Dad. I went down to the end of the hall, and... well... there he was. Standing there, not even looking at me. He had that damned whistle at his lips, and he was blowing it. A mournful sound, like Freddie said. And then... and then, he just vanished."

He looked up at us. "I mean, I guess that's what he did. One moment he appeared to be there, and the next he wasn't. God knows, I was almost in a faint myself... And then Freddie was at my side, ask-

ing me what happened. Frankly, I was afraid to tell him.

"Believe me, since that moment, I've gone back and forth with myself about what I saw—or didn't see. It *had* to have been my imagination... with the lights out, in that wretched house, our being there to hear Dad's new will... I *couldn't* have seen him. And yet—"

"Then how do you explain Grandpa Joe's train whistle?" Fred asked him. "Mom and I both heard it, too."

Uncle Dave didn't answer.

"Well," Bill said, "what happened then?"

"I helped lead Uncle Dave back to the living room," said Fred, "where Walter was holding Mom. He was afraid she might faint again. Then I made my way to the back of the house and managed to find the fuse box. As I'd suspected, a breaker switch had flipped. I guess we'd overloaded the old circuits when we came in and started turning on all the lights. I flipped it back and returned to the living room."

"Of course, with the lights on, everything just looked normal again," Uncle Dave said. "If anything, all that did was make me feel even more foolish."

"What about the will?" Mark asked.

"Walter still held it, unopened, in his hand," Fred said. "As you can imagine, nobody wanted to stay in that house any longer than we had to, so Walter slit it open and took out a single piece of paper. It was handwritten, as Grandpa Joe had explained. Walter said that all the terms of the previous will would stay the same, except for the disposition of the old house. According to this new will, Grandpa Joe wrote that he was leaving the house to Uncle Dave."

"Which was kind of a surprise," Ruthie said. "Dave and I just assumed Dad would leave it to both of us."

"And that was how it *should* have been." Uncle Dave shook his head. "You have to understand, neither Ruthie nor I care for that house. Sure, it has many wonderful memories, but the cost of fixing it up, maintaining it..."

"That's all this new document said?" Mark asked. "That the house was to go to Dave?"

"My father was a simple man, like I told you," Ruthie said. "He just wrote, 'I, Joseph Clarence Hastings, leave the house to Rutherford.'"

"Pretty simple, all right," I said.

"So, guys," said Fred, back to stroking his beard, "any thoughts about our strange story? Or should we do what Mom says and just go find a good medium?"

"I don't know if we should be so dismissive about all this," Bill said, with a surprising seriousness. "For one thing, I've never played a theater that *wasn't* haunted. Or at least, supposed to be."

Mark nodded, almost reluctantly. "I gotta admit, I've seen plenty of places that felt haunted to me. Certain war zones. Burned out buildings, old refugee camps."

His voice grew quiet. "Some places I've been... it's like there's an aura, a sense of some past violence or tragedy... As if the really weird thing would be if they *weren't* haunted...."

I watched his eyes grow somber behind his dark-framed glasses. Though he never talked about his previous life as a covert operative, I often believed I could sense when its shadow passed over him. Like now.

"So you boys agree with me?" Ruthie said at last. "You think it's possible that—"

Her voice caught in her throat—

As, suddenly, all the lights went out.

"Holy shit!" somebody said. I think it was Bill.

"Oh dear God!" Ruthie gasped.

I could hear the others getting to their feet, bumping into furniture. With the drizzle and gloom shrouding the windows, my game room was now as dark as night.

"Nobody move," I said. "I'll get a flashlight."

Suddenly, I heard a high, sharp sound wafting through the room. A single long note, rising in pitch.

"Daddy!!" It was Ruthie again, near hysterical.

"Get a light in here!" Mark's clear voice pierced the darkness. "Where's that goddam flashlight?!"

Then, as unexpectedly as before, the lights in the room blazed on again. We all stood, in various awestruck poses, blinking in the brightness.

"What the hell's going on?" Bill snapped. "And where's that damned *whistle* coming from—?"

"From me," said a voice from the kitchen.

It was Isaac. At the same moment I recognized his voice, I also became aware that he wasn't in the room. In fact, I couldn't swear he'd been sitting with us for some time, even before the lights had gone out.

But there he was now, standing in the kitchen doorway, with a steaming teakettle in his hand. We all watched, in a kind of unthinking trance, as the kettle's high whistle faded to a whisper, and then was silent.

Fred, fumbling in his pockets, drew out his grandfather's train whistle. "But I thought..."

Isaac nodded, stepping into the room. He put the still-warm kettle

119

on the side table.

"You thought that high-pitched sound you just heard was from your Grandpa Joe's whistle," Isaac said. "Just like you did last night, when the lights went out in the old house."

"What do you mean, Isaac?" Fred said.

"I mean," Isaac said, settling into his armchair, "that you and your mother were the victims of a trick."

He looked at me. "Similar to the one I just did, after I flipped the breaker switch in your fuse box. By the way, I hope that was okay. I wanted to illustrate a point."

"Uh... sure," I said. "*Mi casa es su casa.* I guess."

"What's this all about?" Uncle Dave said.

Isaac ignored him. Instead, he turned to Ruthie with a sad smile. "I'm sorry, my dear. As much as you want to believe it was your father's ghost, contacting you from beyond last night, I'm afraid it wasn't."

Uncle Dave sputtered. "Now see here, I *saw* the old man last night—"

"*I* saw Daddy, too," Ruthie insisted. "Remember? On Thursday afternoon."

Isaac shook his head. "You said yourself, Ruthie, you were too tired to keep working, and that you sat down for a rest. I believe you did, in fact, fall asleep, and dreamt that he appeared to you."

Uncle Dave frowned. "That still doesn't explain what happened last night. What about *my* story?"

"That's even easier," Isaac replied. "You lied."

"How dare you!" Uncle Dave turned to Ruthie. "We don't have to stay and listen to this."

Fred gave him a sharp look. "You know, Uncle Dave, I'd prefer if

you did. I want to hear what Isaac has to say."

"So do I," said Bill.

Uncle Dave looked as though he were about to speak, but didn't. He merely sat back and folded his arms.

After a pause, Isaac began. "I may get some of the details wrong, but I do have a theory about the chain of events you three described." He glanced over at Uncle Dave. "Feel free to jump in whenever I get it wrong."

"Go to hell," said Uncle Dave, eyes narrowing.

Unruffled, Isaac continued. "Just before he took ill, I think Grandpa Joe somehow found out that his son Dave wanted to sell the old house—despite his clear desire that it be kept in the family. So Grandpa Joe drew up an amendment to his will, a single piece of paper, on which he wrote by hand that he wanted the house to go to Ruth. I'm sure he believed that she, unlike Dave, would honor his wishes and keep possession of the house."

"Pure supposition," Uncle Dave said, with a tight smile. "Besides, haven't I made clear my lack of interest in the old place?"

"You've sure worked hard to give that impression," Isaac agreed. "But let's move on. Uncle Dave, of course, has no idea that Grandpa Joe had become suspicious. And certainly no idea that he'd changed his will. Not until Walter Hicks informs Dave, Ruthie and Fred in his office a few days after the funeral. Dave guesses instantly that a change in the will is probably bad news for him. But then, he gets a lucky break."

As Isaac spoke, a picture began forming in my own mind. "Ruthie suddenly faints..."

"Exactly. When Ruthie faints, what happens? Fred helps her onto

the couch in an adjoining room, and Walter Hicks goes out for some water. This leaves Uncle Dave alone in Walter's office for just a few moments... enough time to go to the desk and find the combination to the wall safe that Grandpa Joe had written out for the lawyer. Dave memorizes it, then comes to Ruthie's side. With no one the wiser."

I saw Ruthie cut her eyes over at her brother, as though struggling to believe what she was hearing.

Isaac sat forward, hands on his knees. "The next part of the plan required that Dave arrive at the old house some time before the others. Using his key—which of course he *hadn't* misplaced—he goes into the house, opens the safe and takes out the envelope containing the new will."

"Hold on, Isaac," Fred said. "I *saw* that envelope when Walter took it out of the safe. It was still sealed. But you're implying Dave somehow tampered with it..."

"He did," Isaac said. "By use of one of the oldest tricks in the book. I believe Dave took the envelope into the kitchen and unwrapped Grandpa Joe's old teakettle..."

He turned to Ruthie. "Remember how confused you were when you went back to the house last night? You mentioned the 'cooking things.' You said you thought you'd wrapped them on Thursday afternoon, and yet when you glanced into the kitchen some of them were unwrapped. That suggested to me that one of those items might be the old teakettle you'd alluded to earlier...."

"This is outrageous," Uncle Dave announced, though by this point no one was paying him much attention.

"As I say, it's an old trick. Dave unwrapped the teakettle, filled it with tap water and set it to boiling. Then all he had to do was care-

fully hold the envelope over the whistling spout and steam it open. I can imagine his anger when he took out the piece of paper and saw, just as he feared, that Grandpa Joe had left the house to Ruth."

"I—I can't believe what I'm hearing," said Ruthie.

"That's because it's utter nonsense," Uncle Dave said.

Fred took a step toward him. "I want you to keep quiet now, Uncle Dave. Do you understand?"

Something in Fred's tone cowed the older man. He made a big show of squaring his shoulders indignantly, but he didn't say anything.

"If I may continue," Isaac said, smiling. "Here's where Dave got his second lucky break. Grandpa Joe had foolishly handwritten his new will, whose last sentence originally read 'I, Joseph Clarence Hastings, leave the house to Ruth.' It was easy, then, for Uncle Dave to add with his own pen the remaining letters necessary for the last word in the sentence to now read 'Rutherford.' I'm sure Dave brought with him last night a number of pens, of differently-colored inks, to make sure it was a close enough match to that used by Grandpa Joe."

I glanced over at Uncle Dave, who sat perfectly still.

"After that," Isaac went on, "Dave poured the water from the kettle into the sink and put it back on the stove. Then all he had to do was put the forged will back in the envelope, seal it again—perhaps with a glue stick, also brought along for that purpose—and return the envelope to the wall safe."

"But wait a minute," Fred said. "When Mom and I pulled up to the house, Dave hadn't even gone in yet. He was on the front porch, knocking at the door."

"Yes," said Isaac. "I can only wonder how long he'd been standing

there, knocking, waiting for you to arrive so that it would *appear* he'd not yet been inside the house. Again, for anyone who reads mystery stories as avidly as I, it's a familiar trick: you leave the scene of the crime, shut the door, then stand there knocking on it as though you'd been outside the whole time."

Isaac shrugged. "All Dave had to say when you finally showed up was that he'd lost his key. Why in heaven's name would you doubt him?"

"Yeah," Fred murmured. "Good old Uncle Dave."

"That brings us to the moment when you were all assembled in the living room," Isaac said, "and Walter Hicks takes out the will from the safe. Suddenly, the lights go out—"

"I had nothing to do with that," Uncle Dave said.

"For once, you're telling the truth. No, you didn't. As Fred later discovered, a breaker switch had flipped. But you weren't worried—after all, this sudden glitch wouldn't affect your plan. But something else might..."

Isaac leaned back, putting his fingertips together.

"Because here, at last, is where Dave's luck ran out. My guess is, when he'd poured the water out of the teakettle, he hadn't totally emptied it. He'd inadvertantly left a small amount of water at the bottom of the kettle, which he'd put back on the burner. A burner he'd also neglected to turn off. So that now, minutes later, as you all were about to hear the contents of the new will, the kettle finally came to a boil again and began to whistle. A long, single high note, sounding exactly like—"

"Grandpa Joe's train whistle," Fred said.

"Poor Uncle Dave," said Isaac. "He couldn't let Fred or Walter

Hicks go investigate the source of the sound. They'd find a whistling teakettle... one that Ruthie had thought she'd wrapped and put away. It might cause them to start asking questions."

"I think you're giving me too much credit," Fred said wryly. "I probably would've thought Uncle Dave had just boiled some water for tea."

"Really? But when did he do that? He was outside the house, claiming to have lost his key, when you and your mother arrived. As far as you, Ruthie and Walter Hicks were concerned, Dave hadn't been in the house before that."

Isaac smiled. "Besides, as Dave himself said earlier, he doesn't drink tea. Only coffee."

"Wait, I got a question," Bill chimed in. "If the electricity had gone out, how come the stove was still hot enough to keep the kettle whistling?"

"It was a gas stove, remember?" Isaac replied.

"Oh," Bill said. "Right. Never mind."

"Where was I?" Isaac paused. "Oh, yeah. Dave couldn't let either Fred or Walter go down that dark hallway to the kitchen. But then he had a brainstorm... Off of Ruthie's reaction to the whistle, and her belief that it was another manifestation of her father's ghost, Dave suddenly announced that *he* would prove her wrong. He would go investigate. So he went bravely off, before anyone could stop him, down the hallway, toward the kitchen..."

By this point, Ruthie was openly staring at her brother. But he wasn't returning her look.

"Dave knew he'd be swallowed up by the darkness," Isaac continued, "but still he had to act quickly. He went into the kitchen,

removed the kettle from the burner, which he turned off, then went back out into the hall. He'd supposedly just seen Grandpa Joe's ghost when a concerned Fred caught up with him. But, unfortunately, the apparition had conveniently vanished a moment before...."

Isaac smiled. "Now here's the beauty part. Dave not only claims to have seen the ghost of Grandpa Joe, but he's the most vocal in discounting that fact. 'I must've been seeing things,' he says. 'This can't have happened,' and so on. Nothing makes a person more convincing than when he himself seems reluctant to be convinced."

We all fell silent.

"Well, *I'm* convinced," Bill said finally.

Then, to my surprise, Ruthie turned suddenly and slapped her brother across the face. Hard.

"You bastard," she said bitterly. "If you want the old house so much, you can have it. But I'll *never* forgive you for this."

R. David Hastings just stared. "The house? You think I want that dilapidated piece of shit? It's not the house, you silly bitch. It's the *land.*"

"Boy, you have an inflated view of the real estate market," Fred said. "Especially in that area."

"No, my dear nephew," Dave said coldly, "it's you who are misinformed. Thanks to certain friends of mine down at City Hall, I happen to know they're planning to run a freeway spur through that part of town. Exactly where the old house is standing, in fact. That land will soon be worth a fortune."

"Not to you," Mark said. "You're toast... Rutherford."

Now it was Uncle Dave's turn to look smug.

"Not at all. None of what this old fool claims can be proved. None of it! Even if I *did* pretend to see a ghost, is that a crime?"

"No," replied Fred, "but tampering with a legal document is. And Grandpa Joe's new will, though handwritten, is still legit. He had it witnessed, remember?"

"So what?"

"So." Mark picked up the thread. "A forensics lab will be able to ID the glue you put on the envelope, as well as the traces of the original envelope sealant removed by the steam. Then there's your handwriting. Though I'm sure you knew your father's handwriting well enough to match it, I'll bet handwriting experts will be able to detect subtle differences between the letters making up the name 'Ruth' and those comprising the remaining letters."

"Not to mention the inks," Fred added. "Even if you think you matched the ink color, forensic experts can isolate chemical differences in types and brands of ink."

Bill shook his head. "Man, *CSI* has really raised the bar on this kinda stuff, eh?"

"At the very least," I said, summing up, "it's pretty clear there'll be an investigation."

"Which means," Mark said to Uncle Dave, "I think we can safely stick with the 'toast' analogy, when it comes to your chances of cashing in on this little scam."

By now, Uncle Dave had begun looking a bit ill.

"Well," his sister said, glaring at him, "what do you have to say for yourself?"

I have to give him this: good old Uncle Dave managed to rally somewhat. He coughed, got to his feet and bowed to his hosts.

"Thank you all for your hospitality," he said. "I think I can see my way out."

With that, he turned and strode out of the room, and then out of my house. Moments later, I heard his car turn over in my driveway.

Ruthie looked puzzled. "But he was my ride."

Fred bent and kissed her on the cheek. "Don't worry, Mom. I'll give you a lift home."

As he helped her to her feet, she smiled at Isaac.

"Thank you, Isaac. Though I must admit... well, I am a little disappointed. I so wanted some sign that Daddy was still with us. Still... watching over me..."

Isaac rose and took her hand.

"Who's to say he isn't? After all, it's just my opinion that you'd fallen asleep and dreamed that you saw him. Maybe you actually did. Then there's last night... Doesn't it seem oddly coincidental that the lights would suddenly go out, and the teakettle would whistle, so that Dave would have to improvise some way to explain it... and thus reveal himself?"

Ruthie's eyes glistened. "I... I hadn't thought of it like that. You might be right, Isaac. Thank you."

Then, to my astonishment, he bent and kissed her hand.

"My pleasure, Ruthie," he said. The old rascal.

"My thanks, too, Isaac," Fred said, as he led his mother out of the room.

"Well, good work, Isaac," Mark said. "Again. Sometimes I wonder why the rest of us even bother to show up."

"Don't be bitter," Bill said.

I turned to Isaac. "That was really nice, Isaac. What you said to Ruthie before she left."

"I wasn't trying to be nice," Isaac answered. "Not my style. I merely

expressed what I believe to be true."

"Which is—?"

"Which is... you never know."

With that, he picked up the kettle from the side table and headed for the kitchen.

"Anyone for tea?" he asked.

End

Body Of Evidence

When it comes to solving mysteries, it isn't unusual for the Smart Guys Marching Society—with the exception of Isaac, of course—to be totally at sea. Though I must admit, until one particular Sunday afternoon last spring, I never thought this would be *literally* true...

"Man overboard!" cried Bill, our resident actor and theater director, leaning over the port rail and pointing to the choppy waters beyond.

"Jesus, you're a moron," Fred said, sitting miserably on a bench near the cabin door. The usually unflappable lawyer was wrapped in a thin blanket, face half-hidden behind a scarf tied at his throat. Poor guy had been fighting nausea since we left the marina.

Bill turned at the rail. "C'mon, I've always wanted to say that. Oh, yeah, and 'Land ho!'"

Mark adjusted his dark-framed glasses, which looked particularly severe today, shielded beneath a Dodgers cap. "I swear, it's that damned *Pirates of the Carribean* ride. Scars kids for life."

Mark was prowling the deck, intently checking out the few other boats in the vicinity. Though I didn't have the heart to tell him that his new white deck shoes were doing major damage to his image as a hard-nosed journalist.

Instead, I sat down beside Fred. "You want some Dramamine? My wife gave me extra."

He sighed. "I want to be back on dry land, where civilized humans belong. In nice offices, and bars and court rooms. Places that don't rock up and down."

Isaac stood at the railing with Bill, looking out at the waves. "Sorry you're seasick, Fred. Luckily, I got my sea legs many years ago, when I worked on a cargo ship."

"Of course you did," Fred murmured into his scarf.

It was a beautiful day out on the water, about nine miles from shore. Clouds towered like giant white shoulder pads, glazed by the dazzling afternoon sun. There was a sweet breeze rippling the twin sails above us, and the 40-foot yacht on which we were guests was being piloted from the foredeck by a veteran sailor hired just for the occasion.

In other words, it should have been one of those perfect California days, made famous by teen melodramas on Fox, sports car commercials and travel brochures. And, despite Fred's discomfort, it would have been, except for one undeniable fact: we were here because of a crime.

In fact, a series of crimes—so baffling that, as the facts were laid before us the rest of that afternoon, I wondered if even Isaac would be able to sort things out.

But I'm getting ahead of myself.

Sitting on deck on a luxury yacht, drinks in hand, the distant outline of Marina del Rey sparkling like a necklace behind us, it was as perfect a setting as a meeting of the Smart Guys could aspire to.

Not to mention the buffet. Brought aboard before we shoved off by two smiling guys in white crew jackets, it was not only varied and delicious, it was *free*—compliments of the yacht's owner.

"Now this," Bill had proclaimed as we first shoved off, sipping a piña colada and waving to the poor saps gawking at us from shore, "is the life."

Mark had made a quick inspection of the yacht, admiring the rich sheen of the hardwood decking, the polished brass of the cabin's exterior fixtures, the silken purr of the motor taking us past the breakwater.

"Wonder how much this baby goes for?" he'd asked at last, stretching out on the deck lounge. He took a swig of Corona Lite and squinted out at the water. "I mean, ballpark figure."

"Trust me, you can't afford a ticket to that ballpark," replied Bill. He was standing at the build-it-yourself taco spread, getting needlessly creative.

"C'mon," I said, nodding at his heaping plate of goodies, "we're not even under sail yet. Besides, shouldn't we wait for our host to appear before we attack the food?"

"Speaking of which," Isaac said, zipping up a faded Windbreaker that looked older than I am. "Where is our host? Not that I'm complaining, but…"

"Here I am," came a voice from below deck. We heard the sound of footsteps climbing upward, toward us. Then we all turned as one as the cabin door opened.

And out stepped the most beautiful woman I've ever seen in my life.

It had started out, three hours earlier, at my place, like any typical meeting of the Smart Guys. Bill had begun sampling the snacks even before I finished laying out the various cheese platters, baskets of chips and my wife's sister's new "crispy spinach" appetizer (don't ask).

Fred and Isaac were settled into their usual spots on my couch and corner armchair, respectively, and chatting amiably about the latest celebrity assault-and-battery case on the news. Some macho TV star had attacked his ex-wife's live-in "life coach" and broken his nose.

Our only missing member was Mark, who'd phoned earlier and announced he might have something special on tap for today's meeting. I'd hoped he was talking about imported beer, since the supply in my fridge was low, and I was saving my last two bottles of cabernet—the *good* stuff—for dinner with my in-laws, who were scheduled to arrive later in the week from the Midwest.

As I settled in my seat at last, understandably exhausted from my culinary labors and savoring a Dos Equis Lite, I tuned in to what Fred was saying to Isaac.

"That's where the cops made their first mistake," he explained, wielding a Dorito chip with conviction. "Without a warrant, there was no way the judge would allow the marijuana found in the car. The search was illegal, so the evidence is inadmissable. Fruit of the poison tree, as they say on *Law & Order*."

Bill smiled. "That's where Fred gets all his legal information."

Fred scratched at his trim, reddish-brown beard. "No, just the nifty jargon. Plus I get to fantasize about having a hot new female

protégée every year or two."

We'd just begun discussing what topic area might make for a spirited debate that day when my landline rang. It was Mark.

"What's the word?" I asked, hoping the answer would be Heineken. At least a six-pack.

"The word is, it's a go." Mark's voice carried its usual authoritative zeal. "The meeting is moving. Get everybody down to Marina del Rey, the docks near the yachting club. And make it fast."

"I live to serve," I said, sighing. "Anything else, Captain Bligh?"

"Yeah. Bring sunscreen." He hung up.

Which is how the Smart Guys Marching Society ended up lounging on the sun-dappled deck of a luxury yacht, riding a lolling sea off the coast of Southern California, being introduced by Mark to the blonde, 20-something goddess who'd just joined us on deck.

She wore a flowing wraparound skirt and a tight, midriff-baring white shirt that emphasized her smooth, sculpted curves. Her feet were bare, nails painted a frosted pink. Her name was Lisa Norton.

"Thanks so much for doing this, guys," she was saying, smiling against the sun glare. Her beautiful, open face was shaded by a wide-brimmed straw hat. "Especially on such short notice."

"Our pleasure," Fred said. I swear he almost bowed.

Not that I have a right to judge. To be honest, it was pathetic—four middle-aged married men, gawking like awestruck teenagers as Lisa gracefully pulled up a chair. Tanned and glistening, she had the warm smile of a beauty contestant and the gym-toned body of a fitness model.

Only Isaac, rising to shake her hand, seemed less smitten than

intrigued by our hostess. Until she searched his face with those liquid blue eyes, as though looking for a kindred soul, and even his old gaze softened. Then, his face oddly unreadable, Isaac sat back down again.

As Fred and Bill took turns offering Lisa various drinks and tidbits from the buffet, Mark settled in his own chair and sat forward.

"Guys," he said, "believe it or not, there's a reason we're doing this on a boat, out on the ocean."

Bill savored his drink. "You mean, a reason beyond the sheer decadence and coolness-factor? Not that I actually need one... but, sure, let's hear it."

Mark shook his head. "I'll let Lisa tell her own story. I just wanted to explain how we met."

"To hell with *us*," Fred said. "How are you going to explain it to your wife?" His mood having suddenly improved, he pulled off his blanket and scarf, to reveal his standard attire of polo shirt and pressed shorts.

"Very funny." Mark turned to Lisa. "Sorry. They don't get out much."

Her smile was both understanding and self-assured. I had the feeling that our reaction to her was just a daily occurrence, to which she'd long become accustomed.

"Anyway," Mark said evenly, turning back to the rest of us, "I got a call yesterday from Lt. Steve Hartwell, that cop buddy of mine you guys met once. Remember?"

"Sure," I said. "Looked like a linebacker. Engaged to that nice public defender. Carolyn Something."

"They're married now," he said. "But the point is, he called because Lisa had first gone to the police with her story. Which, I

must admit, they initially discounted."

"Let's be honest." Lisa looked at Mark. "They thought I was crazy. Either that, or some kind of publicity-seeker. One officer I spoke with actually referred me to a mental health clinic."

Then, to my surprise, her face fell. "Not that I blame him. I barely believe it myself."

Mark nodded sympathetically. "To her credit, Lisa persevered, and was finally transferred to Hartwell's desk. He's as baffled by her story as anyone, but at least he decided to give her the benefit of the doubt. Remembering how helpful we'd been before—"

Here he paused and nodded at Isaac. "Well, at least how helpful *one* of us had been... Anyway, Steve gave me a call and suggested that Lisa meet with us. That maybe we'd be able to make some sense out of the whole thing."

Bill gave her an encouraging smile. "We'll certainly do our best."

I took this as my cue. "So, Lisa, how would you like to start? Perhaps you could tell us a little about yourself to get things moving."

She nodded. "Not much to tell. I was born and raised here, in Santa Monica. Went to UCLA as a business major. For the past four years I've worked as a sales rep for a pharmaceutical firm."

"She's done pretty well, too," Mark added. "Lisa told me earlier she's vice president of her branch office. Manages a half-dozen employees."

"It's a great group," she said. "All solid, hard workers, especially my newest guy. Kenneth Jarwin. Guy's a real dynamo, always angling for more face time with me. He says he wants to learn everything I know about the business." She laughed. "Which is sales-speak for he wants to steal my job."

"Kenneth isn't harrassing you, is he?" Bill asked.

Here, Lisa tilted her chin up. "Oh, no. Nothing like that. Besides, my boyfriend's a personal trainer and third-degree black belt. Kenny's ambitious, not stupid."

"Oh," Fred said quietly. "Your boyfriend."

I could swear, at that exact moment, a huge cloud passed overhead, dimming the sun.

"Yes. Jack." Lisa took off her hat, and tossed her luxurious hair. "I met him last year when I needed help training for the Ironman triatholon in Hawaii. I was determined to place better than third when I did it again this year." Her eyes shone proudly. "We've been together ever since. He's very... motivating."

By this point, Bill was chomping noisily on some blue corn tortilla chips with what can only be described as a passive-aggressive intensity. But I digress.

"Anyway," Lisa went on, "up till last Saturday, everything was fine, though I miss Jack terribly. He's on a spiritual retreat in the Amazon rain forest, totally cut off from all contact with the world. So, as you can imagine, it's been pretty lonely at night in the condo. And, then, to have all *this* happen..."

She paused, as though hesitant to go on.

"It's okay," I said, in my best clinical tone. "Take your time. Now, what happened last Saturday."

Lisa paused again, gathering her thoughts. "That was the day of the regional sales conference, a week ago yesterday. So that would be last Saturday, March 24th." A rueful grin. "I'm kinda anal when it comes to numbers. Dates and times. Goes with the job, I guess."

"An admirable trait, in my view," said Isaac.

I glanced over to find him sitting contently on his deck chair, sipping a Diet Coke. Up until that point, to be honest, I hadn't even known if he'd been listening.

"Was it an all-day sales conference?" Fred asked.

She nodded. "Yes, and all my people attended. The whole office. Afterwards, I got a ride back to my place with Kenneth Jarwin. So naturally I invited him in for a drink, and to discuss the day's activities."

"How long did he stay?" Mark asked.

"Till about ten, I guess. We had a couple of glasses of wine each, went over some paperwork we'd need for the following Monday, then he left. I was pretty tired after the long day, so I undressed and went to bed. Oh, but I did have another glass of wine. Right before."

"Is that important?" I said.

"I think so. Because—well, I'm usually a pretty light sleeper. But that night, I slept like a log. Then, when I got up the next morning..."

"That would be last Sunday," Fred said.

"That's right. When I got up and went into the bathroom, I saw something in the mirror. I sleep naked, of course, and—"

"Of course," Fred said.

"Who doesn't?" Bill added.

Lisa seemed oblivious, intent on telling her story.

"Anyway, when I looked in the mirror, I saw this..."

She sat up straighter, and lifted the sleeve of her shirt. There, right where her toned upper arm met her shoulder, was a faded tattoo. In black ink, formed of block letters, it spelled out just one word: "Glendale."

At her nod, we all leaned in, peering at the tattoo.

"Glendale?" Bill said. "As in, the city of Glendale?"

"Believe me," Lisa said breathlessly, "I had no idea what it meant. And certainly no idea how it got there. Though I realized right away there was only one possible answer... Somebody had gotten into my room and put it on my arm while I slept."

"And you didn't wake up?" Mark looked dubious. "I know a little about tattoos. They require needles. And they hurt like hell."

"I know." She shifted in her seat to give us a better look at her arm. "But, look... it's not a real tattoo. It's been stenciled on. Like one of those fake, press-on tattoos. But with some kind of indelible ink. And I oughtta know, I spent an hour frantically trying to scrub it off. That's why it's so faded now. But that morning when I first saw it, it was shiny and fresh."

"But who could've done it?" Fred asked. "And how did he or she get into your place after you went to bed?"

"That shouldn't be too hard to dope out," Mark said.

"Lisa, who has a key to the condo?"

"Besides me, just Jack and my father, who lives in Bel Air. But he's in New York on business at the moment."

"Nobody at work?" I asked.

She pondered this. "One time, two months ago when Jack and I went to Rio, I asked Kenneth to drop in a few times and water my plants. I remember I gave him a key."

"Did he give it back?" Bill asked.

"Now that you mention it, no... I mean, I don't think so." Her brow furrowed. "But it couldn't have been Kenneth. That's... that's crazy."

"But didn't you say you slept soundly all night?" I reminded her.

"And that this was unusual? Maybe he slipped something in your wine glass, right before he left. You did tell us you had another glass before going to bed. Maybe there was some kind of sleeping drug in there."

"That's funny," she said, "because when I went to clean up from the night before, I noticed there was some kind of sediment in the bottom of the glass. Dregs from the wine or something."

Fred waved his hand. "But wait a minute... what about the tattoo itself? 'Glendale?' What does it mean?"

"Maybe a practical joke," I suggested.

"I wish." Lisa's voice grew firmer. "Because later that morning, I saw a breaking news story on TV. The night before, some men had broken into the Glendale Savings and Loan. They'd gotten into the safety-deposit boxes and escaped with a load of cash and valuables."

"Hey, I remember reading about that in the paper," Mark said. "There was a follow-up story just a couple days ago. The cops never caught the guys."

"That's right," Fred said. "I saw something about it on the news myself."

"Jesus, Lisa," I said. "After that, you must've really been shaken up."

"Tell me about it." She shook her head. "I didn't know what to do. It seemed... incredible. Crazy. I thought of calling the police. But what could I tell them? That somebody had snuck into my bedroom and tattooed the word 'Glendale' on my arm while I slept? And that it must have happened at about the same time crooks were robbing the Glendale Savings and Loan? I mean, who'd believe it? Hell, *I* didn't believe it..."

"You could've shown them the tattoo," Bill said.

Fred frowned. "They'd just think she did it to herself, or had a

friend do it for her. That she was just some kind of... well..."

"Some kind of nut," Lisa finished for him. "Exactly."

"So what did you do?" Mark said.

"Well... to tell you the truth... nothing." She sighed. "I guess I hoped some friend or other would finally confess to the prank. And that maybe the fact that the tattoo said 'Glendale' was just a weird coincidence."

She brushed her hair back from her sweat-sheened forehead. The sun was beating down harder now. I could feel its bite on the back of my neck.

"I know, it makes me sound like an idiot...." She looked over at me. "Or else the Queen of Denial. But I honestly didn't know what to do... so I didn't do anything. And then, that very next night—"

Fred stared. "You're kidding."

She shook her head. "Even though it was a Sunday, there were some papers I needed at the office, so I drove over to get them. It was about five in the afternoon. As I expected, the office was empty... except for Kenneth. He explained that he had some extra work he wanted to get done himself. We exchanged a few words while he helped me find the papers I was looking for. He even put them all together in a manila envelope and handed it to me. Then I went home to grab a bite and do a little work. Before long, I felt kinda sleepy, so I thought I'd lie down on the couch... just to rest my eyes, you know?..."

"You fell into a deep sleep," Mark said.

"Did I ever," she said. "And I didn't wake up till the next morning. Monday morning. I was still in my clothes from the night before, so I went into the bathroom to take a shower. But when I started to

undress..."

"No way," Bill said, eyes wide.

She took a breath. "I—I know this is weird, but I guess I better show you."

Without another word, she peeled off her shirt to reveal a skimpy bikini top. To a man, all we could do was just... stare. Whether in response to the sight of her full breasts, or to the fact that tattooed across the top of the left one was another word in block letters, I couldn't exactly say. Maybe a little bit of both.

Lisa stood then, and reluctantly pointed to this new tattoo. It read "Hauser."

"Hauser?" Bill was the first to find his voice. "What's that mean?"

"I had no idea," she said. "I couldn't believe it... It had happened again, while I slept on the couch. But I was in my clothes! So how did he—whoever he is—how did he do it without my knowing? You see what I mean? Somebody had to sneak in, unbutton my blouse, stencil this tattoo on my breast, and button up my blouse again."

She looked achingly from one of us to the other.

"I know it all seems... I don't know, funny or something... but not to me. I was more freaked out than ever. Especially when I turned on the morning news—"

"And saw the story about Hauser Ford," Fred said evenly. "I saw it, too. The Hauser Ford dealership on Lankershim was vandalized during the night. Office ransacked, two SUVs stolen and taken for joyrides. They found the cars later, abandoned, in East L.A. The cops figure it was an inside job, since the alarm had been disconnected."

"I remember reading that story, too," Mark said. "No leads on

those perps either."

"So the tattoo predicted... another crime?" I said.

Lisa nodded. "I know, the whole thing sounds crazy. By now, I started to think *I* was crazy. But more than that, I was scared. Really terrified, you know? I mean, what if this wacko did it again, and tried to hurt me? Or even—"

She put her hands to her face. "I didn't know what to do. I couldn't call my friends—they'd think I was just kidding or something. I couldn't even reach Jack—out in some jungle somewhere...."

Bill shook his head sympathetically. "Men can be so selfish sometimes."

I gave him a look. *Puh-lease.*

Meanwhile, we couldn't help but notice the tears welling in Lisa's eyes. "For the first time in my life, I felt alone," she said softly. "Vulnerable..."

She sat back in her chair and composed herself.

"Do you feel you can go on?" Fred asked, offering her a glass of sparkling water.

She nodded stiffly, then took a sip of water.

"You're all being so kind," she said. Then she wiped the tears from her eyes. "I must look terrible."

"Hideous," Fred said, grinning.

Lisa laughed appreciatively. Then, as though to pull herself out of the doldrums, she sat back and stretched languorously. Fred and I exchanged guarded looks.

Finally, after a long, awkward silence, Mark stepped up to the plate.

"Was that the end of it?" he asked her.

Her mood grew somber again. "If only it was. Like I said, I didn't know what to do. I was too scared to leave the condo, but, at the same time, afraid to stay... you know what I mean? Finally, I forced myself to go to work. But everybody could tell I was upset about something. My secretary Josie kept asking me about it, so I pulled her into the ladies room with me and showed her the second tattoo. This one over my left breast."

We all knew which one she was referring to.

"What did she say?" I asked.

"Josie just started laughing. She said she loved it and wished she had the balls to do it herself." Lisa managed a smile. "I knew then that I wouldn't get anywhere telling her the real story. She'd never have believed me."

She sat forward, hugging herself tightly. "But I also knew I couldn't go home alone that night. Not to my place. So I booked a room at the nearest Marriott."

"What happened that night?"

"Nothing. I hardly slept, of course. I'd double-bolted the hotel room door, checked the windows, all that. But I figured I had to be safe. Nobody even knew where I was."

"Not even from work?"

"Well, I had to tell Josie and Kenneth. In case something important came up. But like I said, nothing happened that night. I woke up and checked myself out, front and back view, in the bathroom mirror. No new tattoo."

"Did you go back to your place then?"

"No. I didn't want to push my luck. So I stayed at the Marriott another two nights, without incident. And then...well, I guess that

brings us to Friday night..."

The hot sun had continued to bake the deck. We were all sweating profusely now, wiping our brows and digging in the mini-fridge under the buffet for more drinks.

Lisa polished off her sparkling water and looked searchingly from one of us to the other.

"We'd had a birthday party in the office Friday for Josie, so things didn't break up there until about eight. I guess I'd had a bit too much to drink, because Kenneth offered me a ride back to the Marriott. On the way, he kept asking me why I was staying in a hotel, so finally I told him I was having some work done on the condo. Since Jack was away, it was a perfect time."

"Did he believe you?" Mark asked.

"I think so. Anyway, he walked me up to my room and I opened the door."

"Did he come in with you?"

"No. We chatted for a minute or two in the doorway, and then he shook my hand and said how grateful he was for all that he'd learned working with me. I was a bit taken aback, I guess, but then we said good night and he left.

"I stripped for bed and lay down, but my head was swimming a little from the party and I couldn't get to sleep. I picked up the TV remote and channel surfed until I found something soothing. It was an old black-and-white movie on PBS, Orson Welles doing some Scottish play... Anyway, the next thing I knew, it was morning. I'd slept through the night."

"Oh boy," I said. "I'm almost afraid to ask."

Lisa looked down. "I know. The moment I woke up, I was in a

panic. I ran to look in the mirror, and... well..."

She sighed, and slowly got to her feet again. As we all watched, transfixed, she unfastened the long silken skirt to reveal a miniscule thong. Now she stood wearing nothing but the skimpiest bikini I'd ever seen, and a look of sheer terror.

With a trembling hand, she pointed to a spot on the top of her thigh. There, in the same black ink, was another stenciled tattoo. It read "Nelson."

Before any of us could speak, she burst into tears again. Real, choking sobs this time, her face in her hands.

"I don't understand!... How did he find me at the hotel? How did he *do* it? And *why*? Why *me*?"

I turned to Mark and Fred. "Does the name 'Nelson' mean anything to you guys?"

"Hey," Bill snapped, "what am I, chopped liver? I watch the news just like everybody else. Man, just 'cause I'm in the arts, I gotta take shit—"

"Chill, will ya?" Mark lifted his cap and swept his hand through his sweat-beaded hair. "Yeah. I know the name. Nelson Electronics, in Burbank. They got a store the size of a city block. There was a break-in."

Fred took a long pull on his Corona Lite. "That's right. The night manager got robbed at gunpoint late Friday night. The crooks got away with cash and as much high-end computer stuff as they could pile in their van."

"Their *blue Chevy* van," Bill said with emphasis. "I happened to watch a very detailed report on the local CNN channel yesterday. Right after an interesting documentary on political turmoil in South

America. Anybody else happen to catch that?"

I ignored him, keeping my eyes trained on Lisa. She'd seemed to deflate suddenly, collapsing back into her seat, head bent over her knees. Her rich blonde hair curtained her face, so that her soft weeping was even more muted.

Fred leaned toward her attentively.

"I know how frightening this has been," he said.

"You *don't* know," she said fiercely, between sniffs. "You *can't...*"

"That brings us up to yesterday," Mark said quickly, in an attempt to keep us on task. "Saturday morning. What did you do then, Lisa? After you saw this new tattoo?"

She finally looked up, beautiful face streaked with tears. "I—I was almost afraid to turn on the news, but I did. And before long, I saw the story about the robbery at Nelson Electronics. That's when I knew I had to go to the police. So I did."

Lisa sat up straighter then, trying to compose herself. As though to cover the tattoo on her thigh, she slowly crossed her long, tawny legs.

"As I told you already, the first officer I spoke with thought I was some kind of publicity-seeker," she went on. "He said they often have people coming in after a big crime, claiming to know something about it. He said, 'Yeah, we get wing nuts like that in here every day. Though they usually don't look like you.' Then he made a pass at me."

"Oh, great," Fred said, sighing.

"Finally he sent me to another officer, the one who suggested counseling. He was a lot nicer. But I just hated that nobody believed me, so I insisted on seeing somebody higher up. That's when I was sent to Lt. Hartwell."

She looked over at Mark. "I don't think he believed me, either.

But at least he called you, to see if you and your friends might be able to help."

"We're glad you did," I said.

Mark adjusted his glasses. "When Lisa and I spoke earlier, she told me she'd contacted her father in Europe and arranged to sleep here on his yacht at the Marina last night. And you did, right, Lisa?"

She nodded. "Yes. But I drank three cups of coffee and stayed awake till dawn. Probably why I look like such a wreck today."

"Yeah, probably," Bill murmured.

"But that doesn't solve anything," she said. "I can't stay awake forever. So I thought I'd have Dad's pilot take the yacht out today. That I'd spend the night miles away from shore, on the ocean. Nobody can get to me tonight."

A long pause. "At least, I hope not. I don't think I could stand finding another tattoo on me."

"Not only that," Bill said. "Where the hell would he put it?"

I gave him another look. He just shrugged.

"So," Fred said to Lisa, "that's your plan? To sleep out here on the boat tonight?"

"Yes. I guess I hoped you guys might stay with me..." She looked away. "I mean, there's Captain Dan, Dad's regular pilot. He'll be in the wheelhouse. But I don't really know him. And if even *one* of you could..."

Here she leaned forward, face soft and open, eyes beseeching.

Fred cleared his throat. "Well, I'd like to, but I—I mean, I'm sure we'd all like to help, but..."

Mark folded his arms. "Wait a minute. I think your plan to stay out at sea is a good one, Lisa. At least for tonight. But let's not forget

our real purpose here, which is to figure this whole thing out."

"Are you saying you have some ideas?" I asked.

"Damn right I do," he replied. "For one thing, I think we all know who the creep is that's been doing this."

"We do?" Bill said.

"Sure. That Kenneth guy. Kenneth Jarwin."

"But how?" I asked.

"Think about it," Mark said. "The first night, working late with Lisa, he could easily have slipped something into her wine glass. Something that knocked her out. Then he comes back later, and—using the key she'd given him some months ago—apply that stenciled tattoo on her arm."

"Okay, I can see that. But what about the next time? Lisa had gone to the office to get some papers—"

"That's right. And who does she find there but our friend Kenneth? He puts the papers in a manila envelope and hands it to her... See what I'm saying?"

"No."

Mark sighed, impatient. "When I was in covert ops, we had all kinds of ways to drug or poison someone. All Kenneth had to do was apply some sticky, slow-acting drug to the edge of the envelope. So that when Lisa takes it, the drug is transferred to her hand. Couple hours later, back at home, she falls into a drugged sleep. And again, Kenny-Boy comes in and this time tattoos her boob—"

He glanced at Lisa. "Sorry. Left breast."

She shrugged, and waved it away.

"I see where you're going next," I said excitedly. "On Friday night, after Kenneth walks Lisa to the door of her hotel room, he gives her a

handshake, thanking her for her support and everything. But what if he had that same drug on his hand?... and so transfers it again to Lisa."

"Exactly." Mark adjusted his glasses importantly.

"But hold on," Fred said. "Why wouldn't the drug affect *him*, too? I mean, it's on his hand as well."

"Maybe it did," Mark answered. "But, remember, all he had to do was stay awake longer than Lisa. Just long enough to sneak into her hotel room and tattoo her thigh. Or maybe he's built up some kind of immunity to the drug. I've heard of operatives who've managed to do that kind of thing."

"Whoa," I said. "Another problem. How does he get into the hotel room?"

Mark smiled. "Probably the same way *I'd* do it. Hell, the same way I've *done* it. He just had to make nice with a maid he spotted in the hallway and, while she's distracted by his flattery, he lifts her master key. Boom, he's in."

Bill scratched his chin. "Okay, assuming he's the guy. Why is he doing this? And how the hell does he know about these crimes that are going to be committed? You saying he's some kind of psychic, too?"

"No," Mark replied. "And, you're right, I haven't yet worked out how he knows about the various crimes. At first I thought maybe he knew about them because he'd actually planned them. That he was some kind of criminal mastermind, with underlings who pull the jobs for him. If he knew about them in advance, he'd know what tattoo to put on Lisa."

"But again, *why*?" Bill insisted.

"I have a thought," Fred said quietly. "Remember, this Kenneth was pushy, overly ambitious. Lisa said herself she suspected he wanted

her job. Isn't that right, Lisa?"

She nodded. "That's what I've always thought."

"Then what better way to get it than to drive Lisa bonkers?" Fred took an egg roll from its bed on a spray of lettuce and popped it in his mouth. Apparently his bout of seasickness had ended.

"Think about it," he said, chewing thoughtfully. "Lisa starts to believe she's losing it, and has to resign her position. Maybe she sees a shrink who advises her to get away for awhile, take a long rest. And then who's ready to step up and take her place? Our boy Kenny."

Fred glanced expectantly at the rest of us. "Well? Is anybody else with me on this?"

"I don't know," I said. "Frankly, I still don't buy Kenneth as the brains behind a series of unsolved crimes. I mean, what is he, Professor Moriarty? Besides, there had to be easier ways to get Lisa's job, right? He could file a phony sexual harrassment suit or start horrible rumors about her. But to orchestrate all this...?"

There was another long silence, as we sat in the sizzling heat and lazily rode the waves. Lisa, calmer now, leaned back in her chair, undeniably striking in her brief bikini, a vision of vulnerable sensuality.

Finally, as if breaking a spell created by too much sun, sea and skin, Mark turned to Isaac, who'd sat in his customary silence throughout almost all of Lisa's story.

"Well, Isaac," Mark said. "I can't help but wonder... What do *you* think?"

Isaac stirred, as though from a half-doze, and blinked in the wicked sun. Then he leaned forward in his deck chair and smiled at Lisa.

"I think, my dear," he said, "you have a wonderful career ahead of you."

"In pharmaceuticals?"

"In show business, of course. You're a wonderful actress."

She started. "What—?"

"And I trust you'll get all the help you'll need from our friend in the theater here," he continued, turning to Bill. "Since *he's* the one who put you up to all this."

Bill stiffened, eyes wide. "Now wait a—"

Isaac chided him with an archly raised eyebrow.

Then, to my utter amazement, Bill suddenly broke into gales of laughter.

"Goddammit, Isaac, you *got* me!"

"What?" It was Mark, clearly as stunned as I.

"You mean—?" Fred was on his feet, open-mouthed.

By then I'd turned back to Lisa, who was laughing now herself. Beautifully, of course. Perfectly, in fact. But unquestionably... laughing.

Meanwhile, Mark had taken a menacing step toward Bill.

"But how did you—?" Mark was actually sputtering. "If this was just some kind of act, how come Steve Hartwell called me about Lisa, and—"

Isaac sat back, hands behind his head. "Because your friend the lieutenant was in on the gag. I suspect Bill had no trouble talking him into playing a little trick on you."

"None whatsoever," Bill replied. "He said he only wished he could be here to see the look on Mark's face."

"Some friend," Fred said sourly.

By this point, Lisa had fastened her long skirt around her waist again and slipped on her shirt. Isaac nodded to her appreciatively.

"It was a clever ploy, Bill," he said. "Using a young woman so stunning, we'd be both distracted and hell-bent on helping her. And of course, the strange story itself... especially the mysterious tattoos that required her to keep shedding her clothes, down to a bikini."

Bill beamed. "Nice, eh? A brilliant directorial touch, if I say so myself." He looked over at Mark, Fred and me. "First rule of the theater: know your audience. I knew you guys would just drool and go stupid."

Fred glared at him. "You are *so* dead, man."

"Maybe. But, just in passing, I'd say you gentlemen aren't gettin' enough at home."

Mark turned to me. "*I* say we toss his ass overboard."

"Works for me," I said.

Lisa stepped toward Bill, smiling at the rest of us. "God, you should've seen your faces when I started showing you the goods. I swear, I almost lost it a couple times."

Isaac nodded. "They were indeed putty in your hands."

She eyed him wryly. "Hey, don't think I didn't see *you* checking me out, mister. You're not dead yet."

"Guilty as charged." And he looked it, too.

Bill popped open another beer. "So, Isaac, my man. Did you get all of my clues?"

"What clues?" I asked.

"There were a number of hints planted throughout Lisa's bizarre narrative," Isaac explained. "For one thing, Bill was careful enough to have the tattoos point to specific *real* crimes, things we'd have seen on the news."

Bill favored us with another smirk. "Second rule of the theater:

verisimilitude. That means, using the kind of legit details that give credibility to your story."

Mark grunted. "Yeah, we know what it means."

"Moreover," Isaac went on, "Bill wisely selected only *unsolved* crimes, so that no information would likely come out to contradict whatever theories we might come up with."

"Like Kenneth Jarwin being a criminal mastermind," Bill said, chuckling. "He'll love that."

"He's a real person?" Fred said.

"Yeah, my stage manager. I couldn't resist."

Isaac sighed. "Apparently, you also couldn't resist tweaking us a little about Lisa's boyfriend, Jack. Come on... a spiritual quest in the Amazon rain forest?"

"I bought it," I said, defensively.

Lisa shook her head. "Believe me, Jack couldn't find the Amazon on a map. Not exactly his skill set, if you know what I mean."

"So at least he's really your boyfriend?"

"No, my husband." With that, she took a preposterously huge diamond ring from her shirt pocket and slipped it onto her third finger, left hand.

"Your husband?" Mark said.

"Yeah. And he can't wait to meet all of you. He'll be waiting at the dock when we get back."

"Look forward to it," Mark grumbled.

Bill sipped his beer. "Jack really is a trainer and martial artist, too. But just for the love of it. He's the heir to some mining fortune. Worth millions." He swept the deck with a sweep of his hand. "This is *his* boat, in fact."

As we were still letting this sink in, Isaac turned again to Bill.

"I think my favorite clue was when you had Lisa describe what happened Friday night at the hotel."

"I hoped you'd get that one," Bill said.

"What about it?" I asked. "Lisa said she couldn't sleep, so she ended up watching something on PBS."

"Yes," said Isaac. "Lisa said she saw Orson Welles in 'some Scottish play.' Of course, I knew instantly then that she was an actress. Actors are notoriously superstitious when it comes to Shakespeare's *Macbeth*. They refuse to even say the name."

"And *you* shouldn't have," Lisa said seriously. Then she reached for a saltshaker on the buffet table and tossed a pinch of salt over her shoulder.

Isaac watched her with bemusement. "Even the fact that you said you tried to scrub the first tattoo off suggested the play to me. As Lady Macbeth says, 'Out, damned spot.'"

"All part of the script," Bill said. "Though I did wonder whether you'd get that subtle reference."

"The point is," Isaac went on, "once I knew for sure that Lisa was an actress, I suspected that Bill might be behind the whole thing."

"Well, I've known Lisa for years," Bill explained. "I'm directing her now in a production in Long Beach. She's a wonderful actress, as you could all see. And a helluva good sport."

She smiled demurely. "I guess I love a challenge. Besides, it was such a great part, how could I say no?"

"And you pulled it off brilliantly," Bill gushed, offering her a celebratory glass of champagne.

"Thanks," she said. "Though I can't wait to get home and wash

these fake tattoos off. They're hardly indelible, of course, but they can be stubborn."

"I suggest a drop of baby oil," Isaac said helpfully.

By now, the sun had begun to slide toward the horizon, so Lisa went forward to tell Captain Dan to turn us around and head back to the marina.

On her way, she looked back at us over her shoulder. "Thanks, guys. Best acting exercise I ever did."

As soon as she left, Mark looked pointedly at Bill.

"Okay, you got us. I just have one question: why?"

Bill shrugged. "I don't know, I thought it'd be funny. Plus, I figured the occasion demanded it."

"What occasion?" I asked.

It was Isaac who answered. "Think about it. Remember how specific Lisa was about the date on which she received the first tattoo? She said it happened last Saturday, March 24th. That was a nice touch, too, Bill."

Bill bowed in his seat. "Great minds think alike."

"What do you mean?" I said.

"We've had such an eventful day," Isaac said, "I suppose none of you noticed today's date. If last Saturday was March 24th, and yesterday was Saturday the 31st, that makes today—"

"April 1st!" Fred said, groaning.

"That's right, fellow Smart Guys," Bill said, with a deeply satisfied grin. "April Fool's!"

In the Wind

It was our first murder of the new year.

It was also the first time the Smart Guys Marching Society had gotten together after a lapse of almost four weeks. As usual, we'd had to skip most of the December meetings due to holiday plans with our families.

I remember very clearly that cool Sunday afternoon in January. Bill and Fred had both arrived a bit early. Isaac, wearing a new sweater my wife bought him for Christmas, had trundled in from our guest bedroom even earlier, and was engrossed in the Sunday *Times*.

"Great to get back to the old routine," Bill was saying, helping me arrange platters piled with assorted cold cuts on my coffee table.

Luckily, he'd done a deli run before showing up for the meeting. Since I'd spent the morning visiting one of my therapy patients in the hospital, I hadn't had time to put any snacks together.

Meanwhile, Fred was opening a huge, colorful canister of caramel

popcorn he'd brought home from his law office. It was a tin container the size of a cello case, painted to look like a giant candy cane.

"Client gift for the holidays," he'd explained as he angled it through my front door. "None of the partners wanted it, so I took it home."

"Great. So it's been sitting around for weeks," Bill said. "Stale, dried-out clumps of sticky, petrified carbs. Yum-yum. I'll pass."

"Let me guess," I said to Fred. "Your wife didn't want that thing taking up space in the house, so you figured you'd unload it here."

"Hey, I resent that," Fred answered, as he wrestled off the tin lid. "Truth is, it was scaring the dog."

He lifted the unwieldy canister and pointed its opened end toward Isaac, who sat in his usual corner chair.

"I'm afraid I can't," Isaac said. "My doctor has me on a strict diet. Edible food only."

"You guys are hilarious," Fred grumbled.

Bill smiled and popped open a brewski. "Hey, aren't we missing somebody? Where's Mark?"

"On his way," I said. "He called just before you two showed up. Oh, and he's bringing a guest."

Bill frowned. "Our first meeting in a month and he's bringing a stranger? Feels wrong, somehow."

"This is getting to be a habit with him," Fred said.

I pulled open a Tupperware container packed with broken, left-over Christmas cookies. Jolly Santas in green and red icing.

"He said he's working on a big story," I added.

"That's what he always says."

Fred propped the big canister against the arm of the couch and

leaned back in his seat.

"To hell with him. Let's get on with being smart. I read an interesting article the other day about the difference between faith and belief. Perfect topic for discussion as we start off the new year."

And it would have been, too, if Mark hadn't shown up just a few minutes later, accompanied by an unhappy homicide detective with a story to tell...

"Guys," Mark said, "this is Libby York, LAPD."

We all stood to welcome our guest. In her mid-30s, Detective Libby York was very pretty, despite her cropped black hair and sober, almost sullen eyes. Her smile was brisk and formal as Mark introduced her around. Though she looked slender in her jeans and oversized jacket, her handshake had a lot of muscle behind it.

"I've known Libby for years," Mark explained, as we settled into our customary seats again.

Libby laughed. "We used to be drinking buddies. The veteran reporter and the new chick cop, downloading the day's cargo of bullshit at the corner bar." She gave Mark a sidelong look. "You still hang out at our old place?"

"Yeah. Except now I have a couple beers and bitch about life with a fat vice cop named Farkus. But it's just not the same. Though it is nice to hang with someone who picks up the check once in a while."

Smiling, she casually flipped him off. Meanwhile, Fred was making room for her next to him on the sofa.

"Speaking of beers," I said to her, "can I get you something?"

"Nothing for me, thanks."

Mark took off his glasses and wiped them on his shirt.

"Libby's here because she's part of an ongoing murder investigation, and I thought maybe we could help her out."

"Yeah," she said. "In exchange for an exclusive interview if and when we close this thing."

Mark shrugged. "Hey, a guy's gotta make a living. And murders are always front page news."

"Pay no attention to that Philistine," Fred said to Libby. "Naturally, we'd be happy to help if we can."

"Thanks. But I gotta tell ya, I'm only here 'cause I'm desperate." Her look was openly skeptical. "But as I told Mark this morning, we've just about run out of ideas, and I'm starting to think we've run out of time."

Mark put a slice of sharp cheddar between two sesame crackers. "The good news is, we know the identity of the killer. The bad news is, the police can't find him."

"You mean, he's on the run?" I asked.

Libby nodded. "Looks that way. We've checked the airlines, train stations, bus terminals. We've canvassed cab companies, car rental agencies, the ports in San Pedro. We've even reached out to those pricks at Homeland Security in case he crossed the border, north or south. Nothing. Guy's in the wind, vanished without a trace."

"They have a pretty good description, too," Mark added, between bites. "The perp is white, average height and weight, brown eyes and a scruffy reddish-brown beard. Last seen wearing an Angels baseball cap, plaid shirt and Wrangler jeans."

"Last seen wearing?" Bill chuckled. "I love it when they say that. I always think, then why still wear it? I mean, if *I* just pulled a crime,

one of the first things I'd do is change clothes."

"Maybe most bad guys don't have your refined fashion sense," Mark said. "Besides, it's all we have to go on."

"Let me get this straight," I said, turning to our guest. "You know who the killer is, and you want our help in figuring out how to find him?"

"It's not about what I want," she answered coolly. "But in my weaker moments, I more or less respect Mark's opinion, and he vouches for you guys. He's told me about how you've helped out the Department in the past."

Here she glanced at the floor, voice softening. "Truth is, I'm kinda on my captain's shit list at the moment. So I figured if I could come up with something on this case—maybe just a new idea, a different angle—I could do some damage control."

"What's the problem at work?" Fred said. "If you don't mind my asking."

Mark answered for her. "Detective York was cited for using excessive force taking down a robbery suspect. Put the guy in traction for six weeks. His family's filed a multimillion dollar suit against the Department."

Libby shook her head. "So now I have Internal Affairs crawling through my personal life. Talking to my friends, my ex, even my AA sponsor." She shrugged. "What was I supposed to do? Let the creep escape?"

"A reasonable question," Bill said, glancing at the rest of us as though for confirmation.

"Anyway," Mark went on, "I suggested to her that we run the whole thing by the Smart Guys"—he cocked a thumb in Isaac's direc-

tion—"especially *this* Smart Guy, just in case there's something the cops have missed. I mean, maybe there's a way for a man to disappear that they haven't thought of."

"I can think of a dozen myself," Fred said calmly. "Especially if he makes it out of the country. Then he's gone for sure. My firm's dealt with enough deadbeat millionaire husbands, corporate embezzlers and upmarket parole jumpers to make that plain."

Libby gave a short laugh. "Our guy's nothing like that. Just your garden-variety, low-level thief who was stupid enough to kill someone in the act. Simple robbery gone wrong. Made a total mess of things, then took off."

"When was this?" I asked.

"He's been on the lam almost 48 hours. So, yeah, he's probably just lying low for a while. He can do that forever, I guess. But most of these jerks don't. They talk to friends, they brag, they spend money. Or else they find a ride outta town, outta state. That's why we got people watching every means of transport. Got an APB with his description out all over the place."

She sat straighter in her seat. "I mean, we'll catch the lame-ass bastard. Count on it."

"Unless you don't," Mark pointed out.

"Yeah." She let out a long breath. "Unless we don't."

The moment's silence was broken by the sharp rustle of a newspaper being briskly folded. I turned to see Isaac smoothing down the Metro section on his lap, even as he smiled kindly at our guest.

"You may indeed catch the culprit, my dear," he said. "But I agree with Mark—what could it hurt for us to at least hear the particulars?"

I couldn't help but smile. It was rare for Isaac to take the initiative when it came to a problem we were grappling with. Usually—like most ace relievers—he just sat quietly on the bench till the final inning, before coming in and winning the game.

Mark nodded at the paper in Isaac's lap. "You were just reading about it, weren't you?"

"Just skimming the story in this morning's *Times*," Isaac said. "The victim was a Morris Ames, president of SkyWay Distributors, some kind of national marketing firm."

"That's right," Libby said. "They have a suite of offices in an industrial park off of Pico. Though the company's really grown in the past few years. Apparently, there's been talk of a merger with some huge conglomerate back East."

"Isn't that always the way?" Bill said grimly. "Hell, even Ben and Jerry sold their ice cream company to some corporate behemoth. If I didn't know better, I'd say it was all some sort of international monetary conspiracy."

Mark grunted. "I'll make a note to bring that idea up for discussion at our next meeting. Till then, let's stay on target here, okay?"

"Uh-oh. Somebody didn't have his Starbucks *frappuccino* this morning."

Libby's eyes narrowed. "Jesus, is *this* what you guys are like? I didn't wanna do this in the first place, but if I gotta listen to this kinda crap, I'm outta here..."

She started to rise, but Mark restrained her.

"Hold on, Libby. Let's at least lay out the facts, see what happens. Okay? Give 'em a half hour... You never know, somebody might have a brainstorm." He glared over at Bill. "Correction. Somebody *else*

might have a brainstorm."

"Sorry," Bill said, raising his hands. "My bad."

Libby just stared at Mark, obviously unconvinced.

Finally, and reluctantly, she nodded and pulled a notebook out of her jacket pocket.

"Okay, here's what we got," she said. "Like Grandpa here said, the vic was named Morris Ames. Age 76. Built SkyWay Distributors up from nothing. Started it in his garage or something. Now has a hundred employees locally, another hundred nationwide.

"On the personal side, he has—or had—a wife of 40 years, no kids, a house in Encino. He's a big shot in the Chamber of Commerce, an elder in his church. Has voted Republican since Eisenhower."

"Sounds like one of my firm's clients," Fred said. "Rich. Conservative. Pillar of the community."

"Real traditionalist, too," Mark added. "His only hobby was collecting Civil War memorabilia. In fact, his prized possession was a genuine Confederate cavalry saber, kept in a silver scabbard displayed on a special stand on his desk. Both the sword and the scabbard were covered with exquisite hand-done patterning. Word is, Ames would take the saber out of the scabbard to show any visitor to his office. But only he could touch it, and only he could return it to its scabbard."

"Sounds like a total wing nut," Bill said.

Fred shook his head. "That thing with the sword...."

"Obvious penis substitute," Libby said, "if you want *my* opinion."

Mark looked quizzically at me.

"Hey, I don't know," I said. "Sometimes a saber is just a saber."

"Whatever," Libby said. "Anyway, we've interviewed co-workers,

neighbors, even competitors. They all said he was a tough son of a bitch, but fair. Loved his company more than anything. And, apparently, very opposed to the idea of the merger."

"Unlike his board of directors," Mark said. "And Ames' own vice president, a guy named Ben Fontaine. Though Ames was like a father figure to him, a role model."

"They were tight, all right," Libby said. "Like Ames, Fontaine is prominent in the Chamber of Commerce. Joined the same country club, contributes to the same political campaigns. Though other company employees actually liked Fontaine better than Ames. Fontaine's longtime secretary, Jean Harcourt, described him as a 'kinder, gentler' version of the company's founder."

"Some of that may just be generational," I said. "Men of Ames' era were brought up to believe a boss behaved in a certain way. More removed. Authoritarian."

"That's right," Fred said. "Management styles have changed a helluva lot in the past 20 years. None of our seniors partners would dare pull that Big White Chief crap anymore. The juniors would file a class-action suit."

"All that may be true," Mark said, "but in this case Fontaine's 'kinder, gentler' nature caused a tragedy. In a way, the murder was his fault."

"What do you mean?"

"According to Jean Harcourt, Fontaine was always falling for hard-luck stories. He was the kind of guy who'd give a homeless man a job washing his car, or help some SkyWay employee's kid get a summer internship somewhere. Then, a few weeks ago, she recalled Fontaine asking people to let him know if they needed help with

computer problems at work, or even at home. She said he was trying to drum up freelance jobs for a computer-tech friend who was down on his luck."

I frowned. "I still don't see what that has to do with the murder."

"You will," Mark replied flatly.

Suddenly, I saw Libby glance up from her notebook. I followed her gaze to Isaac, who'd come in from the kitchen, holding two steaming mugs of tea. Frankly, I hadn't even noticed he'd been gone.

"I thought you might enjoy a cup, Ms. York," Isaac said, handing her one of the mugs.

"Thanks," she said, her voice somewhat guarded. She took the mug in both hands and sipped. "It's great. But you didn't have to."

"I know," he replied, settling into his armchair again. He put his mug on the side table, and I got the distinct impression he actually wasn't much interested in drinking it. But he seemed to be avidly watching Libby drink hers.

There was an awkward pause, then Mark cleared his throat. "Now, where were we...? Oh, yeah. The day of the crime. Friday. Three days ago."

"Actually, the chain of events started the day before that," Libby said. "Thursday. According to statements, Fontaine's regular secretary, Jean Harcourt, was out that day, and would be gone till Saturday. Yesterday."

"Was she sick?" I asked.

"No. She flew back to Las Vegas for her high school reunion. Her boss had known about her plans for weeks. He'd already arranged for a temp, named Betty Kent. She came to work on Thursday, and they

put her in Jean's office."

Libby paused. "It's a big room, filled with computers and a couple desks and filing cabinets. It's situated between Ames' office and Fontaine's, with connecting doors to each. Plus all three rooms have doors accessing the main hallway, which leads down to the reception area."

"Did Betty do an okay job?" Fred asked. "I mean, did she get along with Fontaine?"

"Seems like it. Though she worked mostly for Ames. She says Fontaine just took a minute to introduce her to Ames that morning, then was out of the office on business the rest of the day. Ames dictated some letters, had her file some paperwork and then left early to play golf at his club."

"It's good to be king," Bill murmured.

"Tell me about it," Libby replied. "Anyway, Betty stayed on at work until five, then left. On her way out, she saw that Fontaine was back in his office. She remembers waving to him through his open office door as she went down the hall to sign out at reception."

"That brings us to Friday morning," Mark said, glancing over at her. "Right?"

I was struck suddenly by how smoothly he and Libby took turns telling the story. Like a seasoned tag team.

"So Betty comes in at nine," he continued, "and finds Morris Ames there, hopping mad. One of the main desktop computers is on the fritz, and he needs some important data right away. He tells Betty to ask Ben Fontaine to find somebody to fix it fast. So Betty calls Fontaine in his office and explains the situation."

Libby picked up the thread again. "Fontaine says he knows just

the guy, the one he'd been telling people about. He can personally vouch for him. Seems he used to live with Fontaine's sister back East, before her unexpected death. Guy's name is Gregory Sykes. A real computer whiz. Fontaine says he'll call him right away, see if he can come over."

"Does he get a hold of Sykes?" I asked.

"Yeah. Takes a while, almost till lunchtime, but finally Fontaine calls Betty and says—and I'm quoting from her statement here—'Hey, I got Greg here in my office. I'm sending him down to you.' Then Betty hears Greg say into the phone, 'Yeah, honey, I'll be right there.' She says his voice was coarse and unpleasant. Instantly Fontaine starts scolding Greg, but kind of half-kidding, saying 'For God's sakes, Greg, you can't talk like that. You'll get us sued for sexual harrassment.' She hears Greg mumble 'Sorry, man,' and then Fontaine gets on the line again and apologizes to Betty himself. She assures him it's no big deal and hangs up."

Bill grinned. "Sounds like Sykes needs one of those sensitivity training classes."

"He needed something, all right," Libby replied. "Because Betty reports she had a weird vibe off Sykes from the moment he shows up in her office. He's dressed as we've described—plus he's carrying a big backpack, which he casually throws on a chair. Then he takes a pair of surgical gloves and some tools out of the pack, the whole time leering at her. Totally creeps her out."

"I can imagine," I said.

"Finally, after putting on the gloves, Sykes gets to work on the desktop. But he keeps glancing over at her, muttering to himself. Finally, Betty stops what she's doing and asks what the hell he's say-

ing. Without looking up, he answers, 'I'm just wondering what a fine piece o' ass like you is doin' in a sweatshop like this.'"

"Real charmer, this guy," Fred said.

Libby's frank eyes narrowed. "Betty's pretty upset by this remark, so she turns to pick up the phone and buzz Fontaine. But suddenly she feels a blinding pain at the back of her head. Then everything goes black."

"Jesus." It was Bill. "Sykes hit her from behind?"

Libby nodded again, putting down her notebook.

"When Betty came to, she was alone in the office. Then, in a moment, she realized her wristwatch was gone, and that her purse had been dumped out on the floor. All the cash and credit cards were missing."

Mark's tone sharpened. "That's when she noticed something else... the connecting door to Ames' office was wide open. So Betty goes in and finds the old man crumpled on the floor near his desk, his head caved in, blood splattered everywhere. Laying beside the body is Ames' Confederate sword, still inside its scabbard, which is also smeared with blood."

I stared. "The sword?"

"Yep," said Libby. "At this point, Betty says she just started screaming. A security guard happened to be at the near end of the main hallway and came running. He helped get her out of there and called 9-1-1.

"In ten minutes, officers were on the scene. Me and another homicide dick show up five minutes later, then we all wait for the M.E. But we didn't need anyone to tell us what happened. Ames had been bludgeoned, killed by a blow to the head from the Civil War saber. Inside the heavy silver scabbard, which had been swung like a club."

Mark took a swallow of beer. "I talked to one of the lab guys yesterday. He told me the scabbard was actually weighted at the tip, so it would pack quite a wallop."

"Got the job done, that's for sure," Libby added. "The way we figure, Sykes must've come into Ames' office after knocking Betty out, looking to rob the old man as well. Ames probably resisted, so Sykes grabbed up the sword from its stand on the desk and swung for the fences, cracking the old man's skull."

"Makes sense that Ames would resist," I mused. "Tough, old-school patriarch who built up the company with his own hands. When Sykes came in, Ames probably felt more outrage than shock at the sudden intrusion."

"That's how we see it, too," Libby said. "The damn fool. Trying to stop a felon half his age. Anyway, whether he meant to or not, Sykes kills Ames. Then, probably in a panic, he empties Ames' wallet and pulls off his watch. Ames wore a gold Rolex. The physical evidence indicates the watch had been forcibly torn from his wrist. After that, Sykes musta just taken off."

"Anybody see him leave the building?" I ask. "The receptionist? That security guard you mentioned?"

"No, not either of them. Ironically, though, Ben Fontaine saw him. We were still at the crime scene—though the body and evidence had been bagged and removed—when Fontaine showed up. He and a co-worker had just grabbed a quick lunch across the street. Before we could say anything, though, Betty ran to him and burst into tears. 'It was Greg Sykes,' she said. 'He killed poor Mr. Ames.'"

"What did Fontaine say?"

"Well, I came over right away, and confirmed that Ames had been

the victim of a robbery-homicide. Fontaine turned white as a sheet and said that he'd actually *seen* Sykes earlier, when he'd gone out for lunch. Sykes was running like hell down the hallway and bumped into him. But he just kept going, and then out an emergency exit door. 'I called after him,' Fontaine told me, 'but he didn't answer. I was late myself, meeting with Will Creasey for lunch across the street. So I guess I didn't give it another thought.'"

She looked up from her notes.

"Then Fontaine asks me what happened. I told him Ames had been killed with his Civil War saber. Meanwhile, Betty's still blubbering." Libby grimaced. "Real faucet, that chick. I hate that 'damsel-in-distress' crap. Fact is, Fontaine looked pretty stunned himself, but he did his best to console her."

She checked her notes again. "Betty says, 'It was awful. All that blood.' Then Fontaine says, 'I can't believe it. Greg wouldn't bash someone's head in, just for some stupid cash and jewelry. I mean, I know him. He couldn't do it. Not for any reason.'"

"Obviously, he wasn't as good a judge of character as he thought," Fred offered.

"Guess not." Libby shrugged. "I had Betty and Fontaine taken to the station for further questioning. Meanwhile, I canvassed everybody in the suite, taking statements. Two people saw Greg Sykes hurry out the emergency exit door. Plus, when we talked to Will Creasey, he told us that Fontaine had commented at lunch about Sykes' odd behavior."

"Anybody see him driving off the lot?" I asked. "Or even get a license number?"

Libby shook her head. "According to Fontaine, Sykes hadn't

bought a car yet. Took buses or whatever."

Mark nudged her arm. "Tell them the part about Fontaine's sister."

"I was just getting to it." Libby took a long breath. "When we questioned Fontaine at the station, he repeated that he couldn't believe Sykes capable of murder. 'He was brilliant, but geeky,' he said. Sykes had been his sister's boyfriend back in some godforsaken town in rural New Hampshire. But they'd lived together for only six months before she died."

"How?" Fred asked.

"She fell down the back stairs of their apartment building."

"Christ." Bill sat up abruptly, voice tinged with excitement. "Maybe Sykes pushed her. Maybe it was murder."

"No. According to Fontaine, she was alone that night. Sykes was away on a job somewhere. The local cops ruled it an accident."

"So what happened to Sykes?"

"Sounds like he just bummed around for a year or two, doing odd jobs. Then he decided to come out here, start a new life. He got in touch with Fontaine when he hit town and asked for his help picking up freelance tech jobs. Fontaine said he felt obligated to do what he could."

"In a way," Fred said casually, "I guess they were almost like brothers-in-law. I can see how Fontaine might feel he ought to help the guy out."

"Guess so. Though Fontaine admitted that Sykes was a bit odd, very eccentric. Sykes often boasted that he was 'off the grid.' Meaning that he had no social security number, paid cash for everything, never paid taxes. 'Kind of a libertarian nut,' was the way Fontaine described him. 'But he always seemed harmless enough. And, like I

said, brilliant with computers.'"

She frowned. "And that's about all we got."

With that, Libby tossed the notebook on the coffee table, next to where she'd put her mug of tea. She seemed to hesitate for a moment, looking at the cooling drink, before picking it up again.

I found myself looking over at Isaac, whose own gaze was riveted on the detective. What the hell was going on?

My reverie was broken by Fred, who was piling slices of roast beef on his plate as he spoke.

"So what's the status of the investigation?"

Libby spoke between sips of tea. She sounded weary.

"The status is, Sykes has disappeared. Fontaine's devastated, according to his regular secretary, Jean Harcourt, who's back from her trip. She says he feels responsible for Ames' murder, since he was the one who recommended Sykes. He's currently under a doctor's care. Meanwhile, the Board of Directors' considering making Fontaine the new CEO, but he's evidently not interested."

"What about the temp who found the body?" Bill asked. "Betty Kent?"

Libby smirked. "Also on medication. Total pussies, both of 'em, far as I'm concerned."

"What about the murder weapon?" Fred said. "Any fingerprints on the scabbard, or maybe even the saber hilt?"

"No. Remember, Betty said that Sykes wore surgical gloves while working on the computer."

"What about Sykes' place here in town?" I asked.

"Fontaine gave us the apartment address," she said. "One of those rent-by-the-week places. Our forensics guys searched it but didn't

find much. Hangers strewn about, bed unmade. A half-empty box of surgical gloves, tossed in a corner. Sykes musta left in a hurry."

"Did they talk to the apartment manager?"

"It was some stupid kid. He confirms that a guy named Gregory Sykes, matching the description, rented the room a couple months back. Paid up front in cash. Even so, they usually require a credit card imprint, but the kid admitted that Sykes slipped him a hundred bucks to let it go."

"Again, no ID that could help track him down." Fred said quietly. "Talk about disappearing without a trace."

Bill turned to Libby. "You sure you checked all the cab companies, rentals agencies? How about private flights out of Van Nuys Airport?"

"We checked everything," she replied, an edge in her voice. "And remember, this isn't Donald Trump we're talkin' about, renting planes and hiring limos. If anything, Sykes is probably running so low to the ground that he's *under* the radar, not above it."

"In that case," I said, "maybe he just stuck out his thumb and hitched a ride. SkyWay's offices are just off Pico, right? Million cars a day travel that street."

"We thought of that. We figured his best bet would be to hitch to one of the freeways, the 405, 101, one of those. So we've contacted all the motels in a 200-mile radius, just in case he was stupid enough to take a room for a night. We've also put out bulletins to Highway Patrol to check out service stations, rest stops."

Fred scratched his thinning, reddish-brown hair. "In a city this size—hell, in a *state* this size—a guy like this could be anywhere. And like I said, once he's out of the country, forget about it."

Mark leaned back and adjusted his glasses.

"That's it, then? No more ideas?"

He swiveled in his seat to face Isaac, whose eyes were lidded—though whether from fatigue or concentration, I couldn't tell.

"What about you, Isaac?" Mark said. "Any suggestions about finding Gregory Sykes?"

"Just one," Isaac replied. "Stop looking for him."

"What?"

"Why?" Libby stared at him.

"Because, my dear," Isaac said ruefully, "I'm afraid he doesn't exist."

As is often the case when Isaac drops one of his bombshells, we all started talking at once. Except for Libby, whose cool gaze regarded Isaac with equal parts disbelief and curiosity.

"But Ben Fontaine *saw* him," Bill said, half-rising from his seat. "And that temp, Betty. He worked in the same room with her. He knocked her out from behind."

"And what about the office workers Libby questioned?" I added. "They saw Sykes go out the emergency exit door."

"I know what all those people saw," Isaac replied. "Or at least what they *said* they saw."

Fred stirred. "I don't think I follow you, Isaac."

Isaac paused. "Remember that Smart Guys meeting about six months ago, Fred? The discussion about chaos theory and Heisenberg's Principle of Uncertainty."

"I remember it," Bill grumbled. "Gave me a headache."

"Of course I remember it, Isaac," Fred said, looking puzzled. "So?"

"There was this French philosopher you quoted... I forget the name. What was that thing he said?"

Fred thought a moment, then smiled. "Oh, sure. You mean Charles Renouvier. He said, 'Plainly speaking, there is no certainty. There are only people who are certain.'"

Isaac nodded vigorously. "That's right. In this case, it's Betty Kent, and those office workers, and especially the police who are certain—*certain* that Greg Sykes is the killer, and that he's on the run. That he's a greedy social misfit who murdered Morris Ames in the heat of the moment, during the act of robbing him."

Here Isaac swept all of our faces with his gaze.

"In other words, that everything that happened the day of the crime was unplanned, inadvertent."

Libby appraised him with renewed interest. "But you don't think so, do you?"

"No," Isaac said simply. "I think the murder of Morris Ames was premeditated. That it was the result of a plan set in motion some months ago. By Ben Fontaine."

"Fontaine?" Mark said, blinking behind his glasses.

"But that's impossible," Libby said sharply.

"Are you certain?" Isaac's smile was a challenge. "Granted, the motive was in fact greed, but not for something as trivial as cash and a Rolex watch. Ben Fontaine killed Morris Ames because the old man refused to sell the company. He killed Ames because, as VP and heir apparent, it was logical to assume the Board would elect him to run SkyWay Distributors. After which, Fontaine would eagerly accept the merger offer and reap the financial windfall sure to follow."

I, for one, was speechless.

Isaac, on the other hand, merely sat back in his venerable armchair and lidded his eyes again.

"And that," he said, "is what I think."

Mark peered at him. "But how? What actually happened?"

"Well, let's just look at the facts," Isaac replied. "First, Fontaine plans the murder to coincide with when his longtime secretary, Jean Harcourt, is out of town. Everybody knew of her plans to go back for her high school reunion. Why was this important for Fontaine? Because as someone who'd worked with him for years, who knew him intimately, there was every chance Jean would see through his disguise."

"Disguise?" I said. "You mean, he was…"

"Think about it. The temp, Betty, stated that she only spent a few minutes with Fontaine on Thursday morning, and then he was gone the rest of the day. The next time she saw him was that evening, as she was leaving work. He was back behind the desk in his office, and she waved to him through the open office door. In other words, her interactions with Fontaine were quite limited. Again, unlike his regular secretary, who was no doubt quite familiar with his voice, manner, gestures, what have you.

"Recall, too, that Morris Ames had already left his office earlier that day to play golf. I believe that, after Betty left, Ben Fontaine went down to Ames' empty office and tampered with that desktop computer. When Ames comes in the next morning, he finds that it doesn't work. So Ames tells Betty to call Fontaine—as Fontaine knew he would—and ask him to get some repair person in right away. Betty does as she's told, and Fontaine assures her he knows just the person."

Bill said, "That's why Fontaine had been asking around the office to see if anyone needed computer work done."

"Exactly," said Isaac. "He was setting up the existence of a friend

who was looking for freelance jobs. After all, he had a reputation as a Good Samaritan. It was entirely believable that he'd be trying to drum up work for someone. Especially a guy down on his luck, who'd once been his sister's boyfriend."

"Incredible," was all I could say.

"Now this next part is crucial," Isaac went on. "As it nears lunch, Fontaine buzzes Betty from his office and tells her he has his computer-tech friend, Greg Sykes, with him, and that he'll send him right down to her."

"I know where you're going with this," Libby said excitedly. "Fontaine pretends to be Greg Sykes on the phone, to give Betty the impression there are *two* of them in his office."

I swear, Isaac practically beamed at her.

"That's right. Fontaine, changing his voice, pretended to be Sykes. He even emphasized this by having 'Sykes' say something inappropriate to Betty, and then appearing to chastise him for it.

"So the stage is set for Sykes' appearance in Betty's office. And what does he look like? Scruffy beard, backpack, baseball cap pulled low over his eyes. And what does he do? He acts like a demented killer out of a horror film, muttering as he pulls on his surgical gloves. Leering in an obvious way at Betty. Saying more inappropriate things. You see what I mean? He's practically wearing a neon sign that says, 'Notice me! I'm weird! I have lots of specific features you can describe to the police.'"

"Which she did," Mark acknowledged.

"Anyway," Isaac went on, "disguised as Gregory Sykes, Fontaine knocks Betty out when her back is turned to use the phone. Then he goes into Ames' office, where I suspect he's happy to reveal his identity to the old man. Maybe they argued. Maybe Ames did try to

resist, defend himself. Who knows? What I *do* know is that Fontaine picked up the Civil War saber in its heavily-weighted scabbard and clubbed Morris Ames to death."

Isaac's face tightened. "As I say, a premeditated act. The use of the disguise confirms that. As does renting the room weeks ago while wearing the Sykes disguise, and paying for it in advance. As does leaving the bed unmade in the apartment, and making sure a half-empty box of surgical gloves is found there, too."

Isaac drew a breath here, to let this all sink in. I could tell that, as always, he enjoyed the effect his own "performance" was having on his audience.

"So, what happens next?" Isaac folded his hands on his lap. "Fontaine empties Ames' wallet, as he'd done with Betty's purse. He makes a point of roughly pulling the old man's Rolex from his dead wrist. All to make the crime look like a spur-of-the-moment robbery, with an unintended murder thrown in. Then, still dressed as Sykes, he goes down the hall and out the emergency exit door."

"That was when he was seen by those office workers I talked to," Libby said.

"Exactly. Then Fontaine hurries to his car, which I'm sure he parked at an isolated area of the lot. He gets in, peels off the Sykes clothes, beard and hat, stuffs it all in the backpack, then puts it in the trunk for disposal later. Then he meets his co-worker Will Creasey for lunch, as previously arranged, during which he makes a point of telling Creasey about bumping into Sykes as the latter was hurrying out of the building."

"All to make the ficticious Sykes seem real," I said.

"But wait a minute," Mark said. "What about all that stuff about

Sykes being Fontaine's sister's boyfriend? Is that all fiction, too?"

Isaac paused. "I think Fontaine invented the story of Sykes' relationship with his late sister. By claiming that his sister died under mysterious circumstances, it throws even more suspicion on Sykes. It creates the picture of an impulsive, potentially violent man who's killed before."

"So what do you think happened to her? If she even existed."

"I suspect she did in fact exist. That she lived in a small town in New Hampshire and died from a fall. But I bet a check with the authorities there will reveal that she wasn't living with anyone named Gregory Sykes. In fact, maybe she lived alone at the time, or with someone else whom the police subsequently cleared."

"We'll check, all right," Libby said firmly.

Isaac finally took a sip of his own tea, now long grown cold.

"There's one other thing that bothered me about the so-called robbery from the start," he said. "If Greg Sykes was just a simple thief, someone who suddenly saw an opportunity to rob a defenseless girl and a frail old man, why just steal cash, credit cards and jewelry? Why not take what was obviously the most expensive-looking thing in the office—the sword and scabbard? He had to assume it was valuable. Silver. Buffed to a sheen. Proudly displayed on the boss' desk. At the very least, why risk leaving the murder weapon laying around? Remember, he had that bulky backpack. He could've stuffed the sword and scabbard in there and waltzed right out of the building."

"Another good point," Mark had to admit.

"Was that what tipped you off that Sykes was in reality Ben Fontaine?" I asked.

Isaac permitted himself a sly smile.

"Actually, no. It was a mistake that Fontaine himself made, when

he first arrived on the crime scene. Remember, Libby told us that Ames' body and the murder weapon had already been bagged and removed. When Fontaine asked what happened, Libby told him Ames had been killed with the Civil War saber. Then, while consoling Betty, what does Fontaine say?"

He closed his eyes, and recited back what Libby had read to us from her notebook. "Fontaine says, 'I can't believe it. Greg wouldn't bash someone's head in, just for some stupid cash and jewelry.'"

Isaac sat up straight, and opened his eyes to meet ours. "If *I* was told someone had been killed by a saber, I'd assume the victim had been *stabbed*. Wouldn't you? I mean, who would know that Ames had been bludgeoned to death? Only the killer."

"My God," Libby said. "You're right. Fontaine had just shown up. He couldn't have known how Ames died."

Now Mark was on his feet. He turned to her.

"I think you've got that new angle you wanted."

Isaac sighed. "If you can prove anything I've just said. Much of it's pure conjecture."

"I have a thought," I said. "Most surgical gloves are coated with a fine powder, a kind of talc. With forensics today, I bet you could do an examination of Fontaine's hands to see if any residue is left."

"That's right," Bill said. "I saw a documentary about that once. There might be something left days later, even if he washed his hands a dozen times since then."

"Or," Fred chimed in, "you could examine the trunk of Fontaine's car, looking for threads or fibers that might've come from the backpack. Or, if we get really lucky, a loose hair from that fake beard of his."

"Or," Libby said, somewhat deliberately cracking her knuckles,

"you could just give me five minutes alone in a room with him."

Mark laughed. "No chance. You're in enough trouble with Internal Affairs already."

"Jesus, I was kidding." She grinned. "I think."

With that, she rose and thanked us all for our help. Then she stepped over to where Isaac sat and held out her hand.

"Especially you, Isaac. Real heads-up work. Thanks."

Standing, he took her hand in both of his. "Glad if I was any help. And I hope we'll get to meet again."

Issac kept hold of her hand another moment. Finally, a bit at a loss, she said, "Me, too."

Then she turned to Mark. "Hey, man, I gotta get back to the station. Time to put Fontaine in my crosshairs."

Mark looked at the rest of us. "Sorry, guys. I'm her ride, and she's my exclusive. I'm outta here."

After a few more good-byes, he and Libby were gone.

"God, she was cool," Bill said, reaching for one of my leftover Santa cookies. He nibbled it tentatively.

"I liked her, too," Fred said. "Though not, I think, as much as Isaac did."

"Yeah, Isaac," I said, folding my arms. "Why were you so... I don't know...solicitous? What was that about?"

Isaac looked off. "Nothing. She just reminded me of someone." A long moment's pause. "My daughter."

"What?" Bill said, exchanging looks with me. "I didn't know you had a daughter."

"Me, neither," Fred added. "Jesus, Isaac, you never talk about your personal life."

"You're right," he said. "I don't."

Fred stroked his beard thoughtfully. "I mean, I always just figured you were kind of... well, private about that stuff. Sort of like I am."

I said nothing, though I recalled my wife mentioning when Isaac moved in with us that there was a family rumor that he'd had a child at some point. But neither of us wanted to pry once it became obvious just how zealously Isaac deflected questions about his personal life.

Now, however, after swallowing the last of his cold tea, the guarded look on his face seemed to fade. He sat back in his armchair, hands once more folded on his ample stomach.

"Look, fellas, maybe I *am* a bit tight-lipped about things," he said. "Maybe—like Morris Ames—I'm just from a generation that kept private things private."

"We understand that, Isaac," I said carefully. "But we're also your friends. If you ever do want to talk about something..."

His smile at me was as warm as it was skeptical.

"Maybe," he said. "Someday. It's a long story. On the other hand, maybe some mysteries are better left unsolved."

There wasn't much I could say in response to that. So I didn't.

End

Freud Slept Here

"Gentlemen, a toast," Bill proclaimed, raising a glass of fine Merlot. "To me."

Mark, Fred, Isaac and I dutifully raised our glasses and clinked crystal. After all, how could we decline? We were dining in splendor at one of the finest restaurants in Los Angeles—and Bill was picking up the check.

I won't bore you with the details of how four middle-aged married men with children managed to secure a Sunday night dinner meeting of the Smart Guys Marching Society. Suffice it to say that the domestic negotiations—involving scheduling conflicts, child-care responsibilities and rightfully disgruntled marital partners—would have taxed the diplomats at Malta. But somehow we pulled it off.

Much to Isaac's amusement, I might add. Many years older than the rest of us, and a longtime bachelor, he seemed greatly entertained as we took our seats at a secluded corner table, recounting our tales of

187

struggle on the home front that led to this evening's freedom.

As you can imagine, these narratives quickly exhausted the Merlot, even with Isaac, per usual, only drinking water. Finally, though, and after ordering a *second* overpriced bottle, Bill explained why he'd suddenly invited us all out to dinner.

"We're celebrating," he said, beaming. "Remember my director friend, Brett Loftus? Made that movie for Sony Pictures that went through the roof?"

"Yeah," Mark said, rolling his eyes. "*Peter Pan on Mars.* Desecration of a classic."

"Whatever," Bill said. "Meanwhile, it grossed over $500 million worldwide, and that's not counting the video games and action figures."

"So?" Fred said, feigning boredom. Or maybe not. Our erudite lawyer tended to frown on pop culture in general, and big Hollywood movies in particular.

"So," Bill replied, "now that Brett can write his own ticket, he's making a complicated suspense movie, an erotic thriller. Hitchcock meets *Basic Instinct*, only with a little more blood-and-guts to bring in the kids. And guess who has a huge supporting role?"

Now I was smiling, too. "You? Wow, that's great."

Even Mark gave a reluctant nod. "Hey, congrats, man. God knows you've paid your dues."

"Paid 'em with interest," Bill said, shaking his head. "I'm still pinching myself. This could be huge for me. And Brett's a great guy. I mean, sure, he's a self-absorbed, egomanical control freak...but in show biz, who the hell isn't? Plus, he cast *me* in the part, which makes him a certified genius, in my opinion."

"So who are you playing?" Fred asked, his interest apparently piqued, despite himself.

Bill drained his glass and leaned across the table, palms flat on either side of the dinner plate.

"Man, it's a great part..." He glanced over at me excitedly. "*You'll* really love it. I play a rich Beverly Hills psychiatrist who seduces and brutally murders his beautiful female patients."

My mouth fell open.

"What? He does...what?"

"It's so cool," Bill went on. "See, after killing the victims, he arranges their bodies to look like the ink blot designs in those Rorschach tests. Is that sick or what?"

"'Sick' is exactly the word I'm thinking of," I said icily. "What kind of bullshit is that?"

Bill sat back, blinking, as though stung. "Jesus, I thought you of all people would get it. You're a therapist. You know you guys are even nuttier than your patients. This story just takes that idea...well, it just takes it to the next level."

Fred opened his tall, gilt-edged menu. "I weep for Western Civilization."

Mark laughed. "You're *always* weeping for Western Civilization. Come on, it's only a movie."

Then he peered at me through his thick, dark-framed glasses. "And *you* need to chill out. Hell, we journalists are made to look like idiots all the time in movies. Or else ruthless hacks. Or bloodsucking opportunists. Comes with the territory."

Fred spoke from behind the opened menu. "Not to mention how lawyers are portrayed on screen. Unscrupulous, money-grubbing,

ambulance-chasing bastards. But *I've* learned to live with it."

I spread my hands. "You guys are kidding, right? Sure, sometimes reporters and lawyers are depicted as villains. But you see just as many shown as heroes. Dedicated journalists exposing corruption, courageous attorneys going up against big corporations."

Bill eyed me across the lip of his wine glass. "What's your point?"

"My point is, haven't you all noticed how therapists—especially *male* therapists—are portrayed on TV and film nowadays?"

Bill shrugged. Mark studied the wine list.

Needing support, I looked across the table at Isaac. "Isaac, remember Claude Rains in that '40s movie with Bette Davis? He plays a shrink helping her...?"

"Of course," Isaac replied. "*Now, Voyager.*"

"What about it?" Bill said.

"Rains was a great guy. Paternal. Supportive. Always trying to do what was best for his patient."

"Figures you'd like that character," Bill murmured.

I went on. "Then there was Lee J. Cobb in *The Three Faces of Eve*, helping Joanne Woodward parse out the three personalities tormenting her."

"I remember that movie," Mark said. "Not exactly a touchy-feely guy, that shrink."

"No," I agreed. "But like Claude Rains, a therapist of unquestionable motives. Unimpeachable authority. One of the good guys."

"Yeah, so?"

I folded my arms. "So, I have a question: how did we get from there to Hannibal Lecter?"

Fred chuckled behind his menu.

"It's not funny," I said, building steam. "Look at how male therapists are depicted on TV and film today. Evil and homicidal. Manipulative and unethical. Or else they're sexual predators, assaulting their patients. It just... well, it pisses me off."

"That's your idea of a cogent point?" Fred put down his menu and smiled at Bill. "I'll have the lobster, by the way. Caesar salad to start. Okay with you?"

Bill smiled back. "Money's no object, my friend."

"Just checking." Then Fred looked at me. "I understand you're upset by this trend, but you must admit it doesn't come as much of a surprise. Not in today's postmodern, quasi-feminist, antiestablishment climate."

"What do you mean?" Mark asked, buttering a warm slice of Italian rustic bread.

Fred stroked his beard. "Think about it. In today's popular culture, the male therapist is the perfect bad guy. After all, the past forty years has seen a challenge to the whole *idea* of masculine authority. In terms of image, practically all professors, doctors and scientists of the male persuasion have gone from being saints to sinners. Same with therapists. No wonder today's filmmakers find them irresistible as villains. All that education, respectability and power, turned to the Dark Side."

Bill frowned. "Say what?"

Reaching for a breadstick, Fred continued his argument. "In a nutshell, male therapists are a perfect symbol of the failure of patriarchal authority. Much like priests today, they suffer from the failed expectations of a disillusioned public."

Bill regarded him warily.

"Nice speech, counselor," he said. "But the jury's unconvinced."

"No, wait a minute," I said. "I think Fred's on to something. Some people are suspicious, even frightened, by psychotherapy. Certainly they were years ago. Look at movies like *The Manchurian Candidate* and *One Flew Over the Cuckoo's Nest*. Rather than presenting clinical treatment as a means to alleviate suffering, they showed how it could be exploited. Used for brainwashing and manipulation."

Isaac chimed in. "You boys are probably too young to remember, but there was also this movie called *The Snake Pit*. With Joan Crawford, I believe. Those hospital shrinks really put her through the wringer. Kind of hokey by today's standards, but still pretty darned scary."

Fred pointed with his half-eaten breadstick. "Hell, even that recent movie, *A Beautiful Mind*, showed Russell Crowe getting zapped by electroshock therapy. And who's pulling the switch? Some creepy male psychiatrist, a real poster boy for the clueless patriarchy."

"On the other hand," Mark added, with a dark smile, "compare those characters with the way *female* therapists are portrayed on screen. Brilliant. Nurturing. Trustworthy. Barbra Streisand in *Prince of Tides*. Dr. Melfi on *The Sopranos*. That woman shrink on *Law & Order*. Of course, I know I'm the politically incorrect member of our little group, but Fred's got me thinking..."

Fred scowled. "Hey, man, don't blame me just because you're a male chauvinist throwback."

"I was merely making a point. Sue me."

Bill shook his head. "Boy, you guys are priceless. I get this great gig, and you've gotta turn it into a sociological debate. All I wanted to do tonight was drink good booze and eat real food. Christ."

"We *are* happy for you," Mark said. "You know that."

"Of course we are," Fred agreed.

"As am I, Bill." Isaac sat back in his chair, clasped hands resting on his generous belly. "If there's one thing I know about, it's working long and hard at something. And then how good it feels when it finally pays off."

"Thanks, Isaac," Bill said. "I knew *you'd* get it."

"*I'm* happy, too," I said. "Really. And I'm sorry I got up on my high horse."

"Well, get down from it," Mark said. "Fact is, crazy male shrinks are just the new Hollywood cliché. You have your brilliant doctor, your ruthless attorney and now your wacko shrink. Get over it."

Fred pouted. "See what I mean? 'Ruthless attorney.' You left out mudslinging reporter."

Mark laughed. "Okay, let's add him in, too."

Bill sipped his wine. "And don't forget how *actors* are portrayed on screen. Vain, stupid, backstabbing. Clawing their way to fame and fortune."

Mark looked puzzled. "And your point is...?"

"Hilarious, Mark, as always," Bill said. "Now I say let's order dinner and change the goddamn subject."

Which we did. Sort of.

Because halfway through our assorted lobsters, prime ribs and filet mignons—not to mention the occasional Scotch on the rocks—Bill brought up his new movie role again. This time, I knew enough to just shut up and eat.

"Did I mention that Brett Loftus was eccentric?" he said, between mouthfuls.

"Your new film's director?" Mark said. "No, you just said he was brilliant and egotistical."

"Oh. Well, he's also a fanatic about accuracy. He's been that way since we met back in theater school. I remember one play he directed. He practically used up the whole budget—which wasn't much—tracking down the right props. We were doing a revival of *Inherit the Wind*, and he decided we had to have a genuine ceiling fan from that time period for the courtroom scenes. Made everybody nuts."

Mark leaned in to me. "I think we can add another cliché character to our list. 'Fanatical director.'"

"In this case, it's not a cliché." Bill ladled sour cream on a baked potato. "But now, as a film director, he's got a whole new set of things to obsess about. Like with *Peter Pan on Mars*. Brett threw fits about making sure the computer-generated effects looked genuine."

"Too bad he couldn't have just waited 20 years to make the movie," I said. "Maybe he could've done the Mars sequences on location."

Bill laughed. "Hey, don't think that didn't occur to him. He actually called NASA at one point and asked when they thought we'd start flying people to Mars. I think they just hung up on him."

Fred, doing battle with a huge crab leg reluctant to leave its shell, looked up.

"Since Brett's such a stickler for accuracy, I suppose you'll have to go back to school and train as a shrink."

"A rich *Beverly Hills* shrink," I corrected him.

Bill swallowed another mouthful of wine. I could see he was getting a bit buzzed already.

"Funny you should bring that up," he said, reaching into his jacket pocket for a small clear plastic bag. Inside was a single, folded

piece of paper. Even through the plastic, you could see how old and faded it was.

"What's that?" Mark demanded.

"All in good time, my pretty. All in good time."

Bill pushed his half-filled plate away from him and sighed. "I was thinking about taking a breather anyway. Besides, this might make for an interesting story while I digest between rounds."

He lay the plastic bag with its mysterious contents next to the plate, then put his hand on top of it.

"Like I said, Brett Loftus likes to use authentic props whenever possible. Even in films. Remember that scene in the Darling bedroom, before Peter Pan and the kids went to Mars? He made sure almost every stick of furniture—even the stuffed animals—were the real thing. Had his set designers scour the Net looking for antiques dealers, collectors, even likely estate sales. You gotta admit, it looked totally authentic."

"I wouldn't know," Fred said. "Didn't see the film."

"Me, neither," Mark added. "On principle."

Bill shrugged. "Hey, you wanna miss out on the cultural *zeitgeist*, that's your business. Anyway, on this new film—the one *I'm* in, remember, which means you *will* be seeing it—on this new film Brett wants the same level of authenticity. See, my character is not only a brilliant, world-famous psychiatrist, he's a big-time collector. Has original Monets, Tiffany lamps, Louis XIV chairs. Very classy guy.

"Now, about a week ago, right after I got the part, Brett calls me at home, all excited. There's this antiques dealer he's used in the past... older guy, more like a hobbyist than an expert. He just dabbles in collecting stuff, but more than once he's gotten his hands on something

really special for Brett."

"But he's not a professional dealer?" I said. "What's his name?"

"Robert Clayton," Bill replied. "And, believe me, Brett swears by the guy. Anyway, Clayton calls and tells Brett he's found an item that would be just perfect for the new movie. Exactly the kind of thing my character, the shrink, would have in his office."

Bill paused, for effect.

"Well?" Fred said at last. "What is it?"

"Sigmund Freud's desk," Bill replied.

To a man, we all stared, dumbfounded. Except for Isaac, who sat calmly, sipping from his water glass.

Finally, I put down my fork and looked at Bill.

"You're kidding, right?"

Bill sighed impatiently. "Look, I'm not an idiot. Neither is Brett. It wasn't Freud's actual desk, from Vienna or someplace like that. But it *was* a desk he used, if only briefly. When he came to America in 1909."

"Freud visited America?" Mark asked.

"Yes," I answered. "In September of that year, as Bill says. He had been invited to speak at Clark University in Massachusetts."

"That's right," Bill said. "I learned about it when Brett and I drove over to Bob Clayton's place in Santa Monica the other day. He took us out to his converted garage and showed us the desk. It's an old roll-top, apparently dating from the 1890s. According to the dealer Clayton talked with, it had been acquired from an estate sale in the northeast."

"Whose estate?" Mark asked.

"The family of a longtime faculty member from Clark University," Bill said. "They've been storing the desk in their barn since

1922, when the professor retired and moved to his farm in Maine. He'd had all his stuff from his office at the university shipped up there with him. The professor died soon after, but his survivors kept everything under some tarps in the barn. Including the desk."

"What does that have to do with Freud?"

"Well, according to Clayton, the old professor told his family that Freud had used the desk during his visit to Clark. The professor had made his office available to Freud for writing speeches, answering letters, whatever."

"Can Clayton verify any of this?"

"He spoke extensively to both his dealer and the professor's family. They even showed him a photo of Freud and the professor shaking hands in front of a building on campus."

I nodded. "Well, that's pretty cool, all right."

"So I guess the desk's worth a fortune," Fred said.

Bill scratched his chin. "That's the funny part—no, it isn't. Turns out, Freud used a lot of stuff while he was here. Pens, tables, writing tablets. From the dealer's point of view, the desk was no big deal. In fact, Clayton got it from the dealer for a song. Though he tried to be vague about the details, I got the impression he paid less than $500 for it."

Fred wiped his mouth with a napkin. "So how much did he want to charge your friend Brett?"

Bill grinned. "Oh, he knew how much Brett wanted it for the movie. It would be a great prop—the desk my character would use in his psychiatry office. Brett could even add some dialogue to the script that pointed out the desk's origins. It would help show how sophisticated a collector the shrink is."

"You didn't answer the question," I said. "How much did Brett pay for it? Or should I say, how much did the *studio* pay for it?"

"Ah." Bill raised his forefinger meaningfully. "Now we're getting to the interesting stuff. I'm standing there next to Brett, while he and Clayton are negotiating. Brett's offering two thousand, then three. Clayton's hedging, the whole time making a big deal out of showing off the desk. The great condition the wood is in, how many neat little drawers are tucked under the roll-top. Reminded me of a used car salesman. But not a bad guy, really."

Mark poured some more wine. "Let me know when we get to the interesting stuff, okay?"

"Almost there," Bill said brightly. "Finally, it looks like Brett and Clayton have agreed on a number. When suddenly Clayton, who's still been opening and closing those little desk drawers, cries out in pain. Brett and I come closer and see that Clayton's finger has been cut by something."

"What was it?"

"At first, we don't know. But then Brett sees the sharp point of a wire coil, a kind of spring, sticking out from underneath one of those little drawers. He carefully pushes against it—and guess what? There's another, even smaller drawer under the first one."

"You mean, like a secret compartment?"

"Exactly," Bill said. "Those old desks always had secret compartments built into them, for important papers or private letters."

"Jeez, it's like something out of Dickens," I said.

"Or Agatha Christie," murmured Isaac. As often happened, he'd been silent for so long I had to turn my head to confirm that it was indeed his voice I'd heard.

Isaac smiled back at me benignly. "No, I haven't nodded off. I'm still dissecting this delicious salmon."

Meanwhile, Fred and Mark were leaning in on Bill from either side. Fred stabbed the air with his fork.

"Well?" he said. "What was in the secret compartment?"

"This." Bill held up the plastic bag and showed us the folded paper within. "Not the bag, of course. The piece of paper."

"Yeah, we kinda figured that," Mark said.

"As you can see, the paper's pretty old and fragile," Bill said, gingerly removing it from the plastic bag. He spread it out flat on the table. There were some typewritten lines on the single yellowed sheet.

I craned my neck to see.

"I can barely make it out. What does it say?"

Bill sat back, gesturing with his wine glass.

"Why don't you guys gather around and read it? I don't want to touch it any more than necessary. And I sure as hell don't want you jerks to, either. Not with all the steak sauce and melted butter dripping from your fingers."

We all did as Bill asked, standing in an informal semicircle around him and looking down at the sheet of paper. Isaac had his hand on my shoulder for balance as he peered down at the faded words.

"It was typed on an old manual typewriter," Bill explained. "Bob Clayton could at least tell us that much. And that from the condition of the paper, it was entirely possible that it was written in 1909."

"Shhh," Mark said sharply. "I'm reading."

So was I. Here's what I saw:

DOGGEREL

The first is the way to the truth
He soars that trusts in beginnings
Indeed may he struggle for proofs—
Say what you will of Elizabeth the First
Intrigues she withstood and inspired
She never matched swords with the fools
As I have, never in prejudice mired—
Heroes may come and villains may go
Oh the front is embattled by fire
As strong as the weak-minded dare
Xerxes himself he would tire

S.F.

I found myself reading it a second time, then a third. Finally, after a long silence, Mark spoke up.

"I'm no literary expert, but this sucks, right?"

"Oh, yeah," Fred said, straightening his back. "Can we sit down now?"

Bill nodded, and we all returned to our seats.

"Well," he said, carefully cupping the paper with his hands, as though it were an ember that might fly away. "What do you think?"

"First of all," Fred said, finishing his wine, "what happened after you guys found it?"

"What you might expect," Bill said. "Suddenly Clayton wasn't so anxious to sell the desk. If this really was written by Sigmund Freud, he might be able to sell the desk for a ton of money. Or he

might be able to make *two* big sales—one for the desk and one for the poem."

"Bet this didn't make Brett too happy."

"That's an understatement. They started arguing, with Brett threatening to never use Clayton's services again. He said that Clayton owed him for all his patronage over the years. Clayton argued back that he wanted to retire, and a big score like this would finally make that possible."

"So how did it end up?" I asked. "I mean, considering that you've got the poem in your possession."

Bill smiled. "Let's just say, it's hard to argue with a man whose last picture grossed half a billion bucks. Brett asked for a moment and excused himself to go outside. From what I could hear, he called his agent and the studio execs and just started screaming. Clayton and I could only stand there, kind of embarrassed, our eyes not meeting much.

"Ten minutes later, Brett came back in to the garage and said to Clayton, 'Look, I don't know if the poem's genuine or not, but we know the desk is. Freud probably found the secret compartment by accident, or maybe even the old professor showed it to him. If, for whatever reason, maybe as a private joke, Sigmund Freud wrote a silly piece of fluff and stashed it in the secret drawer, then it makes the desk more valuable to me.'

"'And to *me*,' says Clayton. Then Brett says, 'I know. That's why I'm prepared to make you a one-time offer of $350,000 for the desk and the poem.'"

"Three hundred and fifty grand?" Mark blurted out.

"For a poem whose authenticity hadn't even been verified yet?" Fred added, staring.

Bill nodded. "What Brett Loftus wants, Brett Loftus gets. At least until his next film tanks. To be honest, I thought Clayton would argue a little more, but he took the offer. The next day, the funds were deposited in his bank and the desk was shipped to the studio lot. Meanwhile, Brett entrusted the poem to me."

"Why?"

"Because my uncle in Philly is a well-known antiques authenticator. Brett's having the studio fly me there tomorrow afternoon to get his opinion of the poem's legitimacy. All expenses paid, of course."

Bill carefully put the paper back in its plastic bag. "Though to tell the truth, Brett isn't even that interested in whether or not it's genuine. He really just wanted the desk. But he wanted to make sure he got the poem, too. Otherwise—"

"Otherwise, he might feel as though Bob Clayton bested him in a negotiation," I finished for him. "Right?"

"You got it. Brett is one guy who hates to lose."

Another five intense minutes of cutting, spearing and chewing, and dinner was pretty much a memory. As the busboy took away the dirty dishes, we listened to the waiter recommend various preposterous desserts and describe the selection of after-dinner drinks. Essentially, we ordered one of everything and sent the poor man on his way.

Then, surprisingly, it was Isaac who spoke first.

"Bill, before we reach the end of this exquisite repast, I just want to thank you for your generosity."

"Hear, hear." Mark gave a little bow in Bill's direction. "Except for the company, a terrific meal."

"Thanks," Bill said. "My pleasure. But just for the hell of it, does anyone have any thoughts about the poem? Do you think Freud

wrote it?"

I shrugged. "I'm no expert on old Sigmund, but it's entirely possible. Most of his writings were deadly serious, as you can imagine, but he occasionally turned his hand to a quip or a joke. Of course, he was notoriously terrible at it. Though one of his best-known books dealt with the significance of humor in everyday life."

"But did he write poetry?" Mark asked. "I mean, even just for fun?"

"I don't know. Maybe. Remember, whoever wrote this poem entitled it 'Doggerel.' So he certainly wasn't making any claims for its literary quality."

"Although," Fred pointed out, "if you look at the theme of the poem, the author seems to be talking about the difficulties of fighting against the small-minded and the conventional. As I understand it, Freud was constantly battling with his medical colleagues about the veracity of his theories. Wasn't he thrown out of some medical societies because of his views?"

"Hell, yeah," I said. "And you may have an idea there, Fred. The poem does proclaim the heroism of a man who struggles against— what does he call them?—'the fools.' Jesus, maybe he *did* write it."

Bill stirred. "Look, I know I've got a one-track mind about this, since it all started with me getting a part in Brett's movie. But I think it's cool that Freud mentioned Queen Elizabeth, too. I mean, now *there's* a great part! You know how many actresses have played the Virgin Queen?"

He started counting them on his fingers. "Just off the top of my head, there's Bette Davis, Glenda Jackson, Cate Blanchett—"

"Don't forget Helen Mirren," I said.

"You're right," Bill said. "She was terrific, too. So was Judi Dench

in *Shakespeare in Love*. I think she even got the Oscar for it."

Then his brow furrowed. "Though I don't know who this Xerxes guy is. Or was."

"King of Persia," Fred answered matter-of-factly. "Around 500 B.C. Real badass."

Mark regarded him wryly. "Wow, you are a font of totally useless information, aren't you?"

Fred shrugged. "It's a gift."

By then, our decadent desserts and various coffees and liquors had arrived. As the rest of us began to work our way through them, Bill hesitated. I glanced up to find him looking earnestly at Isaac.

"Well, Isaac," Bill said. "We haven't heard from you. I mean, it's all academic anyway, since my uncle will be pronouncing his opinion in a day or two. But what do you think of the poem?"

Isaac paused. "I can't say I'm much of a literary critic myself. Though I do have two questions."

He turned to me. "When did Sigmund Freud die?"

I thought for a moment. "I believe it was 1939. Why?"

Isaac smiled. "Yes, I thought it was about that time. I asked because it helps clear up something about the poem that's been bothering me."

"You said you had two questions," Mark pointed out. "What's the second?"

Isaac turned to Bill. "I was just wondering if you or your friend Brett have talked to Bob Clayton since the $350,000 was deposited in his bank account?"

"I know I haven't. Should we get in touch with him?"

"I don't think you'll be able to," Isaac said. "I'm afraid he's

already begun spending his retirement on some exotic foreign isle, one whose government doesn't have an extradition treaty with the United States."

Bill's face paled. "I don't like the sound of that."

Mark took off his glasses. "Hold on, Isaac. Are you saying Clayton took off with the money?"

"That's what I would do," Isaac replied. "Once I'd managed to swindle it out of Brett Loftus and his Hollywood employers."

"Swindle?" Fred had just started in on his Cheeries Jubilee. "So you think the desk and the poem are fakes?"

"To be candid," Isaac said, "I'm not sure about the desk. We have only Clayton's word for what his own dealer supposedly told him about its history. But a simple call to the old Clark professor's family will verify that story. They may even be able to provide the photo of Freud and his American host that Clayton alluded to. No, I wouldn't be surprised if that part of the tale is true."

"But not the poem?"

Isaac smiled. "Consider this. It was Clayton himself who called attention to the desk's secret compartment by cutting himself—supposedly by accident—on the wire spring release. My guess is, he'd found the secret compartment during an earlier examination of the desk. Perhaps it was then that he came up with his scheme. After all, as he told Bill and Brett, he was ready for retirement. How better to fund his latter years than by bilking a well-funded movie director out of some cash?"

"Wait a minute," I said. "Maybe you're right, and Clayton had found the secret compartment earlier. But couldn't he also have found the poem inside it? That piece of paper sure looks old."

"That's probably because it is old," Isaac replied. "How hard do you think it would be for an antiques dealer like Clayton to get a hold of paper from that period? Or an early 20th century manual typewriter, for that matter?

"Besides," he went on, "Clayton practically told Brett that the poem was a phony. He was just cheeky enough to write it in such a way that the poem itself gave the game away. Unfortunately, neither Brett—nor Bill here, I'm afraid—managed to catch on."

"What do you mean?" Bill asked.

"May I see the poem again?" Isaac held out his hand.

Bill nodded, and once more took the fragile paper out of its protective covering. He gave it to Isaac.

"Look at how the poem reads," Isaac said, spreading it carefully in the middle of the table. "Look at the language. The poem begins, 'The first is the way to the truth.' Then the next line says, 'He soars that trusts in beginnings.' He even mentions Elizabeth the First. Then again, a few lines later, he writes, 'Oh the front is embattled by fire.' See what I'm getting at?"

"No," I said.

"I think I do," Fred said quickly. "The poem keeps talking about 'the first,' 'the front,' 'beginnings'..."

Isaac's eyes glistened. "Which suggests... what?"

Suddenly, Mark snapped his fingers—which, unfortunately, brought the waiter scurrying over.

"Sorry, man," Mark said, politely waving him away. "False alarm."

Then he turned back to the table. "I think I get what you're saying, Isaac. Those phrases are all supposed to point the reader in a particu-

lar direction. To the front, or beginning, of each line of the poem. Is that it?"

"Door prize goes to Mark," Isaac said happily. "Yes, the beginning—in other words, the first letter—of each line. Which, as a quick glance will show, means the letters T-H-I-S-I-S-A-H-O-A-X. Spacing them out correctly, the message reads—"

"'This is a hoax,'" I said aloud. Despite myself, I had to laugh.

"Holy hell," Fred said, smiling, too. "Now I know why he referred to Xerxes. He needed an 'X.'"

Meanwhile, Bill just stared down at the poem with a look of distaste. "That Clayton. What a creep."

"At least he's an honest creep," Fred said. "He told you and Brett right there in the poem that it was a hoax."

"Remember, too," Isaac added, "Clayton had to assume Brett would have it professionally examined. He knew an expert would easily see through the deception. And since Clayton hoped to be long gone by then, he probably thought planting the code in the poem itself might be a fitting joke to play on the egotistical film director. A final, good-bye tweak on the nose."

"That 'joke' cost Brett's studio bosses $350,000," Bill said. "Not that they can't afford it. They spend more than that on wrap parties."

"True," Isaac said. "Though, in a way, Clayton also inadvertently played a joke on himself. In fact, his own mistake when writing the poem was what initially tipped me to the fact that it was a fake."

"What mistake?" Fred asked.

"He refers to 'Elizabeth the First'—meaning, of course, the famous Tudor Queen played on-screen by all those fine actresses

Bill mentioned. But Elizabeth was never known as "the First" until 1952, when Elizabeth II ascended the throne. I remember that event pretty clearly, since I heard the live news report of the occasion on the radio."

I smiled. "That's why you asked me when Freud died."

"Correct. If this poem had really been written in 1909, the author would have referred to the Queen only as 'Elizabeth.' Or, perhaps, 'Elizabeth R,' for 'Regina.' How could he have called her the 'First,' when a 'Second' wouldn't even exist until the 1950s?"

"Good point," Mark agreed.

"Yeah, Isaac," Bill said dryly. "Looks like you've done it again."

Isaac looked abashed. "Sorry about that."

Bill snatched up the poem with a lot less care than he had previously and tucked it back in the plastic bag.

"There goes my trip to Philly, too, dammit," he grumbled. "Did I mention it was all expenses paid? But I gotta call Brett and tell him what we've found out."

Mark patted his shoulder. "Tough break, man."

"But at least the desk may be legit," Fred said.

"And you still have that great part in the film," I added, without much enthusiasm. "The serial killer shrink."

Bill brightened. "That's true. I mean, that's the most important thing, anyway."

"Well, there is one thing more important than that," Mark said, stirring amaretto into his black coffee.

"What's that?"

"You're still picking up the check, right?"

Which brought a chuckle from Isaac, who raised his cup of tea

to the rest of us.

"If I may, let me make the final toast," he said warmly. "To two distinguished gentlemen, Bill and Sigmund. Thanks to them, we've enjoyed both a wonderful meal and an interesting little puzzle. What member of the Smart Guys Marching Society could ask for more?"

"To Bill and Sigmund," I repeated, as we all raised our drinks to touch Isaac's.

"Just remember, Bill," Fred said. "When you get your Oscar, don't forget to mention us."

"Believe me, I will." Bill gave him a wicked smile. "After all, Oscar winners always remember to thank the little people...."

End

One For The Road

"I'm afraid this is my last meeting of the Smart Guys Marching Society," Isaac announced matter-of-factly, as he settled into his usual corner armchair.

Mark, Fred and Bill all seemed to react at once. Bill had been scooping spoonfuls of three-bean salad onto a paper plate; suddenly he froze, spoon suspended in midair.

Fred had been leafing through the Op-Ed section of the *Times*, looking for suitable subjects for discussion; now he let the upper fold fall forward, revealing the stunned look on his bearded face.

Mark had just hoisted a cold Samuel Adams, which now was poised inches from his lips.

"What?" Bill was the first to speak.

"You're leaving?" Fred put down the paper. "Why, Isaac? What's going on?"

Mark was the only one to look at me.

"Did you know about this?" he asked sharply.

I nodded reluctantly. "Yeah. My wife and I have been trying to talk him out of it all week. But Isaac can be a stubborn bastard when he wants to be."

"Stubbornness has nothing to do with it," Isaac said. "You and your lovely wife have been wonderful to me all these many months. But I've imposed on your hospitality long enough."

It's true, Isaac had been a guest in our home for quite a while. Distantly related to my wife, and long retired from a somewhat peripatetic life as a "Jack of all trades," Isaac had been invited to stay with us until more permanent arrangements could be made. Somehow, whether due to our enjoyment of his avuncular presence or to his growing comfort as a member of the family, he'd just more or less taken up permanent residence.

And so things had stood, until he broke the news of his leaving to me and my wife a few days ago. We'd been arguing about it with him ever since.

Now, as expected, Isaac would also have to withstand the protests of the other Smart Guys.

Bill waded in first. "Isaac, I think you're making a big mistake. For one thing, your staying here *hasn't* been an imposition." He turned to me. "Right?"

"Absolutely," I said. "We've loved having him...as we've tried to get through his thick skull."

"Perhaps," Isaac said. "But enough's enough. I'm starting to feel like Sheridan Whiteside."

"Who?" Mark said.

"The old guy in *The Man Who Came to Dinner*," Bill explained. "He

comes to a house for dinner, has an accident and has to stay to recuperate. He ends up never leaving. Drives everybody in the place crazy."

"You're nothing like that character, Isaac," I said, with a sidelong glance at Bill.

"Besides," Mark chimed in, "even if you feel you have to move out, that doesn't mean you can't meet with us every week. I mean, what would the Smart Guys be without... well... the smartest guy?"

"Good point," Bill said.

"I appreciate the sentiment," Isaac said. "But the fact is, I've been invited by an old friend in Vermont to stay in his guesthouse. His wife passed away recently and he needs help running his farm equipment business. It's the kind of part-time work that's perfect for a semiretired vagabond like me."

"Vermont? That's clear across the country." Bill sulked. "Man, this truly sucks."

Isaac sighed. "Of course, I will miss these weekly get-togethers. The verbal joustings, the bad jokes. The very congenial company."

"Not to mention the occasional crime-solving," Fred added. "Which, without you, will probably grind to an embarrassing halt. Four Watsons without our Sherlock Holmes."

"Hardly that," Isaac said. "Besides, we haven't had any mysteries to solve for some time now. Maybe the Smart Guys' good luck in that department has finally run out. Now you four can go back to being the informal think tank that was your original intention."

"I guess so," Bill said, listlessly spearing some cold cuts onto his plate. "But it just won't be the same without you, man."

"That's for damn sure," echoed Mark.

"Which is what I've been trying to tell him all week," I said irritably.

"Haven't made a dent."

We sat in silence for a long moment.

"So," Bill said at last, "when are you leaving town?"

"Three or four days," Isaac said quietly. "Which makes today my last meeting."

"Too bad we can't send you off with a good crime to solve," I said. "A nice double-homicide or something."

Isaac laughed, but I noticed that Fred's face was suddenly alert, as though something had just occurred to him. He returned my questioning look with one of his own.

"How about a nice *single* homicide?" he said, with the briefest of smiles. He turned to the rest of us.

"No way," Bill said, brightening considerably.

Fred held up his hand. "Now don't get too excited. It's an old case, handled by another attorney in our firm. Pretty much open-and-shut. Our client was convicted and has already served ten years."

"Ten? What was his sentence?" Mark asked.

"Life, without parole," Fred said. "Though his lawyer's just mounted another appeal. But I'm afraid he won't get any further than he did with the last two tries."

"Oh," Bill said, slumping again.

"Wait a minute," I said. "Let's at least hear what Fred has to say. I'd hate for this to be our last meeting with Isaac without us trying to figure out some kind of mystery. Even an old one."

"Besides," Mark said, looking suspiciously at Fred, "I have the feeling you wouldn't have brought the case up if something about it didn't bother you."

Fred nodded. "Well, there are one or two things about the original

trial that don't feel right to me. Remember, though, this was ten years ago, and it wasn't even my case. Plus, we try not to step on each other's toes at my firm. But still... how do I put this?..."

"You think your colleague screwed up?" Mark said.

"I'd never say something like that."

Bill sat forward excitedly. "Are you saying his client is really innocent?"

"I'd never say *that*, either," Fred replied smoothly. "I'm just saying I'm not sure he's guilty."

"Lawyers." Mark scowled, reaching for some cheddar and crackers. "Always covering their asses."

"Well, Isaac," I turned to him. "How about one more mystery for the road? You interested?"

Isaac sat back and stroked his white muttonchop sideburns distractedly. But he couldn't hide the light that glinted in his old, pale eyes.

"Well, if you guys have nothing else you'd rather discuss today..."

Bill grinned. "You're a lousy liar, Isaac. I've always liked that about you."

Isaac responded with a rueful smile that I took as my cue.

"Okay, counselor," I said to Fred, offering him a cold Corona Lite. "Looks like the floor is yours."

Fred took a long slug and then pointed the bottle at the rest of us. "I'm sure you remember the Francis O'Dell murder. It occurred almost 13 years ago, but it took forever to come to trial. That's what happens when everyone involved is rich."

"Francis O'Dell?" Bill said. "The old manufacturing zillionaire? With the museums up and down the state?"

Fred nodded. "That was him. Like J. Paul Getty, Armand Hammer. Guys who love to see their names on huge, classic-style buildings. Modern-day emperors."

"Of course I remember that case," I said, munching some Doritos. "Who doesn't? His own son shot him, right?"

"That was the charge. Jury found him guilty, too. Open and shut, like I said. The only surprising thing was the judge's ruling that the trial not be televised. So the city was spared the whole O.J. media circus."

"Still, there was huge fallout in the press after the verdict," Mark said. "Plus all those TV pundits weighing in. Decrying how the children of the superrich are raised without morals, without constraints. As though they're somehow above the law."

Fred smiled. "In this case, public opinion may have been right. I attended a few days of that trial. I saw the accused, Francis, Junior—they call him Frankie—on the stand. Real creep. All attitude, no remorse. Practically admitted he was glad his old man was dead. No wonder they returned a guilty verdict in less than three hours."

"And somebody from your firm defended him?" I said.

"Yeah. Lawrence Danton. Smart as a whip. He worked in criminal law for years before joining our firm and switching to corporate. He'd been the O'Dell family's lead counsel for years. Knew the old man intimately. And the rotten son."

Fred shook his head. "I saw Danton the day after the murder. I could tell he took the old man's death hard. But the family insisted he handle Frankie's defense. Danton brought on an experienced criminal attorney to help, of course, and hired a battery of investigators and consultants. But he was lead for the defense."

"Didn't do much good for the kid, did he?" Bill said.

"Frankie's hardly a kid. He was almost 40 at the time. Classic screw-up son of a prominent man."

Fred shrugged. "Besides, there wasn't much Larry could do. The murder weapon, a .38 revolver, belonged to Frankie. Though the prints were too smudged for a positive ID, it was in his possession as he fled the scene of the crime. Slam dunk for the DA, and everybody knew it."

"So why are you bringing it up?" Mark said irritably. "Hardly seems up to our usual high standards."

"Easy, big fella," Bill laughed.

Fred finished his beer. "Well, to tell you the truth, we were reviewing old case files last week at the firm, as part of a routine inventory, and the data package from the O'Dell conviction caught my eye. Especially since I knew Danton was about to file another appeal. Poor bastard, he's semiretired now, but he won't give up on Frankie."

"But something struck you about those case files, didn't it?" Isaac asked quietly, drawing my gaze.

It looked like he'd begun sorting his beloved cache of paperbacks into neat piles, which only reminded me that the process of packing up his things was already underway. God, I was going to miss him.

"Well..." Fred had shifted in his seat. "Look, I ended up reading everything. Investigators' reports. Trial transcripts. Depositions from within the O'Dell camp. And something seems... well... *off*, I guess."

Bill looked over at me. "Isn't this about the time you suggest that whoever's telling the story should start at the beginning?"

I smiled. "I believe it is about that time."

"Okay," Fred replied. "But first, some O'Dell family history. It's

pertinent."

Bill smirked. "We'll be the judge of that."

Then he began piling his plate with pastrami from Art's Deli and two mounds of potato salad. Apparently he was fortifying himself for a long narrative siege.

"Old man O'Dell was a boon to our firm," Fred began. "I mean, he utilized a dozen lawyers just in our L.A. office, let alone our branch offices back East and overseas. Generated millions in fees. But he was a mean-spirited, bigoted son of a bitch. Universally hated by family and business associates alike. I met him twice myself, and it was two times too much. Scrooge without the people skills, you know what I mean?"

"We get it, yeah," Mark said.

"Luckily, the one guy in the firm that could get along with the prick was Lawrence Danton. He coddled the old guy constantly. Listened to his complaints about his children. Helped keep tabs on his schedule, appointments. I don't know how the hell he did it, but he kept Francis O'Dell happy. Or as happy as the old man ever got."

"What about O'Dell's family?"

"The wife died a few years ago. I think he just wore her down until she gave out. She looked like a skeleton those last years. Anyway, they had two kids, both major losers. The daughter, Jane, was a bulemic part-time fashion model and full-time cokehead. Her taste in boyfriends ran to drug dealers, gangsta wannabes and porn stars. Used to kill the old man every time one of her exploits made the tabloids. Which was pretty damn often."

"I remember her, too," Bill said. "Real party animal. She was like the Paris Hilton of her time."

"What about the son, Frankie?" I asked.

"Another model citizen," Fred said. "Dropped out of a couple expensive schools, tooled around the world till far into his thirties. Playboy type, but a big talker, with big dreams. Always involved in some crazy investment scheme or business venture, then needing his father to bail him out. Bled the old man of millions over the years."

"Why did O'Dell Senior put up with it?"

"Hard to say. Maybe he figured it was promising that Frankie at least had an interest in business. In building up something of his own. But then, finally, after Frankie lost another ten million on a Middle East construction deal that fell apart, Daddy pulled the plug. Cut Frankie's monthly allowance, took the cars and the jets. After that, Frankie had to scrape by on just a hundred thou' a month."

Bill shook his head. "Hardly enough to keep body and soul together."

"It's tragic, I know." Fred smiled. "Anyway, that's when the O'Dell Wars really heated up. Father and son became very vocal, very public enemies. Their arguments were epic, many of which turned up in the press. The papparazzi loved to get shots of them throwing plates at each other in fancy restaurants or screaming at each other outside corporate boardrooms."

I nodded. "It's all coming back to me now. I recall seeing those stories on the news. In the tabloids. Didn't somebody get Frankie on video at some charity dinner, threatening to kill his father with a gun?"

"Oh, yeah."

"Bet the DA loved that," Mark said.

"Tell me about it. It all came out at the trial. The spoiled rich kid

who turns on his loving father when the old man finally puts his foot down. Press ate it up."

"No surprise there," Mark said.

"Maybe," said Fred, "but all this fighting was taking a toll on the old man. His health was failing. Many people thought his ironclad grip on his affairs was slipping. There was talk in the international financial community that the O'Dell empire was showing dangerous cracks."

Fred scooped up a handful of peanuts. "That's when somebody tried to run over the old man in the street."

"What?" Mark said. "I don't remember that part."

"That's because the family managed to keep it out of the press at the time," Fred said. "Though it came out prominently later at the trial."

"Where did it happen?" Bill asked.

"Outside a restaurant in Pacific Palisades. One of those little places off Sunset. O'Dell was coming out of the place with a companion at midnight. Suddenly a car came out of nowhere and ran into him, then roared off. Happened so fast, nobody could ID the car. Not even the companion."

"What do ya mean, companion?" Bill said. "Are we talking man, woman, cocker spaniel...?"

"A young woman," Fred replied evenly. "Hired for the evening. One of many he employed. Apparently, the old man's libido was as impressive as his fortune."

"I should be so lucky when I'm his age," Mark said. "So what happened?"

"Naturally, everybody figured this would be it for the old bastard, but he survived. Had emergency surgery and was put in an exclusive,

private hospital. One of those places that cater to celebrities and the superrich. Docs figured he'd need at least a month to recuperate."

"What did the cops say?"

"About the hit-and-run? Not much. There wasn't anything to go on. No witnesses, no description of the car. But O'Dell's list of enemies circled the globe. Old business associates he'd screwed, financial adversaries he'd made a point of ruining. Not to mention his army of mistreated servants and employees."

Fred smiled grimly. "And that's not counting his own children, both of whom hated his guts."

"Typical problem with such a high-profile victim," Mark said. "Too many suspects, with too many motives."

"Any one of whom could try again," I suggested.

Fred nodded. "Larry Danton thought the same thing. That's why he called in some favors from LAPD and had them station a cop outside the old man's hospital room. Except for the doctors and nurses, the guard had instructions to search everybody entering the room."

He reached for a turkey pinwheel and took a bite.

"Now we come to the night of the murder," he said dramatically. "The old man's been awake and conscious only a few days, but already the entire hospital staff hates his guts. He treats everyone like crap. Complains about everything. Plus, he has computers brought in, Internet access, a bank of phones. His people coming in and out, taking orders. Like some bedridden mogul out of a '30s movie. Though he can barely talk and drifts off every hour or so from the pain medication. The whole scene would've been funny if it weren't so ludicrous."

"How do you have such a clear picture of it?" I asked.

"Lawrence Danton kept the rest of the firm advised. And kept copious notes. He could be kinda anal that way. Luckily, those were in the case files as well, so I got to read them. That's why this is all so fresh in my mind."

Fred finished off his beer. "Anyway, like all good family retainers, Danton tried to be both a lawyer and a kind of uncle. He made repeated calls to Jane, the cokehead daughter, urging her to come visit her father. With Frankie, he was more assertive. He made him come at least once a day to the hospital."

Mark frowned. "Pretty dangerous, considering the son's relationship with his father."

"I know. Apparently, Larry would meet him outside the sickroom and coach him on how to talk to the old man. Maybe there could be some fence-mending. Of course, most days Frankie showed up drunk or stoned. And *every* day he showed up angry and belligerent. Spoiling for a fight with the old man."

"Surely O'Dell's doctor wouldn't allow that," I said. "Would he?"

"Funny thing about that guy," Fred replied. "Very funny, if you ask me. Francis O'Dell's private doctor was a young, ambitious guy named Howard Parker. Brilliant but arrogant, with about the same love of humanity as O'Dell himself. Maybe that's why O'Dell insisted on using him as his primary care physician."

"Why would Dr. Parker put up with him?"

"The same reason anybody else who knew O'Dell did: the promise of money. Turns out, the old man had promised Dr. Parker that he'd fund a new, state-of-the-art research wing at the hospital. Parker apparently liked research better than patients, and dreamed of making a fortune in the biotech industry. Gene-splicing technology, that

kind of thing. The problem was, the day after coming out of surgery following the hit-and-run, O'Dell told Dr. Parker he'd changed his mind. He'd decided not to give Parker the funds he needed."

"How did the good doctor take the news?" Bill said.

"Let's put it this way—not well. According to his own staff, Parker flew into a rage and said he refused to ever treat O'Dell again. Even with the old man having barely recovered from his injuries."

"I don't blame him," Mark said. "Besides, it's not like O'Dell couldn't get another doctor."

"Maybe. But it fell to poor Larry Danton to remind Parker that he'd signed an ironclad agreement with O'Dell to provide continual, personal medical care. That O'Dell would make it his business to sue Parker for everything he had, and ruin his career. O'Dell swore that if Parker deserted him now, he'd see to it that the doctor couldn't get a job lancing boils in Calcutta."

"So what did Parker do?" Bill said.

"What *could* he do?" Fred replied. "He came back to work the next day, tending to O'Dell's every complaint. Monitoring his medication. Running diagnostic tests. O'Dell demanded that Parker be at his bedside from dawn till dusk... just in case he was needed."

Mark scratched behind his ear. "So Parker was there the night O'Dell was killed?"

"Yes," said Fred. "Though it was evening, really. Just before seven. It had been raining all day, so even though Danton told Frankie to meet him at six-thirty, he wasn't surprised when the sorry prick showed up a half hour late. Frankie was even more drunk than usual, wearing a soaking wet raincoat and carrying some huge, leafy plant in a copper pot. Danton says that Frankie could barely stand up, he

was so drunk. Real class act, this guy."

Bill shrugged. "At least he brought something."

"Not exactly. Frankie told Danton that the plant was a gift from his sister Jane, who'd asked him to give it to their father as a kind of peace offering. Then Frankie said something like, 'What I really oughtta do is go in there and dump it on his ugly goddamn head.' Danton says in his notes he *thought* that's what Frankie said, but that he was so wasted and angry he was almost incoherent.

"Anyway, the guard outside the door searches the big plant, then turns Frankie around and frisks him from behind. Frankie's cursing him out the whole time, which just pisses off the guard more and more. Poor Danton has to keep chiding Frankie, while at the same time trying to apologize to the guard. Then Frankie almost stumbles, so Danton offers to help him out of his wet coat. After that, the guard turns to Danton, searches him thoroughly as well, and ushers them both into the hospital room.

"Well, old man O'Dell takes one look at the plant his daughter sent and orders it removed from his sight. Frankie just laughs, like it's no skin off his nose, and slams the pot down so hard on a side table that the attending nurse gasps. Meanwhile, Danton confers with the long-suffering Dr. Parker, who stands vigilant by his patient's bed."

"How *was* the patient, by the way?" Mark asked.

"According to Danton, the old man looked like a living corpse. Skull-like head swathed in bandages, tubes going in and out of his skinny arms. An oxygen tank and an IV feed standing next to the bed. But apparently his eyes were bright and alive. And full of anger."

"What happened then?" Bill said.

"What usually happened," Fred answered. "Frankie leaned over

the bedrail and started berating the old man. Demanding that his share of the family money be released. That he had a right to it. But O'Dell gave as good as he got. Apparently, he called his son every name in the book.

"Then, finally, O'Dell accused Frankie of stealing from him. He said that he suspected Frankie had been embezzling funds from the company for years. And that now he was going to prove it. That's why he'd hired a forensic accountant the week before, to make a thorough audit of the corporate assets. Soon he'd have the evidence he'd need to have Frankie thrown in jail. Of course, by this point, O'Dell was sputtering and gasping so much you could barely understand him."

I stared at him. "And Dr. Parker allowed this?"

"There wasn't much he could do. He and Danton had both leaned in beside Frankie by now, urging him to move away from the bed. Parker told him that this furious argument was endangering his father's health. 'Like I give a shit!' Frankie yelled. Finally, Parker grabbed Frankie's arm and pushed him away. In his drunken state, Frankie stumbled into the IV setup, almost knocking it over."

"Jesus," Mark said.

"Apparently, as Dr. Parker frantically tried to fix the IV, Frankie just grabs up his raincoat and says he's leaving. So Parker confronts him, furious now himself. Larry Danton feared they might come to blows, so he placed himself between the two men and ordered them to calm down."

"Did they?" I asked.

"Dr. Parker did, but Frankie just let loose with a string of obscenities and banged out the door. Danton said afterwards he thought the poor nurse, shuddering in a far corner, was going to faint right then

and there."

"What about O'Dell?"

"That's what Dr. Parker was worried about. After making sure the IV drip was secure, he went back to the old man's bedside. Then, suddenly, Parker cried out in shock."

Fred sat back in his seat. "Danton and the nurse rush to the bedside, where Parker is pointing at fresh blood seeping from under the old man's body. The nurse pulls back the covers and they all see a jagged hole in O'Dell's ribs. Gathering himself, Parker checks the old man's vital signs and looks up at Danton. 'He's dead,' Parker says. 'He's been shot.'"

"Holy shit," Bill said.

"You could say that," Fred replied. "Of course, as soon as he realizes what just happened, Dr. Parker goes and alerts the guard, who's still standing outside the door. Then Parker sees Frankie stumbling down the hallway and orders the guard to stop him. The guard is only too happy to run down the hall and tackle Frankie. When Parker, Danton and the nurse finally join them, they find the guard going through Frankie's raincoat. In one of the pockets he finds a .38, with a silencer attached to the barrel."

"A silencer?" Bill mused. "That's how come nobody in the room heard the shot when the old man was killed."

"Exactly. The guard sniffs the barrel and announces the gun's just been fired. But then he himself becomes agitated, swearing that he'd searched the raincoat earlier, when Frankie first showed up, and that the pockets were empty. By then, the hall was swarming with hospital security, staff, other doctors. Pandemonium."

"What about Frankie?"

"True to form, Frankie was struggling like a drunken bull, cursing everybody out, demanding to be let free. Witnesses said it took three cops to control him as they dragged him off to be detained for questioning. Naturally, Danton went along as his attorney, while Dr. Parker returned to the room to deal with his late patient."

Fred let out a long sigh.

"And that, boys and girls, was that. Man, I need another drink." So one was provided.

I was still digesting Fred's narrative when Isaac politely cleared his throat. Until then, he'd seemed so preoccupied organizing his stacks of old books, I wasn't sure if he'd even been listening.

"A tale well told, counselor," he said.

Fred beamed. "Geez, Isaac. Thanks."

"Very helpful, too," Isaac continued, "since my memory of that whole affair is quite sketchy. I believe I was working a construction job up near the Alaskan pipeline at the time. Not much access to the news, I'm afraid. So most of this is brand-new to me."

"To tell the truth," Mark said, clasping his hands overhead and stretching, "it feels that way to me, too. After all, it's a 13-year-old case. Lots of celebrity murders and mayhem since then."

"Besides," Bill added, "it's pretty much a no-brainer. The wastrel firstborn son slays the powerful, demanding father. Goes back to the Greeks. Shakespeare." He chewed a potato chip coated with french onion dip. "Tragedy 101, with a silencer. Been there, done that."

"Not to mention the likely Oedipal issues," I added.

"Perhaps that's all true," Isaac said carefully. "Though I can certainly understand Fred's concern about Frankie's trial."

Fred looked up, pleased. "You see it, too, Isaac?"

"See what?" Bill asked.

Fred leaned forward intently. "I think the police missed the boat when it came to likely suspects. Or, at least, to a possible alternative theory about the murder."

"Alternative theory?" Mark said.

"Yes. Think about it. Who was allowed to go in and out of Francis O'Dell's hospital room without being searched? Who had a reason to hate the old man for denying him the money he'd promised? And, finally, who had the clearest opportunity to commit the crime?"

"Are you talking about Howard Parker?" I asked.

"Of course." Fred folded his arms. "Dr. Parker was furious when the old man refused to fund his research wing. Not only that, he was threatened with ruin if he stopped treating his ruthless, backstabbing patient. So Parker decides to kill him."

"Ahh," Bill murmured. "Remember what Conan Doyle said. When doctors go bad, they're the first among criminals."

I gave him a questioning look. He pouted.

"Hey, I did a reading for NPR a few years ago," he said. "I do highbrow stuff like that all the time."

"Yeah, we're all impressed." Mark sighed. "Sorry about the interruption, Fred. Now, you were saying..."

Fred sniffed. "Well, as I was about to say, since he's never searched, all Dr. Parker has to do is hide the gun in his hospital whites and wait for the right moment. It comes when Frankie and the old man are arguing at the bedside. Parker pushes Frankie away, then Frankie stumbles over the IV. In that moment's commotion, Parker, already leaning over the old man's bed, slips the gun under the bedcovers and fires."

Fred's eyes narrowed. "Now, remember what happens next. Parker comes over to fix the IV drip. Meanwhile, Frankie grabs up his raincoat to leave, and Parker confronts him physically. I mean, they're literally in each other's faces. So much so that Larry Danton has to separate them. But not before Parker has seized the opportunity to slip the murder weapon into Frankie's raincoat."

"Dr. Parker?" I said, trying to see it in my mind. "Are you serious?"

"Totally," Fred replied. "Especially when you add in that it was Parker who goes back to the old man's bedside and 'discovers' the bloodstains. It's Parker who points to the gunshot, and announces dramatically that the old man is dead. It's Parker who runs out and alerts the guard and tells him to stop Frankie from leaving."

Bill gave a low whistle, as Mark and I just exchanged looks. Was Fred right? Had the wrong man been convicted and served ten long years for a crime he didn't commit?

"Maybe you got something there, Fred," Mark said at last. "With O'Dell dead, Parker gets his revenge and is freed from having to take care of the old bastard for God knows how many more years."

"If nothing else," I added, "it does suggest an alternative suspect for the crime. If I were Danton, I would've tried to float it at the trial. Give the jury a new thing to think about."

"Exactly," Fred said. "A thing called reasonable doubt. A plausible alternative suspect creates enough reasonable doubt about Frankie's guilt to acquit him."

I turned. "What do *you* think, Isaac?"

But he'd risen from his chair and was heading out of the room to the back hall.

"Isaac?" Fred called after him.

"Have to make a phone call," Isaac said over his shoulder. "Won't be a minute. Though you all might ask yourselves one question: how would Dr. Parker get a hold of Frankie's gun?" Then he was gone.

The rest of us exchanged puzzled looks.

"Well, that was pretty weird," Bill said. "Even for Isaac."

"Maybe he's calling the airlines," I suggested. "He mentioned wanting to check on a possible upgrade for his frequent-flyer miles."

"Now?" Fred asked. "We're in the middle of something here. What about my theory of the crime?"

"Actually," Mark replied, "I think it's pretty good. Though Isaac brings up a valid point: what was Dr. Parker doing with Frankie's gun?...Where's the doctor now, by the way? Do you know, Fred?"

"Not really. By the time of the trial, he'd already switched to a different hospital. He could be anywhere. But I could easily find out if he's still in L.A."

"Not as easily as I could," Mark said wryly.

"Oooh, you're so mysterious," Bill said. "James Bond in retirement. How long are you gonna play that card?"

Before Mark could respond, Isaac came back in from the hall. To my surprise, he was carrying my wife's leafy spider plant from her office. It was in a ceramic pot.

"I hope your wife won't mind that I borrowed this," he said cheerfully.

Without another word, he put it down on the coffee table, crowding out the platters of cold cuts and bowls of chips. Regrettably, one of the drooping plant fronds landed in the french onion dip.

"That's okay," Bill said, staring at it. "I'm kinda off the dip lately

anyway."

Isaac then took his old suede jacket from the back of his chair and handed it to Fred.

"Do me a favor, will you?" he said. "Put this on?"

Fred frowned. "I'm not cold."

"Humor me."

Fred looked at the faded jacket, shrugged at me, then put it on over his polo shirt. Then Isaac handed him the potted spider plant. Fred held it carefully in both hands.

"Now," Isaac announced to the rest of us, "let's pretend that the jacket Fred's wearing is Frankie's raincoat from the night of the murder. And that the spider plant Fred's holding is like the plant Frankie brought. According to the story we just heard, the guard searched the plant Frankie had in his hands and then frisked him from behind. There was nothing on him, in his pants pockets or raincoat pockets. Right?"

"That's what the guard said," Fred agreed, peering at Isaac between the plant's bulbous array of fronds. "He testified to that fact at trial."

"Fine. What happened next?"

"Frankie was so drunk," Fred replied, "that Larry Danton had to help him off with his raincoat."

"Just as I'll now help you off with the jacket."

Isaac stepped behind Fred, as though to help remove the jacket. But Fred laughed.

"Whoa, Isaac. I can't let you take the sleeves. I'm still holding the plant."

Isaac smiled and came around in front of Fred again.

"Exactly. For me to help you off with the jacket, you have to let go of the plant. Maybe you could put it down on the floor. Or maybe I could just take it off your hands."

With that, Isaac took the plant from Fred and put it back down on the coffee table. Then he again stepped behind Fred and successfully helped him off with the jacket.

"Okay," Isaac went on, "after the raincoat's been removed, what happens next? The guard searches Larry Danton, and then he and Frankie, carrying the plant, go into O'Dell's hospital room."

Isaac looked expectantly from one of us to the other.

Bill broke the silence. "I don't get it."

"Me, neither," said Mark.

Isaac considered this, as he carefully folded the jacket and placed it once more on his chairback.

"Maybe things will become more clear if you look in the plant," he said.

Mark nodded and bent over the plant, parting the fronds. Then, with a grin, he reached in and pulled out a venerable paperback copy of Bradbury's *The Martian Chronicles*.

I took the book from Mark's hand.

"Okay, Isaac," I said. "How did this book get in the spider plant?"

"I put it there," he replied, "when I took the plant from Fred so I could help him off with the jacket. I already had the book in my pocket. It was easy to slip it down under the leaves when I turned for a moment to put the plant back down on the coffee table."

Isaac's eyes narrowed. "Just like Larry Danton did with the gun he'd had in *his* pocket, when he took the plant from Frankie before helping him off with his raincoat."

"What?" Fred literally gasped.

"Danton?" I said. "The lawyer?"

Mark whipped off his glasses. "Now wait a minute—"

Isaac held up his hands. "Whoa! Not everybody at once. At my age, I can't take that much excitement."

Fred managed to let out a long breath before speaking.

"Look, Isaac. This is Lawrence Danton we're talking about. A respected member of the bar. A colleague at my firm." His face flushed with sudden anger. "Hell, the man's practically retired, and he's *still* working on Frankie's appeals. Still trying to help him get out of prison."

"Which, I agree, is quite unusual, given the pains he took to get him in," Isaac replied, with an equally sharp edge to his voice.

I think we were all taken aback by his tone, one we'd rarely heard from Isaac before. Equally rare for us was the long moment of uncomfortable silence that followed.

Finally, making a show of adjusting his glasses, Mark looked first at Fred, then Isaac.

"Look, I understand Fred's reaction. Danton's a friend and colleague. I'd probably feel the same way. So maybe you should just tell us what you think happened, okay?" Another glance over at Fred. "Couldn't hurt to hear another theory, right? I mean, isn't that what we do here?"

Fred looked less than enthusiastic, but nodded.

Isaac smiled at him. "Of course, I understand, too. And remember, this is pure speculation on my part. But when I realized that there was no way to help someone off with a coat if that person's holding something, my thoughts began circling around Danton."

Fred paused, then allowed himself a rueful smile.

"I see your point. Though maybe I'm also a little pissed that you discarded my own theory about Dr. Parker."

"Not at all," Isaac said. "It's a fine one. Hell, it may be the correct one. Because, frankly, I too thought it strange that Danton didn't raise it at trial. As you say, Danton could easily have presented enough evidence pointing to Dr. Parker's possible guilt to make the case for reasonable doubt. So, I wondered, why didn't he?"

Isaac indicated the copy of *The Martian Chronicles* that I'd forgotten I was still holding. I gave it back, and watched as he carefully returned it to one of the stacks.

"Just as I wondered," he went on, glancing back at Fred, "why Danton had put Frankie O'Dell on the stand. Of course, you'd know more about this than I. But usually, when faced with such an obviously unlikeable client—one certain to alienate the jury—don't most lawyers try to *prevent* that client from testifying in his own defense?"

"Absolutely. When I watched Frankie's performance on the stand, I questioned why Danton allowed it. At the time, I just assumed Frankie had insisted on testifying."

"Perhaps. But it could just as easily been the other way around. Frankie might not have wanted to, but Danton, knowing how bad his client would look, was the one who insisted."

I shook my head. "I'm still not clear about all this. I'm talking about the night of the crime... I mean, what exactly happened...?"

Isaac sighed. "Again, much of this is conjecture, but I think the facts bear it out. Remember what happened after the old man came out of the surgery. There's a guard posted outside the hospital room door. Danton knows that everyone but doctors and nurses will be

searched every time they enter the room. So what does he do? How can he contrive to get a gun into that room, kill O'Dell, and implicate someone else for the crime?"

"All good questions," Fred said, sounding a bit dubious again. "I'm assuming you have some answers."

"Well," Isaac replied, "let's look at Danton's actions that whole week. He insists that Frankie come visit his ailing father every day, even arranging to meet with him beforehand. And every time Frankie shows up, he's drunk and belligerent. So it's probably no surprise that, each day, as Danton and Frankie approach the door to the sickroom, the guard's instinct will be to search Frankie first. Larry Danton notes this. In fact, he counts on it.

"Then, the night of the crime, something new is added to the ritual. Frankie arrives with a big potted plant. But where did he get the plant? From his sister Jane, who asked him to deliver it as a peace offering. I can't help but wonder if perhaps Danton himself suggested this to her."

"What makes you think that?" I asked.

"Something Fred mentioned," Isaac said. "He told us that Danton kept pressing Jane to go to the hospital, to make amends with her father. If I'm right, it was Danton who encouraged her to buy the potted plant, and to call her brother Frankie and ask him to deliver it. Jane may not have been prepared to make nice with her father yet, but she'd probably see no harm in sending Frankie in with a gift... to test the waters, so to speak."

Isaac drew a breath. "Then, that night, Danton makes his play. He's already stolen Frankie's gun, probably earlier that same day. Since Danton was so intimately involved with the O'Dell family, I think it's

likely he knew Frankie had one and where he kept it.

"Anyway, he now has the gun in his pocket, waiting for Frankie to arrive. Fortune smiles on Danton, as Frankie is as drunk and unstable as ever. He's barely able to hold the huge, leafy plant in his hands. The guard—having been through this with Frankie before—predictably searches him first."

I had a thought. "Maybe the guard's suspicions are even further aroused by the sight of Frankie carrying the big plant. I mean, mine would be."

"Good point," Isaac replied. "At any rate, the guard inspects the plant and its copper pot with care. Then he turns Frankie around and frisks him, which only makes Frankie more uncooperative. That's when Danton offers to help Frankie off with his raincoat. To do so, he has to take the plant from Frankie's hands. As he does, turning away to put it down on the floor, Danton slips the gun from his pocket into the plant. Then, after helping remove Frankie's raincoat, Danton himself is searched by the guard—who, of course, finds nothing. Finally, Frankie picks up the plant, and he and Danton go on in."

Mark stirred. "So now there's a gun in the room."

"Exactly." Isaac rubbed his hands together. "Again, pay attention to the sequence of events. Frankie presents the plant to his father, who angrily waves it away. Then Frankie, who obviously couldn't care less about it, puts it on a side table and goes to the bedside to confront his father. As their argument heats up, how hard would it be for Danton, unseen, to retrieve the gun from the plant and pocket it?"

"Not hard at all," Fred admitted. "I recall reading the attending nurse's testimony at the trial. She said O'Dell and Frankie were arguing so loudly, and so vehemently, that everyone's attention

was riveted."

"As Danton expected, of course. Even if father and son had not gotten into conflict so quickly, I'm sure Danton could have found at least one opportunity to retrieve the gun unobserved. The bedside argument only made it easier."

Bill's voice rose. "Then, after getting the gun back, Danton joins Parker and Frankie at the bedside..."

"That's right," Fred answered. "All three were there. That's when Dr. Parker tried to stop Frankie from upsetting his father any further. He finally had to grab his arm and shove him away—"

"Which was when Frankie bumped into the IV stand," Mark continued. "And Parker went over to try to fix it."

Isaac smiled. "Leaving Danton alone for a moment at the bedside. Just enough time to take the gun from his pocket, slip it under the bedcovers, shoot Francis O'Dell, and pocket it again. With the silencer attached, no one would hear a thing."

"Especially with Parker and Frankie going at it again," I said, leaning forward. "Fred said they were almost coming to blows."

"Yes," Isaac said. "But, more important, what had Frankie done just before being confronted at the IV stand by Dr. Parker? He'd grabbed up his raincoat. Imagine him now, perhaps with it folded on his arm, nose-to-nose with Dr. Parker. That's when Danton, seemingly in the role of peacemaker, steps between them. He has to physically restrain them, pull them apart. Right, Fred?"

"That's what the nurse said she witnessed," Fred agreed. "And what Dr. Parker acknowledged in court."

Isaac's eyes shone with satisfaction. "What a perfect opportunity, then, for Danton to get rid of the gun again—this time by slipping it

into Frankie's raincoat pocket."

He smiled at Fred. "You see, you had the mechanics of that part right. Just the wrong culprit."

"Oh." Fred considered this. "Well, that's something."

Isaac put his fingertips together. "After that, events occurred exactly as Fred described. Frankie storms out, unwittingly with the murder weapon in his raincoat pocket. Dr. Parker returns to his patient's bedside, and discovers to his horror that the old man has been shot. Then Parker alerts the guard, who tackles Frankie, and—"

"And," Fred interrupted him, "arrest, trial and conviction ultimately follow. No wonder Danton was willing to be lead attorney on the case. He needed to make sure the railroading of his client proceeded without a hitch."

Bill, frowning, took a long pause before speaking.

"Not to throw cold water on Isaac's scenario, but I do have one question: why? Why would Danton want to kill Francis O'Dell? I mean, no matter how big a pain he was, the old man was also Danton's biggest client. I just don't see why Danton would want him dead."

I'll be honest—now we were all looking at Isaac again. Bill's question was a legitimate one.

"Well," Isaac said slowly, peering over the steeple of his fingertips, "that threw me for a moment, too. Until I realized that O'Dell himself provided a possible answer. I remembered that, during his argument with his son, he accused Frankie of having embezzled from the company for years. And that he'd just the week before hired a top forensic accountant to go over the books. He was sure Frankie was stealing from him, and now he'd have proof."

Fred's face went pale. "Oh my God. I know what you're getting at.

It wasn't Frankie who was the embezzler—"

"It was Larry Danton," Isaac said. "Danton was closely involved in the old man's business. In a perfect position to embezzle from him. But then O'Dell tells Danton that he suspects that Frankie is embezzling from the company. Imagine Danton's reaction when he hears that the old man has just hired an expert to scour the books."

Fred smiled crookedly. "No, Isaac. I think in this instance, you have it wrong. My guess is, O'Dell told Danton his suspicions about Frankie, all right—but then asked Danton to find him a good forensic accountant. Danton did everything else for the old man, why not that, too?"

"Even if you're right," Mark said quickly, "Danton couldn't refuse. It would look too suspicious. He'd still have to go hire the guy."

"Which he knew meant that he'd be found out," Isaac continued. "A distinguished career, destroyed. Probable jail time. So, in a panic, what does he do? Since Danton always knew the old man's whereabouts—Fred explained that he even helped schedule O'Dell's appointments—I believe it was Danton who tried to run over the old man outside the restaurant that night. He'd certainly know where he was having dinner. In fact, it could very well be that another of Danton's duties was procuring those young ladies the old man was so fond of. Anyway, he hoped to kill O'Dell—then, after the dust settled, use the death as an opportunity to quietly fire the forensic accountant. Problem solved."

"Except it wasn't," Bill said. "Francis O'Dell survived the hit-and-run."

"Yes. So Danton's next attempt had to be more considered, better planned. Including having a convenient patsy to pin it on—Frankie O'Dell, the no-account son."

Bill chuckled. "'No account.' Now there's a phrase you don't hear much anymore."

But Fred still looked unhappy. "Okay, Isaac, you've sold me. But what the hell can we do about it? Danton's still representing Frankie, handling his appeals...."

"And I can just imagine how motivated he is on his client's behalf," Mark said. "I'll give him this, though—it's a smart ploy. It keeps the family in his debt, and diverts any possible suspicion away from him." He smiled. "Wouldn't surprise me if he were still dipping into the corporate cookie jar, too."

"Me, either," I said.

"I just had a thought," Isaac said suddenly. "Is the policeman who guarded the hospital room still alive?"

"Well, I'm not sure. I can find out, but I think so," Fred said. "Retired, though."

"No matter. Perhaps he can remember the events of that night more accurately, now that he's away from the pressure of the courtroom. And with some years having passed in which he's probably replayed that night over and over in his mind."

"Unless he's an old drunk who barely remembers what he did yesterday," Mark said sourly. "There's that, too."

"Ever the optimist," Bill said.

"What about the daughter, Jane?" I asked. "As an heir, she certainly can request an accounting of the corporate books. Maybe Danton's been foolish enough not to have totally covered his tracks."

"Good idea," Fred answered. "Unfortunately, Jane OD'd a couple years ago. You must've missed that little item in the tabloids. They found her in some rat hole in Tijuana."

"I'm sorry to hear that," I said. "I didn't know."

"No reason you should. By then, Jane was old news. And you know how the press treats old news...."

"Jesus," I said quietly. "The father and daughter both dead. The son, turning 50, in prison for life... Talk about a family doomed to grief. In that way, Bill was right. It is like some Greek tragedy."

"Yeah," said Mark. "Homer meets the Fortune 500."

Fred scowled. "You can joke, but Frankie O'Dell—no matter what you think of him—has spent the last ten years in prison for a crime he didn't commit."

"Hey, that's right," Bill said. "And meanwhile, this Danton bastard gets away with it...?"

"Somehow, I don't think so," said Isaac. "I'd bet that Fred here will do everything he can to get an investigation into Danton's activities underway. In fact, I think I see those very gears turning in his mind as we speak."

"They're turning, all right," Fred said. "If nothing else, I have enough to go to the state courts and argue for Frankie's release, pending further inquiry."

"Good. I'm glad that, at last, poor Frankie is in capable hands." With that, Isaac sat back in his chair.

Seeing him there, surrounded by his beloved stacks of paperbacks, I grew melancholy again at the thought that it was the last time I'd see him like this. I suppose I stared, as though to burn the image into my mind.

Bill, meanwhile, was about to pop open another beer when he, too, stopped and looked at Isaac.

"Wait a minute," he said. "Just to clear something up—when you left to make a phone call, it was really to pick up that spider plant to use

for your demonstration. Right?"

"Yeah, what about that?" Mark said. "Why'd you lie about the phone call?"

Isaac sat upright, feigning great offense at the suggestion. And, frankly, overdoing it a bit.

"I did no such thing," he said, indignant. "I did indeed make a call, right before I borrowed the plant."

"Then who did you call?" I asked.

"My friend, back in Vermont. To tell him I'd changed my mind about joining him in his farm equipment business."

"What?" Now I was the one to sit upright, with a surprise that was—I assure you—completely genuine.

"You're staying?" Bill said, grinning. "Cool."

"That's great!" Fred said, reaching over to clap Isaac on the shoulder. "Glad to hear it."

Mark's appraisal, per usual, was cooler. "I'm glad, too, Isaac. But, man, you sure love pulling surprises. If I didn't know better..."

Bill cut his eyes at him. "Put a sock in it, will ya?"

I came over and sat next to Isaac.

"What changed your mind?" I asked.

"This," he answered, taking in the room, and the four of us, with a wave of his hand. "Listening to the O'Dell family's tale of woe, I realized that I'd be an idiot to leave this new family I've found here. Not just with you and yours, as wonderful as that's been—" Here he gave me a quick nod. "But with the rest of you guys, too."

Bill's smile turned even warmer. "Back atcha, man."

"Anyway," Isaac went on, "while I don't know how many years I have left, I do know one thing for sure: I want to spend my last Sunday on

earth sitting in this chair, surrounded by these books, and talking about everything under the sun with the Smart Guys Marching Society."

"Okay," Mark said gruffly, "cue the sappy Hallmark card music."

Bill looked at me. "Hey, you're the touchy-feely guy in the group. What do ya think, hugs all around?"

Mark abruptly stood up. "Come near me and you're a dead man." Then, glancing over at Fred: "C'mon, I'll help you get this show on the road with Danton. We can start with my contacts at the paper. Dig up some dirt."

Fred rose, too. "Think we can?"

Mark's smile was all teeth. "It's what I live for."

As they headed out, Mark turned back to the room.

"Next week, gentlemen? Same Bat-time, same Bat-channel? I'm bringing sushi."

"You got it," I said.

"We'll be here," Isaac added.

And we were. All of us.

End

...AND OTHER TALES

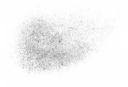

Patron Saint

Dr. Jo Kepler folded her hands on the desk and waited for her patient to compose himself.

"This is so lame," Detective Thomas Nolan said, squeezing his eyes with his thumbs. Teardrops dotted them like beads. His florid face, showing the strain of his 19 years on the job, turned away from her. "You must think I'm a total wuss."

Jo Kepler smiled in a way that managed to be both genuine and clinical at the same time. A single mother in her late 30s, she was pretty in a subdued, unaffected way.

"We've been coming to this point for weeks now," she said gently. "It's a sign of growth, of emotional maturity, that you can risk showing me how you feel."

"And none of this gets written down in your report, right?" Nolan asked, glancing at the file on her desk.

"I'm a therapist and you're my patient," she said. "The fact that I

work for the Department doesn't change that. What happens in this room is confidential. All I do in my report is make my recommendation to your supervisors as to your fitness for duty."

He gave a dark laugh. "Based on *what*, exactly? My drinking, the panic attacks, the sleepless nights? Hell, *I* wouldn't sign off on me."

She didn't respond, letting a silence fill the space between them. Bright morning sunlight baked the walls, warming the thick air. Soon it would be stifling. It was August in Los Angeles.

Nolan stirred, uncomfortable. Sweat glistened on his forehead. He was 45, according to his personnel file, but looked ten years older. Though big and tough as a bear, his body had already begun to sag. He had a cop's beer gut, a cop's stiffened joints, a cop's dour, suspicious squint.

A look Jo Kepler knew well, and not just from the patients she treated. She'd seen it for years in her father's eyes, before he was killed in the line of duty when she was 12.

Now Nolan was training those cop's eyes on her. "You know why they're makin' me come here, don'tcha? It's just the Department coverin' its ass before they yank me off the Task Force and stick me behind a desk."

"There *are* concerns, Tom," she said carefully. "I've seen too many good, solid cops get overwhelmed working a case like this."

"So you think I'm wiggin' out, too?"

"Are you?"

"Why? 'Cause I just blubbered like some loser about my baby brother? 'We used to be best buddies, and now we hate each other's guts.' Boo hoo. End of story."

"Your 'blubbering,' as you put it, is the *good* news. The memories

248

of your bond with Eddie when you were young, your grief over the way things are now... It's the most human I've ever seen you. Frankly, I was beginning to wonder."

"Thanks a lot, Doc."

She smiled. "Hey, I'm on your side, remember? And like it or not, we're stuck with each other."

The detective sat forward, head hanging between his shoulders. "Maybe. But once it gets out that a guy's been sent here..."

"We try to see that it doesn't," she said. It was an understatement, she thought. As a police psychologist, one of a dozen on permanent staff at the LAPD, she worked in a small, single-windowed office in a nondescript bank building in Chinatown. You couldn't even see Parker Center, police headquarters for the city, from here.

Everything was done to normalize the experience for the cops sent to her, including allowing them to keep their guns. Jo could see the bulge under Nolan's blue jacket. A lot of people questioned the wisdom of this policy, which was why therapists like Jo also had a panic button installed within easy reach under their desks. If a cop became violent or self-destructive, a guard stationed out in the corridor could be summoned in seconds.

In her six years with the Department, Jo had never had to push that button. Things had gotten pretty intense more than a few times, but she'd handled it. She was good at her job.

"I meant what I said before," she went on now. "All of your feelings are welcome here. About anything going on in your life. God knows, you're under tremendous stress. With all the political pressure, the media..."

"And it's only gonna get worse." He shook his head. "We just

found victim number eight last night. *Eight* women, Dr. Kepler. The bastard's laughin' in our faces."

Jo lowered her eyes. "Same as with the others?"

Nolan nodded. "Prostitute. Beaten to death. No evidence of rape, no usable forensics. He's gotta be wearin' gloves or something. Only blood at the scene is always the victim's." He paused. "He must surprise 'em, too. No defensive marks, no skin samples under the vic's fingernails. Perp just uses her for a punchin' bag till he hits something vital, and that's it."

He looked off, grimacing. "Can you imagine the rage, the fury it takes to beat someone to death with your fists? I mean, Christ..."

His words hung in the air for a few moments, then he reached into his jacket pocket and withdrew a manila envelope. "I know this is weird, and probably grosses you out, but I gotta show 'em to you."

"I understand," she said. "I'm actually getting used to seeing them. God help me."

Nolan's eyes flickered up at this rare personal disclosure. Jo took a breath and chastised herself. It wasn't that she had any professional qualms about sharing personal feelings with a patient, when appropriate. It was just that, as a police psychologist, she needed to maintain a slightly more authoritative stance with the officers assigned to her. Cops—especially males—responded to hierarchy and chain of command, and it was always a battle gaining their respect. And an even tougher one keeping it.

Nolan spread the crime scene photos on her desk. Steeling herself, Jo examined them. The poor girl. Sad, lifeless eyes peering up at her. Bloodied, broken body splayed against the throw rug, like some discarded toy.

"Her name's Gina Hill," he said. "Twenty-six. Lived in West L.A. Three arrests for soliciting."

"Pattern's the same," Jo noted, struggling to keep her voice calm. "Naked, except for the St. Christopher medal."

"Perp loops it around her neck. Since it's not blood-splattered or marked up, the ME figures it's placed there post-mortem. Some nutso message from the killer."

"Or maybe some kind of ritual. Isn't Christopher one of those saints the Church has discredited?"

"Yeah, but tell that to a dyed-in-the-wool Catholic like my mother. She still won't eat meat on Fridays."

Jo carefully picked up one of the photos by the edges. "Christopher was the patron saint of travelers, right? People prayed that he'd guide their souls to heaven."

He shrugged. "You're askin' the wrong guy, Doc. I haven't seen the inside of a church in 20 years." He sat back in his chair and unwrapped a fresh pack of Camels.

"Your team have any idea why victim number five, that girl down in Palms, *didn't* have the medal on her?" Jo asked. "She's the only break in the pattern, right?"

"Maybe the killer forgot," Nolan said. "Or maybe he got interrupted by something, heard a noise and took off before he could put it on her."

He lit up a cigarette and inhaled gratefully. "By the way, thanks for bendin' the rules about the smokes." He nodded at the ashtray she'd begun leaving out for him.

"No problem. You have enough on your plate without taking away your nicotine fix," she said.

"Thanks. I think."

They shared a smile as she got up from behind her desk and went to the window. As she turned up the dial on the venerable AC unit, she could feel his eyes on her body. It wasn't the first time she'd been appreciatively appraised by one of her patients. While this was due in part to the fact that, in the words of her adolescent daughter, she was "still a quasi-babe," she also knew it was an attempt on the cop's part to maintain some macho distance, some sense of control. Okay, so maybe the Department *did* give her the right to evaluate them; testosterone gave them the right to evaluate *her*.

At least that's how Jo's ex had explained it. A lawyer in the District Attorney's office, Steve claimed to know a lot about the police.

"With cops," he'd state in that patronizing tone that always set her teeth on edge, "it's pure siege mentality. Us versus them. They think it's the best way to keep the upper hand." Then, with a grin: "Hey, what can you expect? Basically, they're all Neanderthals. Except for your old man, of course."

Of course, she'd thought. Prick.

Of all the things she didn't miss about her ex-husband, his pompous lectures were near the top of the list. Along with his politics, questionable ethics and flagrant womanizing. That his genes could help produce a daughter as wonderful as Jenny baffled her to this day.

The air-conditioning came on suddenly, swirling the smoke from Nolan's cigarette as he scooped up the crime scene photos and put them back in the envelope.

Still standing at the window, Jo felt the thick knots in her shoulders, the strain in her lower back. She needed a two-hour workout, a massage, something.

She loved her job, but there was no denying its emotional—and sometimes physical—rigors: rushing in the middle of the night to some cop's home to defuse a violent domestic dispute; advising Department negotiators during hostage situations; cradling grief-stricken widows outside the ER. Plus her first-year trial-by-fire, when an armed robbery turned a peaceful North Hollywood neighborhood into a war zone, and she'd found herself strapped into a flak jacket to deliver psychological triage to embattled police at the scene.

It took a toll. Dealing every day with stressed-out cops complaining about their work, their spouses, their addictions to booze and drugs and danger.

Or else *not* complaining. Keeping it all locked inside. The ones who didn't talk, didn't do much except sit and glare at her, like problem kids sent to the principal's office. Which is how most of them saw it. Their bosses turning them over to some shrink, some stuck-up bitch who thought she could get inside their heads.

No, they rarely talked. Instead, they developed ulcers, sexual problems, busted marriages. Sometimes they got put behind a desk. Sometimes they just ate their guns.

At least Nolan talked, Jo thought, coming back to her desk. It had been tough getting him to open up, to trust her, but he'd come a long way in their two months together.

Then, earlier in today's session, to her utter surprise, he'd even shed some tears. Not about the job, or his frustrations heading up the Task Force trying to stop this serial killer. Not even about his recent divorce. His tears had been for someone else.

"I know our work has been primarily about the case," Jo said now, settling in her seat. "But I'm gratified that you're letting me see

into other parts of your life as well. Like earlier, when you were telling me about your brother..."

"Eddie's just an asshole," he said sharply, stubbing out his cigarette. "A total screw-up. The crap he's put our family through..."

"And the tears when you were recalling the way you were as kids, the powerful bond you shared...?"

"So I lost it for a couple minutes. So what?"

"It seemed to me you were in touch with some deep, painful feelings."

"Christ, don't you get it? It's this damn case!" He stood up violently, the chair tipping back, clattering on the linoleum floor. "It's messing with all our heads. Like Charlie Greer. Did I tell ya about that? I had to cut him loose, send him back to Vice."

"No, you didn't tell me." He's wired tight as a spring today, she thought. Handle with care.

He rubbed his eyes. "Greer got the call on Roberta Ruiz, while I was with the lab guys still workin' on victim number four. So he had to deal with Roberta alone. Man, it really shook him up. He said he can't look at no more naked dead girls." Nolan's laugh turned into a smoker's cough. He spoke between spasms. "Hell, maybe he's healthier than the rest of us."

"Maybe," Jo said. "At least he can acknowledge his limits."

"Yeah, well, tell that to the next victim. I mean, we gotta keep our shit together if we're gonna nail this wacko. That's our job. You gotta just let it go through you, like a bullet that misses all the internal organs and comes out the other side."

Jo shrugged. "That still leaves a wound. A scar." She shifted in her seat. "But let's get back to Eddie."

He wheeled on her suddenly, hands slapping down hard on the desk, making her jump. He seemed to tower above her. Jo tensed, aware of the power in his huge arms, the bulk of his shoulders.

"Leave my brother outta this," he said angrily. "What is it with you shrinks, eh? No matter what the problem is, you gotta dig around in the family."

"Take it easy, Tom."

He leaned in closer. "Besides, aren't we supposed to be talkin' about how my *parents* screwed me up? Hell, I'll lay it out for you: My sainted mother, the delicate Irish colleen. My violent, abusive father. Every damned night, Mom weeping and praying, Dad drinking and screaming. Me and Eddie caught in the middle. You do the math."

Jo kept her face composed. It was important to keep him talking. Whether he knew it or not, he was finally letting her in. His anger was a window to a deeper part of him, where the pain lived.

"You loved your younger brother. You protected him, looked out for him..."

"That's what brothers do, isn't it?" He glared down at her, hands on the desk closing into fists. She pretended not to notice.

"Covered for him when he lied," she went on, "or ditched school, or shoplifted at the mall."

"So what?"

"You wanted better for him. You said so yourself, at the beginning of today's session. You hated seeing how he broke your mother's heart when he got arrested for drunk driving, or—"

"Again, what's the point?"

He moved to a far corner of the room, fidgeting with his tie, his anger fading. "So we're like a bad movie, okay? One brother becomes

a cop, the other a low-life scumbag."

Jo let out a breath. "Pretty active guy for a low-life. Assault charges, drug convictions. I guess the deeper he sank into his world, reveled in it, the more you felt an obligation to be a cop. Get the bad guys. Balance the scales."

"Puh-leese." Nolan laughed. "They actually *pay* you to do this to people?"

"Tell me you're not John Wayne out there," Jo said, pressing him. "Explain your two commendations for bravery above and beyond the call."

"I lost my head." A wry smile. "Twice."

"Bullshit. You're always volunteering for extra duty. Didn't you even volunteer for this Task Force?"

"So I'm a civic-minded guy. Big deal. I'm still countin' the years till I put in my 20 and can pension out. Just like everybody else."

A thick silence. Nolan just stood there, looking at her. He seemed to deflate a bit.

"Tom, I'd like you to sit down, all right?" She nodded at the over-turned chair. "And easy on my furniture."

He smiled sheepishly and sat. But his face was still flushed, his breathing labored. Fumbling with his pack of Camels, he finally managed to light another one.

"Remember our first meeting?" Jo asked. "How you described yourself?"

"Yeah. I said I was always the first cop on the scene. First through the door. Kind of a precinct joke."

"You *care*, Tom. About your family. Your brother. You care about doing your job, stopping the bad guys. That's why these murders are

eating you alive. Why you always have to show me the crime scene photos. So that I'll *get* it. See what you see. Understand the pain you're feeling."

"No shit?" He blew a smoke ring. "I figured I showed 'em to you to gross you out. Knock you down a peg. Show you what goes on in the real world, outside of this nice, safe office."

"Maybe at first that was true. But not now. Now you want me to understand you. Your heart. Your cause."

He waved her off. Then, after a heavy silence, he said, "Look, I don't wanna talk anymore. Can I go now?"

"Not yet."

The sharpness in her own voice surprised her. But she couldn't let him leave. Some vague notion was taking shape in the back of her mind, like a photo slowly developing, coming into focus.

Nolan's eyes, meeting hers, were opaque. Unreadable.

Jo steadied herself. She had to do this just right. "Where's Eddie now?" she asked.

"Ungrateful shit's back at my folks' place, living over the garage. He always crashes there when he's broke or when there's too much heat. Last time, he stole money right out of my old man's wallet, wrecked their car..."

"Why do your parents put up with him? What is he, 30, 32?"

"He's their son, for Christ's sake! Their blood!" He spat the words at her, as though they tasted bitter. "You wouldn't understand. The way we were raised, you don't turn your back on your family. Not even when—" He stopped himself.

"When what?"

He didn't reply.

"It's killing you, isn't it?" she said.

His face grew darker, etched with pain and anger. "I don't know what the hell you're talkin' about—"

"He's evil, Tom. You know it and you hate him for it. But you also love him."

"Shut up!"

"That's what's eating at your insides. The love and the hate and the guilt—"

"I said, *shut up, bitch!*" His hands gripped the chair arms, propelling him out of his seat.

Jo's heart was pounding, but she kept on. "You can't stop him, and you can't turn him in. And yet you have to do *something* for his victims, even if it's just a gesture... a token to guide their poor souls on their way out of this life."

Nolan was standing now. He brought his huge hands up, fingers spread, as though to shield himself from her words.

"You—you don't know—" he said, almost stuttering.

Jo took a breath. Under the table, she shifted her knee a few inches to the left, feeling for the panic button. Where the hell was it?

"I do know, Tom," she said, softening her voice. "I know because you want me to know. Remember what you said? You're always first on the scene. The first to get close enough to the victim's body to slip on the St. Christopher medal, before the other cops see, before the ME arrives to examine her. That's why victim number five, Roberta Ruiz, *wasn't* wearing the medal. It was the one time you weren't first on the scene. Charlie Greer was. By the time you joined the team there, it was chaos. Cops, crime scene techs. There was no chance to bless her, to protect at least her soul, if not her life..."

Nolan was backing away, eyes wide. His mouth was moving, but making no sounds.

"Tommy..." Jo got carefully to her feet.

Finally, Nolan found a voice—one she'd never heard before, a high-pitched sputter, the keening of a child.

"Sweet Jesus, stay with me. Mother of God, protect me..."

Jo gasped. She knew now, with blinding clarity, the price Tom Nolan had paid for keeping his horrible secrets. The herculean effort it had taken to keep himself together.

Now, with the truth revealed, his psyche was literally unraveling....

Instinctively, she came around her desk, hands reaching to touch him... as though to pull him back from some dark place.

The blood was roaring in her head. Fear knotted her stomach. It all seemed unreal, like a feverish nightmare unfolding...

"I understand, Tommy," she heard herself saying. She forced her legs to move her toward him, as he backed up against the far wall. "You were doing the only thing you could do..."

The Detective's eyes were blinking, as though against a harsh light. His voice had sunk to a whisper. "Holy Mary, Mother of God..."

Jo took another step closer. "But it has to stop now, Tom. We have to call Lt. Rossi. Get him to send a unit to your parents' house and pick up Eddie."

But Nolan was shaking his head.

"We have to, Tommy. You know that."

Her eyes searched his face, beseeching him. Looking for the man behind the grief, the terror, the guilt.

His words were choked. "He's not there."

"Not there? Did you tell him you knew? Did he run?"

She took his hands in hers, gripped them with a fierce strength. "Where is he, Tom?"

"Where he can't hurt anybody anymore."

He leaned back against the wall, as though finally giving up the ghost. He closed his eyes, let his shoulders slump.

Jo froze where she stood, as the implication of his words sank in. The breath seemed to go out of her.

With an effort, she steadied herself. Suddenly, absurdly, she was conscious of the noise from the air conditioner. The car sounds from outside. But at least the roaring in her ears had stopped.

She grew calmer still. No, this wasn't a nightmare. This was real. And Detective Tom Nolan, regardless of what he'd done, was first and foremost her patient.

"Tommy..." She stood next to him, stroking his arm. He was docile as a child, head hanging down.

Voice quiet, almost serene, he said, "I buried him behind the batting cage at Beeman Park. We used to play there every day as kids. We were a team. Second base and shortstop. The Nolan Brothers, guarding the infield."

"You'll have to take the police there," she said softly. "Show them exactly where you put Eddie."

He nodded, oblivious. "It's okay, though. I put the Christopher medal around his neck. And I said some prayers. God will understand. Eddie—I mean, it wasn't really his fault. Those girls... what he did... he just wasn't right in his mind. You know?"

"Yes, I know," Jo said. She returned to her desk and picked up the phone.

Tom Nolan stayed where he was, huddled against the wall. His lips were moving again, perhaps in silent prayer.

Jo paused, phone in hand, and looked at him. She wished she shared his faith in the power of the St. Christopher medal and that she had one to give him for the journey he was about to take.

Players

Reese was sitting on the bed, looking down at the half-emptied bottle of Scotch and the loaded .38 on the side table, when the phone rang.

Damn! Just when he'd summoned the nerve to do it—to finally and forever put an end to things—

The phone kept ringing. He hesitated only another few moments, then picked it up.

"This is Reese," he said. He reached for the bottle, took another swig.

"It's me," said a voice on the other end. "Artie."

"I figured," said Reese. "How's Florida?"

"Hot." Artie laughed. Short, staccato bleats, like a trumpet.

"You know what I mean," said Reese. God, he hated this. How'd he get into this mess in the first place?

"The numbers aren't good," Artie said. "When the Feds and the SEC get through with it—then there's that funny business with the

fund—"

"Spare me the details." Reese picked up the .38, hefted its weight. Heavier than he thought it'd be.

"The way I see it," Artie was saying, "there're two ways to go—"

Reese grunted absently. "There's only one, and you know it."

The gun lay against his palm, his forefinger curling around the trigger. Testing it. A little play there. What had he read somewhere? Squeeze it—slowly, deliberately—no quick, jerky motions. Oh, yeah, and relax the grip.

Sure, he thought. *I'm relaxed as hell....*

"Reese, you there?" Artie cleared his throat. Laughter near him came over the line.

"You're not alone," Reese said.

"Doesn't count. Rented for the evening."

More muffled laughter. Young. Male. *Christ.*

"Well, pal," Artie said suddenly. "Time is money. What are you gonna do?"

"First thing," said Reese, "I'm gonna relax my grip."

Artie was silent. Reese smiled to himself.

"You sure about this?" Artie said at last.

Reese was looking at the .38's snub nose. Black. Thick lines. Jesus, it was an ugly thing.

"Reese?"

"I'm here." One more big gulp from the bottle should do it. He'd hold it against his gums, swallow slowly, letting it burn all the way down...

"You want anything?" Artie's voice was quieter now.

"I want to be somewhere else," Reese said sharply. "Not in

this damn house, not in debt up to my eyeballs, not about to be indicted—" He let out a breath. "I want to be some*one* else. Think you can manage that, Artie?"

"'Fraid not." Another pause. "Listen, just so you know... I'm gonna call somebody I know over at the phone company. This call never took place."

"You mean, there won't be any record of it."

"Same thing."

"Gotta hand it to you, Artie. You sure know how to cover your ass."

"Which is more than *you* can say."

"Tell me about it." Reese saw it all arrayed before him—arrest, conviction, jail time. *Hard* time. Ruin.

Money, he thought bitterly. In the end, it always comes down to money.

"Hell, Artie," he said, "I had a good run."

"You're a player, Reese. Sometimes players lose. That's what makes it a game."

"Yeah. Right." Reese drained the bottle. His head was spinning. Was his hand shaking, too? Pathetic.

Artie tried another tack. "Look, you gotta think of your family, your kids. Not to mention the insurance company. Tryin' to fool *those* bastards—"

"I'm touched," said Reese. "But don't worry about it. It'll look like an accident. I'm foolin' around with my new gun, it goes off—I mean, I'm a goddamn model citizen. Nobody'll believe I'd ever..."

His voice trailed off.

"There's no other way?" Artie actually sounded regretful.

"Nope."

Just like that. "Nope." A whole life summed up in one syllable. It was enough to make you laugh.

Except that Reese didn't feel like laughing. He stared at the phone in his hand, almost as though he could see Artie at the other end, and sighed. Damn crooked lawyers.

He hung up without saying good-bye.

Just then, the door to the bathroom opened, releasing a cloud of steam into the room. Reese's wife stood in the doorway, wrapped in a towel, wet from the shower.

"Who was that on the phone?" she asked, stepping into the room.

"Artie. It's all hit the fan."

"Which means what, exactly?" Her voice grew an edge.

"Which means, I'm screwed. Finished."

"Just as Daddy predicted," she said sourly, wringing her wet hair in her hands. "I was a fool to marry you."

"No," he answered, "you were a fool to leave everything to me in your will."

She was just glancing up to respond when Reese pointed the gun at her and—slowly, deliberately, just like he'd read somewhere—pulled the trigger.

End

A Theory Of Murder

My friend Albert Einstein unwrapped his sausage roll, then looked up at me with those frank, dark eyes. "Tell me, Hector, what is the secret to living in harmony with a woman?"

I shrugged in my thick overcoat. It was cold out here in the dawn mist, beneath the wintry mantle of holiday snow. We sat, as we did every morning before work, on a bench overlooking the Aare River.

"I know less about women than you do," I answered, sipping my tea. "At least you've managed to marry one."

"I prefer to think that Mileva married *me*. For my money, perhaps?"

"It can't be for your looks," I said.

He smiled, then bit into his steaming roll, chewing as carelessly as he did most things.

Below us, the river flowed stubbornly around islands of scrabbly ice. Traversing its treacherous surface was a sleek racing scull being rowed

by the university team, undaunted by the frigid conditions. I could just make out the half-dozen broad-shouldered students, encased in thick coats and heavy blankets, urged on by their coxswain.

We ate in a familiar, comfortable silence. Then I became aware of the rolling of cartwheels on icy cobblestones, the flap of shop windows opening to the new day. Cool morning light poked through the haze, revealing the shapes of old, weathered buildings—relics of a past that young men like Albert and I had long since shrugged off.

We were the new generation, like those students on the water. The men of the future. It was the year 1904.

We finished our meager breakfasts and trundled down the snow-draped streets. It was two days before Christmas, and we passed several small clusters of religious folk, in gaily-colored mufflers and hats, ringing their bells and collecting for the poor. As usual, guilt made me dig into my own relatively poor pockets for some change.

Albert had said little as we made our way through the growing, early-morning throng. He'd seemed quite distracted these past months, though whether due to marital problems or his struggles with his arcane physics papers I couldn't be sure. Whenever I asked about them, he'd merely say they weren't ready for publication yet. I confess I doubted whether they might ever be.

At last, Albert and I arrived at the patent office. Inside, we found our employer, Herr Hoffmann, his thick mustache stained with coffee. A copy of this morning's *Gazette* was in his hand.

"Have you heard the news?" he said, more agitated than usual. "*Have* you?"

"Are the planets still holding to their prescribed parabolas?" Albert asked mildly.

"Are they *what*—? Honestly, Herr Einstein—"

Hoffman shook his head and raised the folded newspaper like a flag.

"The most horrible of all," he said gravely. "Just last night... not five blocks from this very room. And during Christmas, for the love of God."

"More murders?" I said, stunned. "Like before?..."

"Worse. An entire family. Husband, wife, three children. Murdered in their beds. Slaughtered like cattle."

I took the paper he offered, my hands trembling as I read the horrible details.

"You must see this, Albert," I said. "It's unnatural. A crime unlike any in history."

"Now that, dear Hector, I sincerely doubt. I trust you've heard of the Boer War. The massacres on the African coasts. Certain penal colonies in the Australian continent...."

"Yes, yes," I said irritably. Truly, Albert could be maddening at times. In such moments, I didn't envy Mileva her choice of husbands.

"My *point*, Albert," I went on coolly, "is that a monster is afoot in Berne."

"Exactly!" Hoffmann sputtered. "We have a Jack the Ripper in our midsts."

Albert opened his eyes, at once penetrating and leavened with sadness. "Yet one far less discriminating. The Ripper chose his victims from among the women of the streets. This killer chooses them... at random? That, I suppose, is the great bafflement. How he chooses his victims, or why."

Hoffmann nodded. "That's what the police say. There appears to be no motive." He pointed to the paper in my hands. "You see, they've listed the deaths so far. The watchmaker, stabbed in his shop. The knifing of the elderly couple. Three seminary students, hacked to pieces. Now this poor family."

"No recurring pattern," Albert mused. "So unlike the universe, when you think about it. Or the habits of most men."

"Except for one thing," I said. "He always uses a blade of some kind. A scissors for the watchmaker, a knife for the old couple, a thick cleaver for the students. Appalling."

"*And* inefficient," Albert said. "Unless the killer's trying different approaches to discern the most effective. Trial and error. Hypothesis and experimentation. The scientific method."

I stared at him. "The man's obviously deranged! And you talk of *methods...*?"

Hoffmann clucked his tongue. "Sometimes, Herr Einstein, I worry about you."

"I'm touched, Herr Hoffmann."

"Exactly. That's what I'm worried about." Hoffmann laughed at his own wit and shuffled over to his desk by the front door. "However, should you feel inclined to join the rest of us in the real world, I'd appreciate the schematics of the Beringer application by first post."

As I turned to my own work, I caught sight of Albert once again leaning back in his chair. He seemed to be staring at a spot on the ceiling. Or perhaps *through* the ceiling, and the sky beyond, to the very edge of the universe.

I hated to agree with Hoffmann, but Albert's mind did usually seem everywhere except in this real world of brick and soil and sau-

sage rolls, of yearning and sorrow and sudden, horrible death.

My odd friend Albert. So secretive about his as-yet unpublished physics papers, yet so casually sure that they'd stun the world. At times as playful as a child, at others sober and introverted.

Especially today, since hearing the gruesome news about the murdered family. Albert and I had exchanged not a word, cloaked in a thick silence broken only by the shuffle of drafting papers, the scratching of pens, the muffled ticking of the wall clock.

Until lunchtime arrived... along with an Inspector Kruger of the local police, who entered stamping snow from his boots.

Herr Hoffmann stood, mouth agape, as the tall, slender Kruger pulled his gloves from his hands and saluted.

"Just routine police work," Kruger assured us. "We have these murders, you see. The whole Department is engaged."

"Of course." Hoffmann rubbed his hands nervously. "It's a comfort, knowing our police are on the job. Berne is a peaceful town. We've never known such brutal events before."

Kruger smiled. "Calm yourself, Herr Hoffmann. Men must be strong. It is our duty." He turned to me. "Actually, I'm here to ask Herr Franks to come with me. To headquarters."

"Me?" Like an idiot, I actually pointed to myself.

Albert rubbed his nose inoffensively. "Is Hector a suspect in these killings, ludicrous as that sounds?"

Kruger tightened his jaw. "I can't say more."

I looked over at Albert, whose own jaw tightened. He'd never handled authority very well, he told me once. I could plainly see that now.

"I suggest I accompany you, Hector," he said at last. "As your second."

Kruger looked as though he were about to respond, but then merely shrugged. He ushered us out the door.

The police wagon, wheels rattling, turned onto Aarstrasse. I frowned at Kruger, wedged between Albert and myself in the rear. "This is not the way to police headquarters."

Kruger shrugged. "We must make one stop first."

We pulled to the curb before a rambling, two-storied house shadowed by ancient firs thick with snow. A squad of uniformed policemen milled out on the lawn, hugging themselves against the cold, smoking brown cigarettes. As we climbed out of the wagon, the men came quickly to attention.

Beside me, Kruger merely grunted his displeasure and led me up the icy porch steps and into the foyer of the somber house. I heard Albert's steady shuffle behind us.

The first horror awaited us in the drawing room. Splashes of dried blood covered the carpet, the arms of chairs, the gilt-edged picture frames—even the still-hanging Christmas tinsel and carefully-wrapped presents under the tree.

The Inspector pointed at an obscene black stain near the hearth. "Herr Gossen and his wife were killed there."

I couldn't find words, but I heard Albert's quiet voice behind me. "The children?"

Kruger nodded to the staircase. "Upstairs."

He led the way up the velvet-lined steps and into the first of two bedrooms. Toys, stuffed animals and colorful downy blankets attested to the ages of the former occupants. Twin boys, I recalled from the *Gazette*, not yet five.

Kruger drew our attention to the little beds. Blood-soaked. Sheets a tangle. "Murdered as they slept," he said. "Perhaps it was a blessing."

I found my voice. "But why are you showing this to *us*? To *me*? I don't understand—"

Kruger stirred. "You will. In the girl's room."

He led us to the second bedroom, evidently that of a girl in her teens. Soft, feminine. I thought I saw the glint of a blond hair in the afternoon sun, where it adhered to a bloodstained pillow.

I took a breath, then felt Albert's reassuring grasp on my arm. It was he who questioned the Inspector this time.

"I don't see the reason for bringing us here," he said.

In reply, Kruger took a folded cloth from his pocket. Within lay a heart-shaped gold locket, smeared with blood.

"It was found clutched in the dead girl's hand," Kruger explained. "Which was severed from her body, and lay a few feet away from it on the floor."

"No!!" I cried. It took both of them to keep me upright as I swayed, gasping. "It... it *can't* be..."

"So you recognize the locket?" Kruger stared at me.

I nodded dumbly. How could I not? It had once been mine.

"It was a cruel act," Albert was saying to Kruger, as we sat in the Commissioner's office at police headquarters. "And unnecessarily theatrical."

"Perhaps." Kruger's bald head shone in the wintry light from the windows. "But I thought it might be effective."

"For what? Extracting a confession from Herr Franks? You can't

possibly suspect Hector of these heinous crimes?"

I sat in silence on a padded bench at the far end of the large, wood-paneled room. I felt disembodied. Adrift in a nightmare from which I couldn't awaken.

Until I was startled from my melancholy by the arrival of a slender young girl, in the company of a police matron.

"Mina!" I said, leaping from my seat. Upon seeing me, Mina froze in her tracks, face turning pale as chalk.

She was as beautiful as I remembered, luminous eyes now red-rimmed from recent tears.

Kruger rose, and turned to Albert.

"This is Fraulein Mina Strauss," he explained. "She was a schoolmate of the late Fraulein Gossen."

Mina's voice quavered. "Poor Katie. She was my best, my truest friend. We..." She burst into tears, hands covering her face. The stoic matron idly handed her a handkerchief.

"Fraulein Strauss is also known to Herr Franks," Kruger said, finally looking at me. "Isn't that so?"

"Yes. I... we..." I looked at the floor. "I loved her once. Some few years ago."

"Love?" Mina's eyes found mine. "It was an infatuation, Hector. I was only sixteen, and even I had the wit to know that." She turned to Kruger. "Hector worked for a summer for my father. He... flattered me with his attentions. But I never returned his affections. Even after he sent me the locket."

Kruger pointed to the gold locket on the table next to us, still nested in the folded cloth. "This locket?"

Mina nodded, miserable. "I shouldn't have kept it, I know. But it

was so pretty. Perhaps I'm vain. Perhaps..." Her smile back at me was kind. "I'm sorry, Hector."

Albert took a step forward, hands in the pockets of his loose trousers. Old pipe ash flecked his sweater.

"Might I ask how the locket came into the possession of Fraulein Gossen?"

Mina gazed warily at Albert's careless appearance. I could sense that she found him... unimpressive.

"I gave it to Katie," she said carefully. "As a token of our friendship, our bond. We shared a special kinship... a..."

She looked at me for a long moment, then away, as though having decided I wouldn't understand. Her voice dropped to a whisper. "Now my world is over. Finished."

I found her words perplexing, and glanced over at Albert. But his expression was unreadable.

Suddenly, a heavy tread sounded in the doorway. It was the large, imposing figure of Commissioner Otto Burlick. In his wake came a sturdy-looking young man wearing rimless glasses and a crisp college uniform beneath his winter coat. He had the same thick, dark features as the Commissioner.

Behind him, lounging in the doorway, was another college youth. Though he had the sullen look of a street ruffian.

Burlick lumbered over to his desk, rumaging hastily through the top drawer until he pulled out a checkbook.

"Won't be a minute," he said to the room, exasperated. "My son Jeffrey is in need of a loan."

"It *is* a loan," Jeffrey, the first boy, protested. He glanced neither at me, Mina, nor the Inspector. "I'll pay it back."

"Don't grovel, Jeffrey," said the boy in the doorway. "It's disgusting."

Jeffrey whirled at this, face reddening. "*Do* shut up, Hans. If it wasn't for you, egging me on..."

Hans laughed sourly. "So now it's *my* fault you bet on the wrong boat?"

Burlick looked up from his desk, bristling. "Hans Pfeiffer? I've heard Jeffrey speak of you. You think you're some kind of tough character. No doubt you'd benefit from a good hiding."

He turned to his son. "As for you, Jeffrey. Gambling on athletic events? Is this what they encourage at your university? I shall have to speak to the Chancellor..."

Jeffrey gasped, mortified. "Father, don't!"

Burlick returned to his checkbook. Jeffrey, seemingly at a loss, swept the room with his eyes. Then, with a forced casualness: "Hello, Herr Einstein."

Albert registered a mild surprise. "Do I know you?"

"I've seen you around the campus," Jeffrey said easily. "A real scholar, I'm told. Not like me. You wouldn't want to hear about my difficulties with mathematics."

Albert gave him a rueful smile. "I can assure you, young sir, mine are far worse."

The sound of Commissioner Burlick ripping a check from his book drew our collective gaze. He gave it to Jeffrey, glowering. "Now go! And, by God, look to your studies."

Jeffrey nodded, stuffed the check in his pocket and sauntered out. Hans turned to follow, but not before giving Mina a leering wink that made her look away.

An embarrassed silence filled the room. Then the Commissioner

settled into his chair and smiled gamely.

"Sorry about the interruption. With children, one does what one can. After that..." He shrugged, then turned his attention to Mina. "So, Inspector, have we taken the young lady's statement?"

"Yes, Commissioner." Kruger sniffed. "It was Fraulein Strauss who gave Katie Gossen the locket we found. As a gift."

Albert cleared his throat. "Excuse me, but how did the police know the locket had originally belonged to Hector?"

Kruger laughed shortly. "Because we are not incompetent, Herr Einstein. The locket is inscribed at the back with a serial number and the name of the maker, Gerd Oberlin, on Marktgasse. He checked his records and declared it had been sold to one Hector Franks, at whose instructions it was sent by post to Fraulein Mina Strauss."

Albert nodded. "And from whose hands it then passed to the murdered girl. So I don't see how Herr Franks is further involved."

"Perhaps he learned his gift had been unappreciated by its recipient," Burlick said officiously. "That in fact it had been given to another. Driven by jealousy and rage, he stole into the Gossen home to retrieve it. There, surprised in the act, he was forced to..."

"Butcher the entire family?" Albert chuckled.

The Commissoner looked at him sternly. "I have seen stranger things in the course of my career, young man. And I *don't* appreciate Jewish impertinence."

Inspector Kruger seemed embarrassed suddenly, but by what I couldn't tell. At any rate, he was quick to usher Mina, Albert and myself out of the Commissioner's office, and into the bustling corridor beyond.

"Am I free to go?" I said to Kruger, trying to sound indignant. I

had somewhat found my feet again.

"For now. But keep yourself available to us." He turned to Mina. "The same for you, Fraulein Strauss."

Mina nodded, then turned and allowed the matron to escort her briskly down the corridor. She never even glanced in my direction.

And I knew, as one knows these things, that I should never see Mina Strauss again.

That night, I sat in my rooms surrounded by discarded newspapers. The murders had gripped the imagination of the Continent. The killer's reign of terror was recounted in explicit detail, including wild theories of genetic insanity, religious cults, political anarchists gone amok.

I poured myself an unaccustomed second brandy and sat, sleepless, in my chair by the fire. I couldn't imagine sleep. Not after what I'd seen that day.

And Mina...? Seeing her again after all these years. Learning what had happened to the locket. How could she have been so callous as to give what I had offered her to another?

I was stewing in this self-pitying broth till almost four in the morning, when a pounding at my door broke me from my reverie. I glanced at the mantel clock. At this hour?

I pulled open the door to find an equally exhausted-looking Albert Einstein, bundled into a thick wool coat.

"My God, Albert, do you know the time?"

"More intimately than most, I promise you." Then, with uncharacteristic urgency, he brushed past me into the room and began looking about. "You'll need a warm coat, of course. And boots. You don't

happen to own a revolver?"

"A revolver? What are you talking about?"

"All will be explained." He stared at me, impatient. "Well, are you coming or not?"

The predawn chill was like a cloak of ice. It had also snowed again during the night, leaving two-foot-high drifts that impeded our progress toward the boathouse.

Beyond the long, wood-framed structure were the venerable spires of the university, which lay under the gloom as though crouching for warmth. The only sound was the distant tolling of Yuletide church bells for the morning's first service.

As we carefully approached the silent building, I could now hear the river lapping gently at the dock. Out on the frigid water, silent as ghosts, the rowing team propelled their boat smoothly through the mist.

Albert led us to the near side of the boathouse, and then to a position beneath the single window. We peered through the smudged pane at an empty room, warmed only by the light of a huge cast-iron stove. At the far end of the room stood a large water keg.

I turned to see Albert nodding to himself. "Of course, the drinking water... I *wondered* how he planned to subdue them. Some kind of soporific in the water. Then he could—"

"I swear, Albert, if you don't tell me what's going on—"

"It occurs to me, Hector, that I might be putting you in harm's way. I did leave a note for Inspector Kruger, but I doubt he'd take me seriously..." He frowned. "Not that I blame him, given my gross stupidity about these murders...."

By this point, I merely stared at him.

"It was so obvious, I couldn't see it," Albert went on in a fierce whisper. "There *is* a pattern, of course. Prime numbers. Divisible only by themselves and one. Perhaps a mocking reference to his own troubles with mathematics? Who can say with such a man? One who kills so ruthlessly... I recall reading Buhler on the subject of compulsions, Atwood on multiple murderers. Mileva has some interest in psychology, and keeps many books on—"

Flustered, I cut him off. "Wait! Prime numbers...?"

"Yes. 1, 2, 3, 5, 7, et cetera. *One* watchmaker, *two* old people, *three* seminarians, a family of *five*, a rowing team—"

"Of seven!" I exclaimed. "Six oarsmen and the coxswain."

He nodded. "Where better to find the necessary seven victims than at his own university? He's familiar enough with the sport to gamble on it. And there has to be at least one more murderous act for the pretense of a killing spree to be maintained."

"Pretense?"

"To hide the *real* motive for the crimes, and the real—and only— intended victim. Katie Gossen. The killer knew her murder would inevitably lead the police to his door... unless it was merely one in a series of brutal, senseless deaths. Part of an insane pattern based on prime numbers."

A sudden noise from within the boathouse silenced us. Footsteps against creaking floorboards. Muffled, secretive.

Carefully, we once again peered into the shadowy room.

A figure in a black overcoat and gloves was leaning over the water keg. On the bench beside him, its blade glinting dully in the half-light, was a thick-handled axe.

I felt Albert's restraining hand on my arm, but I risked another

look. The man was lifting the keg lid, pouring some kind of powder inside. As he bent, his face shone in a pale shaft of light.

I sank back next to Albert, stunned. "But I thought it was—I mean, you *saw* what kind of creature Hans Pfeiffer is. The way he winked at Mina..."

Albert nodded. "Yes. Coarse, familiar. But how could he not take notice of Mina Strauss? An uncommonly beautiful girl. Yet *Jeffrey* never gave her a glance. I thought that was odd... unless he knew her. Unless he purposefully ignored making eye contact. Because Mina knew him—or, at least, of him—from hearing of his unwanted attentions to her friend Katie."

"How in God's name do you know of this?"

"I asked around at the campus," Albert replied. "Jeffrey was hopelessly enthralled by Katie, and she spurned him. I thought something like that might be at the core of this, thinking of how Mina had likewise rebuffed you."

I stiffened. "Thanks very much."

He ignored this. "I'm sure his advances were crude and improper. He has a reputation for violence and drink. A loutish, aggressive type, under which lies an even darker, murderous nature. He finds being thwarted in his desires intolerable. Emboldened by his father's wealth and position, thinking himself above the laws of God and man, he's driven to murder."

I struggled to absorb his words. "So you guessed that he needed at least one more to make a convincing picture. The seven members of the rowing team... But how did you know?"

"Imagination, Hector. The unheralded seedbed of all theory." A wry smile. "I simply imagined what *I* would do in his place."

Another squeak of floorboard from within drew our eyes to the glass. Jeffrey was moving back against the far wall, axe in hand. Melting like a wraith into the lattice of shadow.

"Now all he need do is wait," Albert whispered. "The team will be returning any moment. After a vigorous workout, they will doubtless drink from the water keg. Jeffrey knew there were too many to handle unless they were incapacitated."

I nodded. "So after the drug takes effect, he can move in for the kill. Unless..."

Where this sudden flush of courage—or foolishness—came from, I cannot say. But suddenly I was barreling as fast as possible through the snow, around the corner of the low-slung building and through the opened double doors.

"Hector!" Albert called out, but I'd already crossed the threshold into the room.

Jeffrey Burlick had turned at the pounding of my footsteps, and rushed now from the shadows to confront me. I leapt at him, hands outstretched, a cry bursting from my lips.

We ended up in a heap on the floor, Jeffrey awkwardly trying to bring the axe to bear. I saw the horrible glint as its blade sliced down toward me. I saw my own death.

Then I saw Albert, face red with exertion, struggling with both hands for the axe. But the burly young student merely flung Albert to the floor.

Winded, scrambling to get up on our elbows, we looked up at the glowering face of a demon. Jeffrey hefted the axe as though it were weightless, raising it high.

"*You* two thought you could stop me?" he cried. "Two penniless

patent clerks? No one can stop me!"

"You *must* stop!" I gasped. "Even you must see, killing these men avails you nothing. You've had your revenge on Katie... you've ended her life. Why must you end these others?"

"Revenge?... on Katie?" His eyes narrowed to dark slits. "She's nothing! She means nothing to me. The design is all. The purity, the immutable beauty..."

He paused then, regarding me with bemusement. "Something a man like you could never understand. Bound by your pathetic, bourgeois pieties..."

As, tightening his grip, he raised the great axe once more to strike—

When another voice shot through the room. "Not as pathetic as you, Jeffrey!"

Burlick froze where he stood, as the tall, ramrod figure of Inspector Kruger stepped through the doorway. He held a police revolver pointed at Jeffrey's chest.

"Put down the weapon or I'll be forced to fire."

Jeffrey wavered, glance darting from us to the Inspector.

"I assure you," Kruger said sharply, "I don't care who your father is. I will shoot you where you stand."

A strange, anxious smile played across the young man's lips. "My father?... with his rules and regulations. So rigid, unbending. The unspeakable hypocrite! You don't know what he's *really* like, what he did to—" His voice caught. "*He's* the monster."

His eyes blazed now as he turned to stare at Albert. "And yet powerless against the march of mathematical inevitability! Surely, Herr Einstein, you must understand. If no one else, surely *you*..."

Then suddenly, in two brisk strides, Kruger was at the killer's side, the revolver pressed hard against his ribs. Jeffrey Burlick gave the Inspector the merest look, before letting the axe fall with a clatter to the floor.

Albert rose beside me and smiled at the Inspector.

"I see you received my message," he said. "I'm surprised you gave it any credence."

"I'm surprised that *anything* surprises you, Herr Einstein. Not after this." He nodded at Jeffrey, who, to my utter incomprehension, stood calmly with his arms folded, as though waiting for a train.

"No." Albert was shaking his head. "I miscalculated. Your arrival here was an unexpected variable. A random occurrance. If I didn't know better, I'd think perhaps God plays dice with the universe after all."

My fear rapidly being replaced by irritation. I hated when Albert talked like this.

"Forget your theories, for the love of heaven!" I snapped at him. "We were almost killed this morning."

"I wasn't the one who seemed intent on heroics. Honestly, Hector, that was perhaps the most amazing surprise of all."

In a matter of minutes, a police van had arrived and Jeffrey was bundled away in restraints by two stout officers. Inspector Kruger followed them out.

Alone with Albert in the eerie stillness of the boathouse, I gave voice to my thoughts. "Young Burlick must suffer from a diseased mind... it's the only explanation..."

Albert looked off, in that way I'd become accustomed to.

"No, he's not mad. He knows the difference between right and

wrong. I saw that clearly. He just... doesn't care."

"But that's unthinkable! To butcher innocent people without remorse? Without a conscience? Believe me, Albert, I doubt there's a word for such pathology in your wife's scholarly books."

"Perhaps not," he replied with a sad smile. "But I fear one day soon there will be."

Outside, another gentle flurry of snow had begun to fall, and I realized with a start that tomorrow was Christmas Day. Though, admittedly, such holiday thoughts were far from my mind at that moment.

Albert and I stood with Kruger, watching as the rowing team, oblivious, began making their way to shore. From the dock, I could hear the sounds of another pair of policemen, dumping the keg of drugged water into the river.

Another sound, that of boots scraping heavily against frozen earth, made us turn. Jeffrey Burlick, shackled hand and foot, was being led to the rear of a police van. As the door was held open for him, he paused and looked directly, nakedly, at us. Then, showing a small, tight smile, he turned and stepped into the van.

As it rumbled away in the blur of morning light, Albert looked gravely at Kruger.

"He's the Commissioner's son. This will cause a scandal."

"Not my concern."

Their eyes locked. "I *am* curious why you believed me," Albert said quietly.

"Let's just say, not all of us share the Commissioner's prejudices, Herr Einstein."

Then, with a curt bow, Kruger went to join his men. Albert watched him go, before brushing himself off and heading in the opposite direction. I followed.

"That's quite enough adventure for me," he said. "Now it's back to my physics papers."

"No," I said. "It's back to the office, and the Beringer patents. We work until six, even on Christmas Eve. Or Hoffmann will dock your pay."

He grimaced. "And Mileva will be furious."

Then, smiling, Albert Einstein put his arm around my shoulder. "Ah, Hector, the mathematics of love. Compared to it, physics is but child's play."

On the way back to work, we stopped for a sausage roll.